The Inspired Heart

To Bruce & Marcia,

Blessings,

[signature]

The Inspired Heart

An Artist's Journey of Transformation

JERRY WENNSTROM

SENTIENT PUBLICATIONS, LLC

First Sentient Publications edition 2002

Grateful acknowledgment is made for permission to reproduce the translation of Rainer Maria Rilke's poem, "Dann bete du, wei es dich dieseer lehrt," from *Rilke's Book of Hours,* Riverhead Books, 1997, Joanna Macy and Anita Barrows, translators.

Printed in the United States of America

Cover design by Kim Johansen, Black Dog Design
Book design by Bill Spahr

Library of Congress Cataloging-in-Publication Data

Wennstrom, Jerry, 1950-
 The inspired heart : an artist's journey of transformation / Jerry
Wennstrom.— 1st Sentient Publications ed.
 p. cm.
 ISBN 0-9710786-9-6
 1. Wennstrom, Jerry, 1950- 2. Spiritual biography—United States. I.
Title.
 BL73.W43 A3 2002
 291.4'092—dc21

SENTIENT PUBLICATIONS
A Limited Liability Company
1113 Spruce Street
Boulder, CO 80302
www.sentientpublications.com

*This book is dedicated to all things receptive and feminine,
especially to my mother, Mary, who died this year,
and to Marilyn, my wife.*

Contents

In The Hands of Alchemy 1

Foreword

A few years ago I received a book from a thoughtful woman who lives in the United Arab Emirates, an illustrated version of the Sufi tale *Mojud: The Man with the Inexplicable Life*. Mojud starts out as an inspector of weights and measures but then receives several visits from the spirit guide Khidr. Each time his life settles, the spirit appears with a new adventure. Everyone thinks Mojud is mad, but with a sacred simplemindedness he empties his will and follows directions. Finally, the story says, "Clerics, philosophers and others visited him and asked, 'Under whom did you study?' 'It is difficult to say,' said Mojud."

I think Khidr must have visited Jerry Wennstrom a few times, too. His many beautifully told stories show that Jerry has Mojud's openhearted faith, the intelligent willingness to read the signs life offers of what to do next and where to turn. As Jerry himself realizes, it is the way of the Holy Fool, the one who grasps the simple idea that being open to life is ultimately more rewarding than trying to control it.

Joseph Campbell once wrote that Aphrodite can be seen today standing on the corner of 42nd Street and Fifth Avenue. The timeless spirits and the timeless truths are ever-present, if disguised in ordinary clothes and personalities. Jerry's insights show all the traces of the world's ancient wisdom, though he uses his own handcrafted images and phrases. This is another example of what happens when you open yourself to people and events without self-protective judgments.

Reading Jerry's own tale within his many vivid stories, I am also visited by Perceval, who found his way through the forests and the wasteland with a simplicity of mind and an egolessness that was magical. As I was reading how Jerry consistently appreciates the holiness in his many troubled acquaintances, I also thought of R. D. Laing, that brave soul who was ridiculed for his own wayward life. Jerry's attitude echoes Laing's insight that psychological problems are actually spiritual in nature and deserve to be treated as such.

I don't share Jerry's enthusiasm for "wholeness," but I like his description of it as coming full circle. My favorite image for this is the ancient ouroboros, the snake that bites its tail. We humans are not evolving but circling, and the stuff of our souls keeps coming back for more attention and more living. I appreciate the form of Jerry's book, a series of stories that circle around. I like the fact that they aren't entirely chronological and that each one is a beginning.

I imagine Alexander Calder mobiles spinning all around me as I read, and I trust that view of life, one that gets nowhere, no, not even spiraling toward a better end.

While Jerry's stories will remain with me for a long time as lessons in being open to life's paradoxes, I am also taking note of powerful phrases that conjure up ancient wisdom: "Seasoning sanctifies … Insanity, too, is god … The power of the bloodline … Our dualistic package … Form is death … I had to leave this perfection … We do not make very good gods … The whispering God … Enlightenment is surrender."

I'm sure that many people will find comfort and inspiration in this book. Jerry is able to describe a spiritual journey outside of any ancient tradition or modern system, and I trust that originality. He avoids the many hollow words that sometimes enter contemporary spiritual thought and embodies the idea that you can be fully spiritual and fully secular at the same time.

Jerry's experience shows that simply by being receptive to deep intuition and living intelligently from the heart, you can achieve a degree of holiness. In the old Sufi story people were amazed that Mojud, an untutored wanderer, developed the power to heal. I expect Jerry's book to be a source of healing, and so I can ask him the question put to Mojud: "Under whom did you study?" I would expect him to answer, "It is difficult to say."

—Thomas Moore

Acknowledgments

I credit my dear friend, Carol Wright, for initiating the process of writing these stories. Through her they were brought to the attention of Connie Shaw, now our friend, editor, and publisher at Sentient Publications.

I met Carol not long ago at an art show that I was having on Orcas Island. Carol is one of those people who believe in the magic of others, the same magic she knows and holds in her own heart. Our mutual friend Laura recently said of Carol, "She loves lives, lived." Carol also gave me my web site. In the process of creating it, she interviewed me to get a better idea of what to put on the site. She asked many questions, and this book in its original form came out of my attempt to answer them. I answer them here in the best way I know how, in living story and insight.

So much wonderful and often unasked-for support comes to us through those in our lives who hold us in their love and give their effort and considerations. I would like to thank those friends who have encouraged and helped me with the completely magical process of writing this book. A special thanks goes to Marilyn, my wife, who helped so much with the initial editing. Thank you, Joyce and Ken Strong, for your unconditional love and support. Thank you, Vi Hilbert, for your dedicated work and sharing. Thank you, Anne Dosher, for creating heart connections around the world. Thank you, Beth White, David La Chapelle, Lucy Brennan, Miles Sanstad, Joanna Macy, Anita Barrows, Susan Scott, Claire Dunne, Deloris Tarzan Ament, Carolyn North, Judith Adams, David Whyte, Sister Adele Myers, Ardai Baharmast, Laura Chester, Stephanie Ryan, Laura Simms, Jack Clifford, David Spangler, Betsy Robinson and Joe Kulin from *Parabola Magazine,* Christina Baldwin and Ann Linnea, partners in Peer Spirit, and all those in my life who have shared and helped formulate the deeper meaning of one life's journey.

For photographs, thank you, Mark Sadan, Sharmil Elliot, Terry and Gordon Sanstad, Mike Hoffman, and Deborah Koff-Chapin. A huge thanks to friend and photographer Ed Severinghaus for the last-minute miracle of most of the high-quality new photographs that are now in the pages of this book.

A very special thank you to Thomas Moore for taking time out of your large and beautiful life to write the foreword for my one, small book. Thank you for writing it from your creative and unpredictable "fluid sense of self."

And a special thanks to you, Connie Shaw, my editor and dream-publisher with a vision. Thank you for your intuitive faith in me and for your infinite patience with the clumsiness of an enthusiastic nonwriter. I especially thank you for your spontaneous tears of gratefulness when receiving my gift. "Such stuff as dreams are made on."

Introduction

In 1979, I destroyed all the art I had created, gave everything I owned away, and began a new life. I sensed an inner and outer world in perfect order. I sensed that I could become a willing participant in that order, and that it allowed for my individual expression and unique contribution. I know now that my participation was conditional on how well I learned to listen and to see the inherent patterns within the natural order I sensed. The return of a physical creative expression came later, after I learned what was required by the inner life. The new life that I gave myself to required unconditional trust and noninterference. I asked for nothing from any human being. I needed to know if there was a God, and I risked my life to find that out. I know now that we risk far more when we attempt to create a life devoid of a personal relationship with our God.

I ate when I had food and I fasted when I did not. I accepted whatever came into my life. It was that simple. I was familiar with fasting; I had done it once a week since I was twenty years old. Now, eating became a miracle. At first, I had something of a small following as an artist, and people were still interested in what I did, so they gave to me. Soon it became apparent that I was not going back into art, and many of these people faded from my life. I had a close circle of friends of the spirit who understood what I had given myself to, to some extent. They had their doubts, and so did I. My life was just too much for our modern western mind to consider. Eventually I saw the ways in which the miracle carried my life. I could never have continued this strange and lonely journey if I had not seen that. My joy and my ability to help others were gifts of that miracle and were my only tools for disarming the fears that were inevitably projected onto me. Fielding the fears of others was probably the most difficult task of the new life. I had to confront the fears within myself first. I had to give to others unconditionally and expect nothing in return. This is a society where everything is not enough.

On the surface, I looked like what most of us put all of our energies into avoiding. *I became nothing.* I had chosen to make an intuitive and conscious leap into the void so I did not have the luxury of asking for sympathy when the journey became frightening or impossible. Even the least intelligent among us would have suggested that I get a job and feed myself. I knew that I did not have that choice. I knew that once I jumped into the vast and empty ocean I saw before me, there was no measure in between that could save me. I would

swim or drown. In water up to my neck, no choices and no turning back would be possible. I knew this was real.

In the cyclical rhythm of life, we eventually come up against a profound moment in which we must decide how much faith and courage we are willing to give ourselves to. Most often, in deciding this, we also establish how much courage we will live with for the rest of our lives. This crucial point usually comes to us at around the age of thirty. The opportunities at that time are like no other. Only the rare human being can leap into a deeper faith beyond that opportune stage in their life. Usually, if we have not done it under the best of circumstances, when the physical and spiritual winds are at our back, then we rarely find courage or reason enough to do it later in life. However, grace has no limits, and this is not written in stone. Only *we* know what we do with that moment once it arrives in our life, or where we may have set it to rest. Have we chosen the safe life, its foundation rooted in fear? Or have we chosen the Mystery, in which all may be lost or gained? We have only our inner knowing, and as an external indicator, the miracle, which informs us of the power of our choice. No one can judge, yet everyone intuits our choice by the ways in which it resembles their own.

I tell mostly stories here. The stories lead up to the leap of faith that changed the way I lived my life, and they go beyond into the magic that carried and continues to carry my life. It is the story of the journey full circle, of leaving and returning to the world and to art. I also share what I have discovered and the thought processes involved. The particular point of view from which the stories are told and lived is that of a spiritual seeker and an artist. However detached I may have become from the label "artist," I never lost sight of art's essential heartland, and I held a creative vision throughout my journey. My detachment from any particular religious affiliation did not preclude the essential spirituality of the journey. I hold true that the path lived attentively is a sacred path, and that the fundamental spirit of art is alive, well, and deeply esoteric. As does any spiritual path, art has the potential to deliver us into our own true *becoming,* which is identical to our world's becoming. Art expresses and defines the deep and collective spirit of our time.

These stories are true. They are based on my attempts to learn the ways of the new life to which I so radically gave myself. I could only sense the form the new life would take. I did not know how to live this life, or if it was even possible. I was inspired by the lives of many great souls about whom I had read, and this helped me. I found courage enough in their stories to initiate and fully accept the challenge of my own calling. However, I did not know their gods; I had only just met my own. I knew very little about how to communicate with these gods or where the communication would take me. I trusted a higher good that I sensed was much

better equipped to inform my choices than anything I had available in the limited range of will and intelligence.

These are stories from an edge of reality where I confronted weakness, doubt, and the very good possibility that the human psyche has its limits. Living this way brought fear to the surface, but it also brought the elimination of fear by a kind of grace. Reason was of very little use in informing the vital decisions I made and ineffective in producing hoped-for results.

Just as I wandered and discovered my way along an unreasonable and unpredictable path, I have wandered and discovered in the amazing process of writing this book—the first I've written. As I step into the worldly arena with my story and attempt to put something so ineffable into words, I realize I am fair game. I ask for no mercy. I only pray that my words remain true to the essential source that guides the journey and that they may enliven your own journey. As for the particulars, the shortcomings, and the dross of this creation, I claim them as my own.

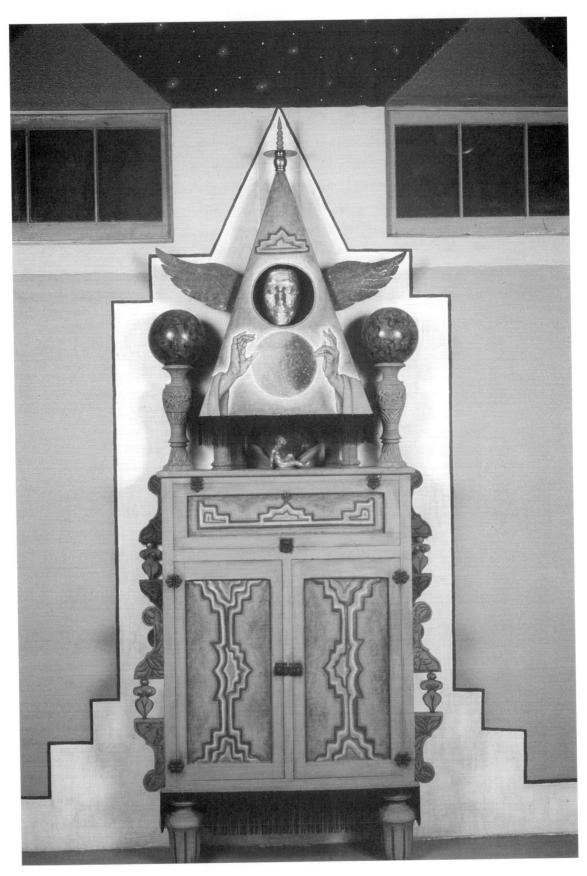

In the Hands of Alchemy. 8' x 5'.

In the Hands of Alchemy

Hilda's Gift

My friend Deborah asked if I wanted to come with her to the Cathedral of St. John the Divine in New York City to see Hilda Charlton, a woman I now believe was a saint. Deborah said that the healing work Hilda was doing with people was miraculous. Once a week, Hilda held spiritual gatherings at the cathedral and had developed quite a large following. Well over a hundred people often attended her inspiring evening gatherings.

I went to see Hilda only one time. That night, Deborah arrived as scheduled. I wore the clothes I had been wearing in the studio all day. They were my "paint clothes," a favorite old black cotton sweater and pants both covered with paint. When we arrived at St. John, we sat in the back of the large group that was assembling. Hilda got up from her chair and began to speak. She was mesmerizing and intense. I thought she looked and sounded like a witch. I was fascinated just watching her. She was a blend of creative theatrics, incredible chutzpa, and miracles. At one point, she closed her eyes and began talking about someone in the room who was hidden behind a veil. She said, "The veil is thin, like dirty black clothes. Don't think the veil is dirty. It is not! I see a bright light ready to shine!" Then she shook off the trancelike state that she had spoken from. I felt her energetically before our eyes met. She looked out into the audience, and then very deliberately she turned and looked at me sitting in the back. I felt singled out, as if a spotlight had been turned on me. Then she bit a piece of candy in half and threw the remainder to me, saying, "Eat it!" So I ate it.

Then she looked away and spoke to the group like a mother speaking to small children. In her nasal, high-pitched, witchy voice she said, "I have a story for you kiddies. Would you like to hear a story?" She told her story in the most comical way, poking fun at her own

seriousness as a young performing artist. She had been a "doncer" when she was a young woman. She danced for many years before being recognized and getting her big break. Some Hollywood producers gearing up for a new film were looking for a dancer to play a major part. They were considering using Hilda for the part. She was excited by the opportunity to land this major role. She arrived at the Hollywood set for her audition on time. A panel of stony-faced judges sat, waiting for her, at a long table. This was her big moment. For this occasion, she had made herself a special gown of chiffon (which she humorously pronounced "shee-fone").

Finally, she was going to show the world what a great artist she truly was. The music came up and her dance began. Dramatically, she took three steps back and fell right into a fishpond. She had not noticed it when she entered the room. "Those stony faces crumbled. They could not contain their laughter. They were laughing so much that no one even got up to help me out of the fishpond. I had to pull myself out, dragging yards of dripping shee-fone behind me." She walked across the floor of the cathedral, hilariously imitating the way she had dragged the gown. Then she said, "You see, I am here tonight with you because God had other plans. I went to India and studied with many great saints, and now I dance for God." She did a comical little dance.

Hilda did many things and told many stories that night. I was deeply moved by it all. When the evening was over, Deborah said, "She was talking to you, wasn't she?" As we were about to leave, I wondered if I should go up and talk to Hilda. Hilda looked across the room, fixed her gaze on me, and said, "Don't talk! You have all received what you needed here tonight. Quietly leave now and hold on to what you have received." So we went out the back door of the cathedral.

I walked around the corner and found a canvas stretcher leaning up against the wall of one of the smaller chapels. The painting had been cut out of the stretcher, leaving a ragged edge where the picture once was. The combination of Hilda's moving story and the destroyed painting gave me an intuitive feeling that I, too, would soon let go of my art form and my paintings.

I was doing more painting at that time than ever before in my life. I had worshiped on the altar of that false god every day for many years, and I had produced an enormous body of work. There was a documentary film being made about my art, and people were beginning to take an interest in what I was doing. My entire life and identity revolved around my art! Referring to that period of my life, I often say that if it were possible to paint my way to heaven, I would have done it, because I tried hard enough!

However, something was stirring deep inside. After that meeting with Hilda, and for the first time since I began painting, I stopped for an entire month. I did very little during that time. I fasted and read *A Course in Miracles*. The combination seemed to lead me forward into a deeper understanding that I could not quite fully grasp. In my thoughts, I was poking around in a personal and collective limitation. I was inquiring in the area of art and beyond, into fixed social assumptions about how we live our lives. When I spoke about what I was feeling to others, I believe they felt the same blend of fear and allurement that I was feeling. There were equal amounts of yes and no, which at times felt like paralysis. It seemed to boil down to making a choice between fear or God. That was it! But it was too unreasonable to contemplate. God looked everything like nothing! What would become of me if I gave myself to nothing? What would that mean as an artist? Would I be without a center, like that orphaned and ragged painting that I found outside the cathedral that night?

My personal struggle was entwined with the unspoken collective agreements woven into the fabric of our western culture. We collectively agree on what is real. Intelligent inquiry into the nature of reality is acceptable, safe, and reasonable. It does not go beyond the known boundaries, where it could enter into the realm of original creation. To remain a citizen in the known and acceptable world, we cannot risk going beyond those boundaries. If we do, then we are in unknown territory, and the risk is our own! Should the risk succeed in bringing through a new reality, then a seasoning process begins that allows the new reality to take shape in the world. Seasoning sanctifies and builds on the integrity of a new reality so that it will have an organic resonance in the hearts of individuals. As it begins to enter the collective heart, it slowly becomes a complete and recognizable expression in the world.

Clearly, everybody loves the winner who can take the risks and bring this new reality through. This is the Great Mythic Story with the happy ending that most of us identify with, whether we do it ourselves or not. However, the collective mind despises the loser that recklessly bumps and rattles the unconscious, fear-based, cultural agreements while making his descent! I knew that the only way to give myself to an unknown Truth that I believed to be reality was to completely let go of any reference point to the known world. I had to risk *everything* that I knew to be my world. I had to leap, empty-handed and alone, into what looked like nothing.

After an excruciatingly difficult night–struggling with feelings of despair, indecision, and inspired new vision–I destroyed all my paintings. Then I gave away everything I owned. I lived that way for the next fifteen years.

Light Trail

By 1979, the documentary film about my art and life had been in progress for several years. It was focused more on my art than on my life, and of course, when I destroyed my art, that changed. The decision of the filmmakers to interview me about this unexpected turn of events made the film as much about my life as about my art. With everything gone, I walked away from art completely, thinking I would have nothing more to do with it or with the film. Throughout the filmmaking process, I had been only minimally involved, and now, with nothing left to shoot, further participation seemed unnecessary.

Many of the people who worked on the original film, *The Art and Life of Jerry Wennstrom*, were also involved with the creation of the later one, *In the Hands of Alchemy*, some twenty-two years later! We all laughed recently when Mark Sadan, a filmmaker involved with both projects, told me that when I destroyed my art, he was afraid that I might destroy the film too if I had access to it! I was not kept informed of their progress as he and Deborah Koff-Chapin, the other filmmaker, continued their work on the film.

Several months after I destroyed my art, the film was completed, and its début was arranged at a very artsy establishment owned by David Weinrib. This was an old church that had been turned into a rather unusual art center and gallery. Considerable creative stir went on around David's gallery and many well-known artists frequented the events. David and his wife, Joanne, also had their home and studio in the building. David produced the events in the sanctuary area of the large open space of the church. He brought in many artists, visual and otherwise, from the larger New York art scene for both his art center and for the convent's Thorpe Intermedia Gallery, of which he was a cofounder.

I made no plans to attend my film's début. I felt my path had led me out of any further involvement with the film and the art, but I had mixed feelings about the event. So I resolved to trust in what happened. If I were meant to be there, then somehow I would be.

Around dinnertime the evening of the début, there was a quiet knock on my door. I knew the knock—it was Jenny Kohn, a wonderful older Jewish woman who often invited me to her house for the Sabbath meal. We had these Sabbath meals once a week, even though they did not always fall on a Friday evening. She taught me the Jewish prayer, and at our meals we lit the candles, said the prayer together, and had our blessed meal.

On this particular evening, Jenny came to invite me for dinner once more. After the meal, we sat quietly, just staring at the candle. Then, out of the silence, Jenny started and said, "Oh!

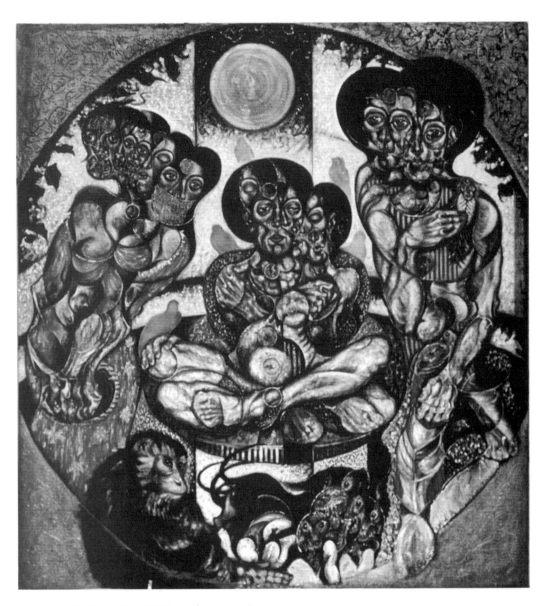

Navigating the Mechanics of Flight. 7' x 6' (destroyed).

What day is this? Isn't your film being shown tonight? Aren't you planning to go?" I said, "I'm not sure." Jenny said. "Yes, we must get you there. This is important for you! It starts in half an hour!" She jumped up, not knowing quite what to do, since neither of us had a car. Then she said, "I just met the most wonderful Middle Eastern man today! He said he was interested in art. He and his wife sell lawn ornaments. I will ask him to drive us there." Jenny immediately called the man, and to my surprise, he arrived in about ten minutes! I was happy about attending the event

and at the same time a little afraid. I wanted to see the film, but I knew my life was being reduced of all externals. The art and the film seemed distant and perhaps meaningless to my life now.

The man arrived with his wife and a friend of theirs. The five of us piled into his big old car and headed to the event several miles away. I was in a strange, altered state, feeling as though something very important were about to unfold. I thought it was somehow appropriate that a man who sells lawn ornaments—the most humble of art forms—should be taking me to a final expression of what my life as an artist had become. I intuited that a metaphorical life-or-death situation was about to unfold for me with this film. I felt a lot of energy stirring. At that point, my life had been so drastically reduced that I thought the only thing left to let go of was physical existence. At one point, as we were driving down the highway, I heard tires screeching and people in the front seat swearing. I said a silent prayer: "God, if I am to die, please don't take anyone with me." After a few swerves and a few more Middle Eastern curses, we were all still alive and heading to our destination. To get our minds off of the near accident, one of the men sitting in the front seat said, "What movie are we going to see?" The others in the front said they did not know. At that point, Jenny spoke up and explained that it was a documentary film about me. I could almost hear their thoughts. If I was indeed the man of the hour, what was I doing halfheartedly hitching a ride with them at the last minute?

We pulled into the gallery parking lot, full of cars and people milling about. As we walked in, I thought how appropriate it was that the gallery was in a church. I prayed that any of the holy momentum that this old church might have accumulated would give me the strength I needed to survive the night. I felt as if I were a thousand miles away from the people talking to me. Some were congratulating me on the film, even though they hadn't seen it yet. The large audience was mostly made up of the savvy New York art community, riding high on the glorious golden calf of art-as-god. But this was a god and a religion I had defiled by destroying my art. After they saw the film, would they still congratulate me? I had a reputation in the community as an extremely driven painter, and the word had gotten around about what I had done. Several people had called me after the destruction of my art, wondering if I had perhaps lost my mind. Were people here out of macabre interest? Had they come to see how the wild man was going to pull off this outrageously empty point of view? I didn't want to talk. I smiled and nodded and sat where I was directed, high up in the church balcony with the latecomers. The evening seemed so unreal, and my heart was beating faster than it should have been.

The evening opened with a sweet dedication by the filmmakers to me and my life. Then to my surprise, my dear friend Steven Roues (Weitzman) came onstage and sang a song he had written for me. It was an amazing song called "It Must Have Been a Miracle." Steven has a

beautiful presence and the look of a biblical Jew. He is tall, dark, poetic, and fierce. He sang that night about Moses going to the mountaintop and bringing down the truth and about Mary having a baby boy. "And it must have been a miracle … " Moses broke the tablets and that baby boy walked into his own death. Nothing seemed to survive. I felt like I could cry forever for everything the world could not hold in place. I closed my eyes, trying to keep my emotions invisible. With so much heart-pounding energy running through me, all I saw was light when I closed my eyes. I sat very, very still and waited for the film to begin.

When the music ended and the stir of people finally settled, the lights went down and the film began. I was watching this film for the first time, right along with everyone else. I had not even seen any of the original footage.

The sheer volume of images flashing across the screen was overwhelming. They came one after another in quick succession: my recorded battles with angels and demons, magnified and poured out in light onto the screen. Just when I thought I could not bear seeing one more image, the film shifted. Then it was just me on the screen—very, very still. You would not even have known it was a motion picture if my cat, Jasmine, had not made a timely appearance, walking through the picture. Through the filmmaking device of voice-over I was talking and not talking at the same time. The words were emotional and raw; I was talking about the destruction of my art. The film ended with words that expressed all that remained in my life: "Only God is real."

Thankfully, before thought even had a chance, there was a long and holy silence, then surprising applause. The filmmakers walked up onstage. I hardly spoke at that time in my life, so when they asked me to come down out of the rafters and join them onstage, I went hesitantly, as a dead man, emptied and in a state of prayer. I sensed that this moment was all or nothing. "Matter never dies, it just changes form," said Albert Einstein. The matter of the artwork, which I had destroyed, had changed form and become the empowering life force that came through my life that evening. This unplanned evening turned out to be, unequivocally, the most powerful night of my life.

People began asking me questions, some loving, some frightened and challenging. From up in the balcony someone shouted down, "What about the art that was destroyed? You have taken this from the world. How did this act do anything for anyone?" My answer, in a voice not my own, was more a visceral, unworldly experience than it was a spoken sentence. I said, "What is happening here *now* is touching the world." And as I spoke those words, I saw rippling strings of light extend out into the world. Those of us in that church traveled on those strings, even if it was only for one eternal moment, and then there was silence.

I have never known a more powerful moment in my life, before or since. Something beyond death had been delivered back into life and sanctified, guiding light trails back to the world. When the evening was done, many people approached me and wanted to talk. I did not feel I wanted to say any more. Jenny whispered to me that the people we came with needed to leave and she pointed to the back door, which was just opening. We turned toward the door and disappeared, perfectly! I did not watch the film again until ten years later.

The Gift of Silence

I found myself feeling less and less comfortable with words. The shell of wordy, social behavior was all that I had left when I tried to talk. My life had radically and irrevocably changed. Why, then, was I still walking and talking as if the world were the same? I could not go back, yet nothing had replaced all that had fallen away—certainly no social protocol for spoken language. I suppose that I unconsciously believed that if I shed the remaining thin shell of social conversation, I would dissolve into nothingness. I continued my attempt at being sociable and chatty, but felt ridiculous. Sometimes words just came out nervously when I was around people. I felt pressured by an unseen tyrannical force or social norm to speak and smile when spoken to and smiled at. Perhaps it was simply the momentum of an old pattern. My act of giving everything up scared many of the people who knew me, and I was afraid myself at times of serious doubt. Maybe I believed that if I were to continue my old sociable behavior, that would somehow prove that the change I was going through was really nothing. "See? I am okay." Empty social conversation felt inappropriate, as it would have if I had experienced the loss of a child and had acted as though things were the same. Things were not the same. I needed to find a new way of being in the world, which was to be discovered only in silent unknowing.

It finally became too painful to continue social chatter. I did the best I could in social situations, which were becoming fewer. But for the most part, I rarely spoke, and would do so only when I felt genuinely moved. It required a surprising amount of courage to remain silent when those around me expected something different. The new silence required a vigilant and attentive awareness that did not brood nor take advantage of the discomfort of others who were silent in the attempt to create a safe haven for me. The challenge was to find comfort within myself and let that comfort extend to others if they chose to be around me. This was a difficult

task, with no support coming from those involved in the busy activity of the world around me. I know I appeared strange at times and sometimes spoke painfully out of nervousness and avoidance. Under these conditions, speaking had all the grace and beauty of a death rattle, which is basically what it was. I had no viable choice but to meet this challenge and find comfort in the silence itself for myself and for those around me. The world as it was no longer worked for me.

I knew I was being criticized for my strange behavior, first for destroying my art, and now for this business of not talking. I often felt trapped between worlds with nowhere to go. When I felt doubtful and weak and gave myself to indulgent self-pity, I just wanted to die and leave this world completely. I thought, "If I can't be here like a normal human being, then why am I here at all?"

A friend had gone to India for several weeks to spend time with her spiritual teacher. She left her bankbook with me so that I could do some banking for her while she was away. On one particularly difficult day of feeling the pressures and the struggle with silence, I went to do the banking for my friend. I hated banks. Even when they gave me my own money, I felt as if I had just gotten away with something.

Since I was there anyway, doing the banking for my friend, I thought I would take the opportunity to cash a seven-dollar check I had been carrying for months. My dislike of banks had caused this tax refund check to remain uncashed for so long. I walked into the bank and handed the woman behind the counter the check. She looked at the government check, looked at me, and said, "Do you have any ID?" I handed her my driver's license. She looked at it and said, "This is expired. Do you have anything else?" I looked through my wallet and handed her my library card. She looked at that and said, "This is expired too. Do you have anything else?" I then handed her my Social Security card. She said, "This isn't valid ID." I said, "That's all I have." She laughed, cashed the check, and with a mischievous twinkle in her eye said, "I think you are an expired person!"

As I left the bank that day, I was putting my friend's bankbook away when a piece of folded paper fell out and landed opened on the sidewalk. Picking it up, I read the caption, "Don't Worry, Be Happy." I read more and found that it was about a spiritual teacher named Meher Baba. I had heard of him, but I didn't know anything about him. The brochure said that at a certain point in his life he had stopped talking completely and had lived out the remainder of his life in "profound silence," communicating with the world and his followers in ways other than the spoken word. Reading this brochure, and later, a book about his unusual, silent life, gave me the support I desperately needed to continue along the path in search of my own true voice. I knew I did not want to spend the rest of my life in silence like Meher Baba, but I also did not want mindless words and the fear of silence to interrupt my need at that time for healthy silence.

Gilbert, Lewis, and Beyond

Gilbert and Lewis were my mentors. They were gay men in their mid-seventies when I met them. I was twenty-one. We remained close friends for about eight years. I met Gilbert and Lewis through a mutual friend, Tala. She was a beautiful young woman with whom I was secretly in love. Her father was Burgess Meredith, the famous actor. Gilbert and Lewis had many creative and famous friends.

Gilbert was a cultured, gregarious extrovert. He loved to talk and tell stories. I never knew if his stories were true or not; some of them seemed so outlandish. He grew up on a large ranch in California where his father grew walnuts. He told me that his grandparents came to California from the East Coast in a covered wagon. He said his grandmother had gotten an arrow through her wrist, crossing the plains, and he often asked to see the scar when he was a child. When Gilbert was a young boy, his father frequently went to the local saloon to drink with the other ranchers. He would bring his son with him, sit him on the bar, and let him play with the gun that he carried on the ranch. Gilbert claimed that as he sat on the bar playing with his father's gun, drunken men would pinch his cheek because they thought he was so cute. He said it hurt and he didn't like it. Eventually, the pinching created a tumor on his cheek that had to be cut out. Supposedly, that was how he got the slight scar he had on his left cheek.

When Gilbert grew a little older, he wanted to become a dancer. He ran away to New York City and got bit parts doing theater and working with the Russian Ballet, if only at times as a curtain boy. On arriving in New York, he shared a flat with the artist Mark Toby. He was Toby's roommate for a year or two. One day he told Toby that he was torn as to what to do with his life, because he had so many creative interests. Toby's advice to him was to "do it all." He said this advice had such a profound effect on him that he did exactly that. He did it all for most of his life. Gilbert was the most diversely creative person I had ever known. He was an artist in everything he did. He designed theater sets, interiors, and clothing. He created his own line of handwoven fabrics and another line of designer panels from woodblock prints that he hand-carved. He acted, danced, and performed. He did it all!

Gilbert claims to have met Claude Monet in Paris. One time while Gilbert was vacationing in France, he visited his uncle Guy Rose. Guy had been living and working in Paris as an artist. One day Guy told Gilbert, "Today you are going to meet a very great man." Gilbert was excited, but did not know whom he was going to meet. He was taken to the gates of a Giverny estate house. A bearded man emerged from the house and walked through the

garden toward the gates where Gilbert and his uncle waited. Guy introduced them. Monet greeted them, shook Gilbert's hand, and then walked back up the path and into his house without saying another word. Gilbert spoke of that meeting with great reverence and emotion. He also told me he had danced once with Isadora Duncan at someone's apartment in Paris. He told her that he was a dancer, and she wanted to see what he could do. So, he said, they danced together.

The story goes that Gilbert and Lewis met in New York City when they were both young men. Lewis was a pianist, in New York with his domineering mother on a concert tour. Lewis and his mother always traveled together when he was performing. Performing was his mother's idea, and Lewis hated it. When Gilbert and Lewis met, they ran away together, leaving both performing and Lewis's overpowering mother forever, and spending the rest of their lives together. I saw Lewis play the piano only once in the eight years that I knew them. It was after a little argument the two of them had. Gilbert insisted that Lewis play for me. With arthritic hands, Lewis begrudgingly played something. Shortly after that, the out-of-tune old piano disappeared forever. Lewis often listened to scratchy old classical records, but only when Gilbert suggested that he do so. Gilbert would say, "Lewis, don't you want to listen to some music?" and Lewis would say, "Yaaaaiiis." The record often played for a while, got stuck, and no one even noticed. Gilbert didn't hear very well, and I don't think Lewis really cared. Sometimes I would quietly walk over and turn the machine off.

Lewis's way was to sit quietly in the background and watch. He had the look of a mystic. Rarely speaking, he would look glassy-eyed past you as you sat in the room with him. When he did speak, he had a warm, polite, midwestern accent. By all appearances, he fit the description of the benevolent old grandfather. That was partially true, but not completely. He had a deadly accuracy in perceiving even the slightest flaw of character in those around him. And he was watching! Lewis was transpersonal. He depended on Gilbert to live out what was personal and human for both of them. He spoke formally and appeared to give, receive, and reveal nothing. His gift was like music. He created atmosphere and space rather than filled it, and others could dance to his music if they wanted to. He did that beautifully most of the time, and in that he was my teacher.

Gilbert danced to Lewis's music. He let go of the inner life and depth. He depended on Lewis to carry that for both of them. Gilbert was playful, fun, and full of emotion. He was charming, and would carefully choose the least offensive words no matter what he was talking about. His unwritten objective was beauty. He won people over easily, especially women, who loved to mother him. When he got overexcited or upset about something, he

Lewis (left) and Gilbert (right).

occasionally fainted! Gilbert was gregarious and hospitable and he loved the social life; he had many visitors. But he could also be petty and jealous. When the party was over or a particular guest left, Gilbert immediately turned to Lewis for an assessment of the situation from his deeper perspective. They laughed and poked fun at what Lewis perceived in the behavior of the unsuspecting visitors.

It was a long time before they trusted me enough to let me in on this feeding frenzy, in which unsuspecting weakness and ego was consumed. Sometimes it was fun and felt right, and I would join in with my own insights, to their approval. Other times it felt cruel, and I didn't like it. When that happened, I just sat quietly. Then they would scrutinize my silence. I often got confused and forced a smile, or I would simply get angry and refuse to participate further. I was young and I was attempting to learn what was real and what was not. They had many a feast on my naive bungling. It wasn't until much later that I came to appreciate the lessons I learned in the

presence of Lewis's deep and impeccable gaze. I do not think of Lewis as a kind person. He was not. But like a transpersonal God, he was wise and dangerous, and I respected him.

Being seen by Lewis taught me to see. For that, I am forever indebted to him. Distinguishing between seeing the truth of a situation out of love and seeing for reasons of power required delicate self-scrutiny. Compassion was paramount in this discrimination. This is where Lewis's undeveloped talent for human interaction failed him. It's also where I found freedom from the aspect of my learning process that involved Lewis. It is very difficult to talk about these things and keep the distinctions clear, but I remember the exact moment that I found my freedom. It was a tense moment in which I was being severely scrutinized. I felt like I was being overpowered by something. In that moment, I know I chose kindness, and I felt Lewis choose power. As though watching a samurai's decisive moment, I looked on sadly as Lewis stumbled and fell on his own sword. And then I watched both Gilbert and Lewis digress into confusion and chaos. The power they had relied on in relation to me had failed. The next day, Gilbert came to me in the way he usually went to Lewis and asked what had happened. All I said was, "What Lewis does is not always kind." If he had possessed compassion, Lewis would have been a saint. He certainly had the inner depth.

My closeness to these two men, who embodied two halves of a beautifully complete circle, enabled me to see the importance of becoming whole. In relationships, the individual's potential for wholeness is often projected onto the other. When we depend on another human being to carry an aspect of our own wholeness, we fall into the hole left by our lack of development. Gilbert and Lewis's combined personalities were the right teachers for what I needed to learn. Their wholeness together was my guru.

Gilbert and Lewis lived in a magical world in which creativity was flagrantly expressed everywhere! They lived in a three-hundred-foot-long chicken coop that had been transformed into a house and studio. Panels slid, Japanese style, between sections of the house. Just when you thought you had seen all there was, Gilbert would slide away another panel and show you yet another room! They had gardens, a stage for performances, and stairways that ascended to nowhere. Gilbert came up with the inspired ideas, and Lewis helped him bring them into form.

For the garden, they made an octagonal water table with eight seats and place settings. In the center was a large round holding tank full of water, and the settings were placed around the perimeter of the tank. When dining at the table, you pushed the floating bowls of food on the water in front of you to pass them. Once, at a time when Gilbert had begun to lose his eyesight, we were having a dinner party at the water table. A woman arrived with a bag of potato chips. She went into the kitchen to find a bowl for them, but all she could find was a

colander. When she returned, Gilbert was so excited about showing off his wonderful table that he grabbed the colander full of potato chips and attempted to float them on the water! They did float—like leaves.

I spent a lot of time in their beautiful world, helping with many things. It was interesting being in a close relationship with two gay men. I knew so little about that world in general. I was always very clear about my sexuality with Gilbert, and there was no need to be with Lewis. Gilbert told me that Lewis was not sexual at all, and that he himself had lovers. I explained that I was not gay and freely expressed my love and respect for them. Sometimes I was uncomfortable about what people might think of our friendship; however, I valued our relationship and refused to be influenced by the pressure of misguided judgments. Gilbert always kissed me hello and good-bye, which I didn't mind. He walked with me on his arm when we went into New York to the opera or the museums. I naively assumed that people thought he was my grandfather. I later realized that Gilbert was proud to walk with a young man on his arm. He wore his big hat and decorative Hollywood-style scarf, and off we went. We spent quite a bit of time in the East Village, where gay men often smiled at us. Once, going down the elevator at the Museum of Modern Art, Gilbert and a man about his age smiled at each other. As the man got out of the elevator, he said to Gilbert, "Watch out! This elevator goes straight to hell!" Afterward, Gilbert explained to me that the man said that because he thought that Gilbert and I were lovers. He explained that the man was gay and was envious of Gilbert being with a young lover. I had been entirely unaware of all of this. It took an interesting kind of courage for me to maintain our unusual friendship and to do the work that it required. I knew it was important work and that it was a gift to have Gilbert and Lewis in my life.

We did once, however, have a falling out over the issue of sexuality. Gilbert made the most beautiful robe for me as a gift. He also made a similar one for himself. He said he wanted to present the robe to me ceremonially and wear them together. The plan was for me to come over late one night and have dinner and a good bottle of wine, and for us both to wear the robes. He even suggested we wear them in the city sometime, which we laughed about, but never did. I was suspicious of his plan and felt a little uncomfortable, but I chose to give him the benefit of the doubt and showed up at the designated time.

All went as planned until after dinner. Gilbert said to Lewis, "Lewis, isn't it bedtime for you?" Lewis said "Yaaaaiiis" and went to bed. Then Gilbert began explaining to me in detail how two men make love. Finally I said, "Why do you feel the need to tell me this? I am not gay, Gilbert. I explained that to you!" He brushed my comment aside. I was beginning to feel angry

and manipulated. I felt it was hard enough for me to stay so open to all of the unusual things their lives were about. Why was he making it harder for me? But I was determined to courageously meet this moment halfway. I felt our friendship was at stake. I didn't know where it was all going, but I knew where I was *not* going. He gave me the robe and asked me to put it on. I did and thanked him. We talked a while, and then Gilbert put his arms around me and kissed me, quickly touching my crotch. That was it! I pulled back and said angrily, "Gilbert, I have always been up front and clear with you about my sexuality. Why are you doing this?" I walked out, leaving the robe behind.

I didn't see Gilbert for several months after that. I felt bad about the entire mess. We had always gotten together at least once a week to do projects or to go on adventures to fun places. I missed my interesting old friend. The whole thing seemed ridiculous to me. In thinking it over, I remembered how, in my youthful awkwardness, I had tried to seduce women. Who was I to judge him? What was the difference between what I felt around women and what he felt around me? Maybe this blowup was my karma. It was an opportunity to find out how women felt when they received unwanted advances.

The release of my anger corresponded precisely with our reconnection. I was driving down the street where Gilbert lived on my way to visit a friend, when I saw Gilbert walking out to his mailbox. I knew he didn't see me, because he could not see very well at that point in his life. I pulled up to the mailbox just as he reached it. He turned, put his hands on the car door, and poked his head in to see who had stopped. I put my hand on his and said, "How are you?" He said, "Good! How are you? Would you like to come in for a cup of tea?" I said, "Sure!" We never had a problem around sexuality again. Later when we spoke about it, he still could not believe I wasn't gay. He said, "If I ever hear you are fooling around with some other man, that'll be it!" I said, "Gilbert, I assure you, you will never hear that about me." Somehow, he couldn't separate the love we had for each other from sexuality. He took personally the fact that I made this distinction.

Shortly afterward, Gilbert and Lewis took a trip to Mexico. The trip was planned months in advance. They had originally asked me to go with them, offering to pay my expenses. They never mentioned it again after we had the falling out, so I didn't either. They went on the trip without me, and it ended up a disaster. Their age and failing health made the rigorous journey difficult. Everything seemed to go wrong while they were in Mexico. They returned frightened and visibly shaken. It was especially difficult for Lewis, who kept passing out on the bus as they drove into the higher altitudes of the Mexican mountains. Lewis never quite recovered from that trip. Gilbert partially blamed me for the difficulty. He said,

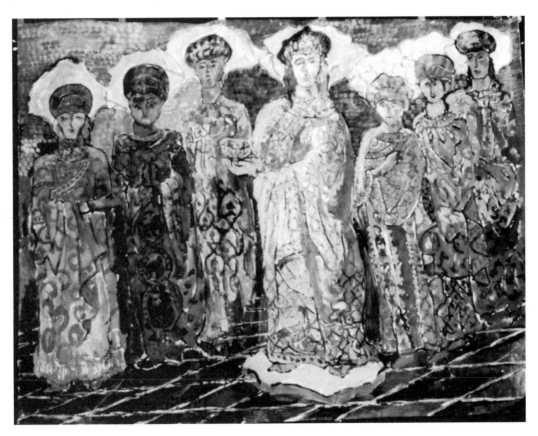

Spirits. 3' x 5'. Painting that Gilbert and I did that looks Byzantine.

"You should have been there to help us, but you won't sleep in the same room with me!"

Gilbert had glaucoma and was losing his eyesight quickly, so I helped him with his artwork. I adapted to his painting style and painted just like he did. People didn't know the difference. He actually sold as his own a painting that I did! We laughed about that. We were amazingly connected in a creative way. Once, we each had the same dream about ideas for a painting we were working on together (see above).

Gilbert continued to take the occasional commission from interior designers for his decorative panels made with woodblocks. Eventually he had to stop. He couldn't see well enough, and his work was getting messy. He had to let go of much of his commercial work, which was very difficult for him to do. I helped him as much as I could, but there were limits to what I could do for him. I began to feel that I would be more useful in helping him to let go and to make the necessary changes. The process that Gilbert and Lewis were going through at the end of their lives seemed very connected to my own process. That was the time in which I started to feel that painting was a false god. I needed to let it go, but I did not know how to do

that. Painting defined who I was in the world, and I thought that it was all I could do, although I sensed something more. I was quite interested in finding out what this "more" was. The building I lived in was full of artists' lofts. I talked with other artists and often became very inspired by the larger possibilities I sensed beyond painting. It both scared and inspired me that I didn't know where these feelings and ideas were going to take me. Interestingly enough, while I talked about detachment from painting, I was producing more artwork than I had ever done in my life! I was working at a frenzied pace.

Gilbert's blindness progressed, and I tried to help him accept gracefully the changes he had to make. One day I said to him, "Gilbert, your life is in God's hands. If you can no longer paint or do your art, why don't you just let go of it? Trust what is happening to you. You will be given other ways to be creative. Even if you die, *that* will be creative!" When he felt most desperate, he would listen and find comfort in what I said. But mostly, he would *will* his way through. One day he said to me, "It's easy for you to talk about letting go of art. Look at you! You are young and just starting out. You do *your* art. Don't talk to me about letting go and trusting." I began to feel that the universe was whispering its truth. I heard that whisper in other ways too. I felt and talked about a new kind of freedom. I explored intuitions, but I knew I was not living them out completely. Art began to feel like a trap to me, yet I was afraid to let go of it. After much praying for guidance, I finally was able to destroy what I had created.

Several days passed before I told Gilbert what I had done. I was very touched when he cried and said, "Congratulations!" But sadly, shortly after that, he reversed his position and regarded what I had done as an absolute threat. In retrospect, I see that this is where Gilbert's half circle came up against its limits. He needed to go inward and could not do it; that was Lewis's department.

Lewis was not doing well. It was both touching and sad to see how Gilbert tried to keep him going. Gilbert was very anxious about Lewis's health. He got angry with Lewis for staying in bed all day. Gilbert and I were working outside one day, and Gilbert was going on angrily about Lewis and his "limitations." Finally I felt his heart open and he said, "If you only could have seen how beautiful Lewis was as a young man!" I turned to Gilbert and said, "Gilbert, if you love Lewis, you have to let him die!" Immediately, he came undone and sat right down on the ground. I thought he had fainted. I sat down with him and put my hand on his shoulder. A wave of emotion ran across his face and his eyes filled with tears, and then he quickly recovered.

In the dream I had that night, Lewis knew that it was time to die, but he was afraid. I tried

to help by talking to him about dying, but I was frustrated by his inability to understand. Finally I realized that I had to show him how to die by dying myself. I was afraid, and I didn't want to die. My death involved strapping to my face a mask with long spikes aligned with my eyes, nostrils, and mouth. When I put on the mask, the spikes would go through my head and kill me. To show Lewis exactly how it was done, I mustered up the courage and reluctantly gave myself to the experience of dying. When the spikes were coming toward my face, I woke up from the dream with a pounding heart. Lewis died the next day.

I continued to help Gilbert for a short while after that, but it became more and more difficult. One day he said angrily, "If you think I am giving up the Goddess of Art, you are wrong!" I tried to accept his position and continued to help him. When I did, he became tyrannical and demanding. The playful way we once did art together had become a serious and willful ordeal. His eyes got so bad that he could hardly see at all. After I destroyed my art, something irreversible changed between us. My heart was not in painting anymore, and he knew it.

Gilbert was very loved; several women helped him with different aspects of his life. One day, after arranging for one of these women to take over the personal care that I had been providing, I told him that he was in good hands and that I was leaving. My own life went deeply inward. A year or two later, I heard that Gilbert was dead.

Bread for the Journey

I was often hungry. I was learning trust, and hunger was my relentless teacher at that time. Sometimes my hunger became larger than I could bear. One rainy day, on such an occasion, I walked by a funeral home. I often walked by this particular funeral home on my way to the library. As I passed by, I looked in and saw a funeral going on. I thought, "How much easier it would have been to die, to just leave the earth like Christ did." I knew that what I had walked into looked like death, and everything that my life had been about was gone, but I was still here, hungry! How would I eat and take care of myself and find God too? Just as I had that thought, I looked down in front of me and saw a soggy twenty-dollar bill floating by in the gutter. I was fed that day and every other day the gods chose to feed me, and when they did not, I did not eat.

Saved by the Divine Feminine

Clock time meant little to me. I did what I wanted with my time. Sometimes I went for a walk at odd hours of the day or night. One night very late, I decided to go out. When I went out for walks, I often carried little boxes of Superman-brand raisins to give the neighborhood children. The children knew me and came running when they saw me walking down the street. On this particular night, I walked past a gang of older teenagers, sitting on the stoop outside the YMCA. It was late, and the building was closed. A few young women were in the group. The young man who appeared to be the ringleader asked me for a cigarette. I said, "Sorry, I don't smoke," and continued on my way down the street. When I was quite a way from them, he called me back: "Hey! Come back here." The streets were abandoned, and I was a little afraid, but I thought, "I will not give into fear. I will be a human being and trust." So I walked all the way back. The young man had a cigarette between his teeth. He said, "Got a match?" I said, "No, sorry," and continued to walk down the street. This time, just when I thought that was the end of it, I heard, "Hey! Come back here!" That was a real moment of decision. I was far enough away to keep going, but I decided to honor the god of this strange and frightening moment, so I walked back. The gang members all looked at me with sinister smiles on their faces. The ringleader said, "What DO you have?" Without saying a word, I set a box of Superman raisins down in front of each one of the men sitting on the step. Then I turned and walked down the street. As I walked, I heard the boxes of raisins hit the street beside me. Then I heard, "Hey get back here, Whitey!" So I walked back. The gang surrounded me. The leader, in a very aggressive and angry voice right in my face, said, "What do you think you're doing, giving me these raisins?" Then came a moment of surprise, even to me. I went deeply inward. Having grown up in a poor black neighborhood, I was able to find a deep, sad love for these angry young black men. I said, with a good deal of genuine emotion in my voice, "I was just trying to be kind." At that moment, the leader fumbled his words and lost his power. In a flash, the women swooped over and surrounded me with love. They said, "You leave him be." Then they said to me, "You be on your way now, they don't mean you no harm." As I walked away, I glanced at the embarrassed leader. He had blown it! The women that he wanted to impress had defected and come over to my side. They saw him as a bully.

A World of Our Own

Richard was a diagnosed schizophrenic from a wealthy family in New Jersey. I assume that after many unpredictable years of raising Richard and trying to help him live a normal life, his parents reduced their efforts to paying for an apartment in Nyack and giving him enough money to live on, and then left him alone.

After I let go of my possessions, I made myself available to all who came. Richard was one of the first to show up at my door. He had the delicate, unworldly features of an angel. He was young—a few years out of high school—he was a mystic, and he was crazy. I had many adventures with Richard. He taught me how to be unconcerned with the eyes of the world. He didn't care what the world thought, or more likely, he was not aware. He couldn't do otherwise; society kept him on the outside. He was avoided and often feared. The world left him free to live out the mystery on the streets, as a crazy man. Insanity, too, is god! Richard taught me something about this divinely inspired, neglected expression. I was a reluctant follower, but fascinated with his magical sense of reality! I felt blessed and terrified as a tourist in his strange and often mystical world. In contrast to his lack of self-consciousness, my own concerns about how the world saw me became more obvious. When Richard came to my door, I was always a little afraid of what might unfold. I was also excited by the extraordinary things that happened in our unreasonable adventures in the realm of spirit. When Richard and I went out on these adventures, we were both very attentive to strange occurrences. He taught me to be attentive. He paid attention to something unworldly most of the time. I gave him conscious sanity; he gave me conscious insanity. We were teachers for each other.

I was walking on a busy street with Richard one day when he said something outrageous and poetic, as he so often did. I so appreciated what he said that I replied, "Richard, I bow down to the God in your wise heart." Then I bowed my head to him.

He said, "Get down on your knees when you pray."

In defense, I said, "I don't say my prayers on street corners." He sensed my nervous reluctance. I knew if Richard saw that you were ashamed of his outrageous suggestions or behavior, he would disappear internally. Sometimes he would simply walk away. He didn't need the external world to live out his mystery. I was always a little careful to listen to what he said for fear of losing him to the depths of his interior world. Sometimes when he asked me to do something ridiculous, I would simply say, "No, Richard, you are crazy!" That was okay sometimes, but I knew in other instances, I needed to be humble enough to receive his crazy

and wise teachings. It may be God talking—I never knew. So I got down on my knees in the path of the people walking down the street. I felt very uncomfortable. To lighten up the moment, I had a little smile on my face, so I would look as if I were just playing around.

Richard said, "No, that isn't prayer." He just kept saying "no" with every attempt I made. "NO." At that point, three other people stopped to watch. We became a temple, where two or more gather to pray. Finally, my embarrassment was too much. I let go of my self-consciousness and did it for God. I surrendered to prayer right there in the middle of that busy street. Richard just smiled and gave me a very loving look. Strangely enough, I felt like I had received a blessing.

Richard's sexuality was questionable. I never asked him about it, but I gathered from things he said that he was all over the map in that aspect of his life. One day we were walking on the beach of the Hudson River. I saw laying in the sand a glass ring—the broken top of an old Coke bottle, weathered and worn to smoothness. I picked it up and said, "Richard, give me your hand." He did, and I put the ring on his finger.

He went into a panic and screamed, "Take it off! Take it off!" I removed it quickly and threw it in the water. I said, "Richard, what is wrong with you? That wouldn't hurt you. There were no sharp edges on it." He mumbled something about a strange sexual encounter with a priest whom he had trusted. The priest tied him up and cut him with glass. He showed me the scars.

One day he came to my door very upset, talking about "jackals." They were after him. He kept saying, "You have to come with me!" Finally, I said, "Okay." He put his arm around my neck, headlock style, and we walked that way down the three long flights of stairs and out onto the street. Then he dragged me down Main Street. Why the headlock? I think it was because he was afraid I would leave him alone with the jackals. He was screaming obscenities as we went. People turned to look. Embarrassed, I just gave myself to the experience.

After a long walk, he loosened his grip, and we entered the hallway of a run-down old apartment building. He looked very frightened. We went up another three flights of stairs. He placed me carefully in front of one of the doors, pounded with both fists on the door, and screamed obscenities to the jackals. Then he ran away, leaving me there alone. I waited to see what would happen. Nothing. No one came to the door, so I left. A month later when I saw Richard again, he came in looking guilty. I looked at him and said, "That was crazy." He said, "I know." We never mentioned it again.

One day Richard came to my door very agitated. When he was like that, I took him for a walk, often down by the river. Sometimes he would be agitated about something specific. That particular day's agitation was undefined. To get to the river, we went through a poor, mostly

black, neighborhood. That day, we saw a group of very young and very dirty children playing in a vacant lot. They were sitting in a circle. As we walked by, it felt as if everything went in slow motion. The children all looked up at us at the same time, as if they were one being. They stared for the longest time. I felt transparent and deeply connected to them. Then, as if with one voice, starting out very quietly and getting progressively louder, they said in a little sing-song voice, "Hiiiiii, Jeeeerrry." There was no way those very young children could have known my name! I had never seen any of them before. I felt intuited to my very soul. I felt like they knew more than my name. I was one of their own; they knew ME. I also felt special in the eyes of Richard, because they knew me, not him. I could see he thought that I was blessed at that moment as well. The Bushmen of the Kalahari have a way of greeting one another. When they meet, they say, "I see you." I imagine that to the magical Bushmen, this greeting from the children would not be at all unusual.

The story gets even stranger. I feel the need to say here that this is absolutely true. I say that because if I heard the story, I would think it embellished—partially true at best! Richard arrived at my door the next day, which was unusual. Our encounters were often so intense that he would come just once a month or so. Again he was agitated, and we went for a walk, the same as the day before. We walked down the same street at an entirely different time of day. It was late and getting dark. The children were sitting in the same spot. Everything felt exactly the same. I began to feel an excitement and pride, knowing they were going to say my name again. This time, after a long stare, they said, "Hiiiiii, Richhhaaarrrd." I never saw those children again.

Richard showed up one day in a panic. I tried to get him to sit and have tea, but he could not. He was upset because animals didn't like him anymore. I had to help him, or he would die. At first I tried to talk him down, but could not. He kept asking, "Will you help me? Will you help me?" Finally I said, "Yes! Let's go for a walk." As we walked down the three flights of stairs, I was trying to think of something to do to help him. I remembered an old man who often sat down by the river, drinking beer. He had no legs and he sat in a strangely decorated old wheelchair. Most importantly, I remembered seeing a dog with him occasionally. It was a long shot, but I said, "Richard, go to the store and buy a six-pack of beer. We are going to need it." Beer in hand, we walked toward the river where I had seen the old man. As we were walking, a large dog ran out from behind a building and went straight for Richard, viciously barking and growling. I pretended to throw something at the dog, and it ran off frightened. Richard was terrified, screaming, "You see! You see! Animals hate me!" And he began to cry.

I felt such compassion for him. Even if it were an illusion, I envied how much he valued his connection with the spirit of the animals. He felt he could not live without this connection. I said, "Richard, I told you I would help you. Trust me." For some unknown reason, I felt I could help him. He listened, stopped crying, and we continued on. He had no idea where we were going and I was not sure myself. I was praying that the old man would be there with his dog. In the distance, I saw the man, but no dog. My heart sank. As we approached, I said to Richard, "Give him the beer." The moment the beer touched the man's grateful hands, a PACK of dogs ran out from behind a house and sweetly jumped all over Richard. They ignored me completely. In his joy, Richard looked like a happy child, so vulnerable and innocent. As we returned home, Richard didn't say a word. He just smiled. When we reached the place to go our separate ways, he turned toward his home and I toward mine—healed.

Kali the Destroyer

One day a large Dutch woman in her forties came to my door. Someone I knew had sent her because they thought I could help her. She came in, and we had tea and talked. She had a quality of blatant excess about her, and I could see that she was troubled. I treated her kindly, which she seemed to appreciate. She told me a story about how she saw angels, "but only once." She had fallen in love with the man who later became her first husband, and they had parked in a lovers' lane. She looked out the window and saw angels surrounding their car.

She began visiting me regularly. Each time she came, she got a little more intense, pushing and prodding, asking for things. She would unreasonably challenge the things I said to her. She arrived one day with a large radio blaring, smoking cigarettes, and chewing gum noisily in my face. A few times, she sat real close and tried to seduce me. I made it clear that I was celibate and not interested in an intimate relationship. She went through the small refrigerator in the kitchen area and made fun of the absence of food.

One day she said she was going to move in with me, but first she was going to quit smoking. I said, "Oh! Do I have anything to say about that?" She said, "No!" I sensed something building and was a little nervous, yet interested to see where this was all going. The atmosphere developed further into chaos each time she came. She was getting more erratic. I saw

her on the street with two older black men one day. When she came the next time, she boasted that they thought she was very sexy and that I didn't know what I was missing. She started singing "Frosty the Snow Man" at me.

She told me that she grew up in Europe during the war. When she was a little girl, her town was bombed. The houses were destroyed and people died. She said that made her crazy, and she had to take medication. She laughed when she told me that sometimes people came and took her away to an institution.

One day I heard a knock on the door – I think I *felt* the knock more than heard it. My cat often greeted visitors at the door; she loved people. This time, the cat ran away and hid. I opened the door. I saw and felt a wild woman, completely out of control. She had the look of death in her glazed eyes. She smelled terrible and was soaked with sweat. I took three steps back and sat down on the floor in the lotus position. She came storming in and slammed the door behind her. Then she proceeded to completely wreck my house, starting in the bathroom. I had made a life-sized woman out of the steam heater there. I had always thought that the sculpture looked a little like her. I heard her tearing the woman to pieces, throwing the parts against the wall and smashing them. Then she stormed back into the room and tore off all of her clothes. She continued destroying things. I stayed in a place of absolute stillness. The energy in the room was more intense than I had ever experienced with another human being. It was beyond what I thought I could handle, but I held still. Internally, I felt I had to stay completely present with this wild destructive dance. It was all I could do. The energy in that room was so creative and charged that any thought I held onto would have manifested into form. At one point, I felt a wave of violence coming from her. Then she came crashing down from the sleeping loft, screaming in pain, having hurt her leg. I felt the wave of violence again. She had cut her leg on a nail and was bleeding. At that point she screamed, "Who are you? I want to kill you! I get hurt."

At one point I felt a wave of my own anger at what she was doing. She picked up on that fast and was right on me! I let it go, and she backed off. In the intensity of that atmosphere, a thought was a creation. The only way to give this strange experience the space it needed was to have no thought. When she had finally exhausted herself, she collapsed on the floor, whimpering, "How am I going to get home?" Earlier that day, someone had left me a handful of bills. I reached into my pocket and handed them to her for her cab fare home. When she left, I was depleted and felt completely ungrounded. I walked down to the river on shaky legs. Staring into the dirty water of the Hudson River, I intuitively knew to jump in. I can't explain it, but being in the water brought my life force back, and I felt grounded again.

When ET Came Home

One winter morning, I was walking by the Hudson River. There had been a snowstorm the night before. I came to an open lot covered in a fluffy blanket of new snow. I was not sure if I should trespass, but there was no one around, so I decided to make a snowman in the lot. It was warming up a little, so the conditions were perfect. I rolled the snowball until it was so large I couldn't move it anymore. That was the first layer. Then I made the second and the third, stacking what I could lift, one on top of the other. When it came time to add the details, I noticed a small boy standing close by, looking at me. The oversized jacket he was wearing had long sleeves that covered his cold hands. He appeared to be a racial blend, with dark skin and a large, misshapen head. His soulful eyes seemed to look in two different directions at once. I remembered reading somewhere that mystics had eyes like his. They saw the physical and the spirit worlds at the same time.

He seemed taken with the large snowman I had made. I asked if he would like to help me. He walked over slowly, picked up some of the sticks I had gathered, and began decorating the snowman with me. We were working quietly, exchanging only an occasional word, when we heard a group of boys noisily coming our way. One of them shouted, "Hey, ET!" I asked, "Is that your name?" He nodded his head, yes. I said, "Oh, that's a cool name."

The other boys were a little older. They seemed to have a lot to say about the sexual orientation of our snowman. In response to their banter, I said, "Well, if you don't like it, why don't you come over here and help us make it better?" They did help, adding a variety of suggestive body parts. When the androgynous snowperson was done, we joked about our creation. Then I left for home. When I was a fair distance away, I heard loud laughter and yelling. I turned around to see the snowperson being reduced to snowflakes.

More surprisingly, I saw ET right behind me. He said, "Can I come to your house and get warm?" I said, "Sure." I made him tea, and we quickly became friends. He was an unusual child—sweet, open, and very present. He was a leader by way of his quiet inner knowing. Although he was younger, the other kids listened to him. They often referred to something ET had said in defense of a point they were trying to make. The other children came to my house only after ET established the friendship. ET reminded me of a pigeon that I often fed outside my studio window. This particular pigeon was small and had a deformity. He had only one foot; the other was a little stub of a leg. His way of competing with the more aggressive and more beautiful birds was to find his own brave magic. He was a little friendlier

too, and he would come right inside the window to eat. This pigeon was the first to arrive when I put food out on the window ledge. The other birds would follow once they saw it was safe. That was ET's role in his family. Everyone liked him, and his gift at winning hearts and getting inside was a mystery to the other children. They depended on ET to make their scary world safe.

ET laughed a lot—a genuine laugh. As he laughed, he danced in little circles as if he couldn't keep his joy contained. I found out later that most of the other children in the gang the day we made the snowman were his brothers. None of them looked alike, so I never suspected. Soon his sisters, too, began to visit me. Then their mother started coming. I fed them when I could, and I gave money to their mother at Christmastime. She was a very large, southern woman with blonde hair and more children than she knew what to do with. When I met her, she was pregnant. Shortly after, I ran into her on the street on a hot summer evening. She was carrying something under her arm. When I got closer, she swung her parcel out toward me. It was her naked, new, shriveled baby. The experience of having this newborn thrust in my face caught me off guard. I tried to act happy for her, but I was overwhelmed with the moment. The idea of yet another child to feed and the way the child was presented to me were too much for me to take in. My feelings betrayed me as I pitifully croaked my response, "Congratulations." I knew she saw through me and I felt bad about it as I walked away.

One Sunday morning several of the children came to visit me, and ET began asking questions about my large loft space. He wanted to know what it had originally been used for. I knew the building had experienced several incarnations. Someone who had lived in Nyack for many years told me that my particular space was once a black gospel church. I loved the idea that my loft had been a place of worship. I especially liked that it had been a church for the black community. After I explained this to the children, ET said that he had never been to church and would like to go sometime.

From my window, you could see a black gospel church on the next block. I stood up, walked over to the window, and saw that people were just arriving for their Sunday morning service. I said to the children, "Let's go to church now!" The children seemed interested and a little nervous about doing this. I assured them that I would be there with them and that they had nothing to worry about. Little did I know that I was the one that should have been worrying! So off we went to church. The people had settled in, the doors were closed, and the service had begun by the time we walked down the hill and into the church. I was in the lead as we shuffled noisily through the doors. Just as we entered, Tracy said loudly, "I ain't going in no nigger church!" At that, the children all bolted, abandoning me completely. Everyone turned

to see who had uttered those disrespectful words, and I was the only one standing in the doorway! I was also the only white person in the church.

The children's current father was Haitian and their mother was Caucasian. All the children in their large family were of mixed blood, yet I had heard them call other black children racist names. I once heard them call one of the boys in the neighborhood "a Haitian nigger." They did not say these things out of any form of affection, which I have often heard adults do. When I asked why they said these things, since they were part black themselves and their own father was Haitian, they avoided the question as if I had somehow embarrassed them by noticing. I told them that I liked the many Haitians in the neighborhood and that I liked them too. I said that I was proud of them and asked them why they were not proud of themselves. They just giggled guiltily and did not want to talk about it any further.

I headed into the church and found a seat as quickly, quietly, and respectfully as I could under the circumstances. As the service continued, I heard noises outside the church doors. The children were throwing themselves against the doors, screaming, and running away. I think that they felt bad about having abandoned me and so were acting out in a negative way. I was beginning to feel terrible about the chaos I had wrought on this lovely little church. I felt that my attempt to give the children their first experience of a church service had been misguided and ultimately disastrous. I wondered whether I should get up and leave, taking the children with me, and allow these good people their worship. As if intuiting my dilemma, two women came over and sat beside me. They comforted me by asking, "Were you trying to bring those children to church here today?" Relieved to be understood, I said, "Yes."

The church was very hot and I was slightly red from both the heat and the embarrassment. The two women laughed kindly, and one of them handed me a paper fan with a picture of Jesus on it, while the other fanned me with hers. I silently thanked the Jesus on a stick for cooling off both the situation and me! Soon the children went away, and I felt held by the two kind, sympathetic women sitting beside me and by the wonderful service, which continued uninterrupted.

It was a lively service. A very large woman played wildly on a full drum set, accompanied by a single electric guitar. The man playing the guitar held a simple, repetitive, African-style rhythm. The response from the congregation was full-bodied and ecstatic! The worship was a holy, emotional joy to experience.

Regardless of the terrible beginning, it turned out to be a wonderful gift for me. When it was over, I was flanked by the two smiling women as people came over and welcomed me to their church. This was a congregation that lived its principles. The two women who initially

accepted me, in spite of Tracy's racist remark, were clearly important members of the church. I was blessed by these good people and silently offered them blessings in return.

Tracy was the rebel in the family, and he got in trouble often. I had an old stereo in my loft that the children liked to play music on. They said they had no music in their house, so I gave the stereo to them. We packed it up, and they excitedly took it home, arguing about who would be in charge of it. The next day I asked, "So, how's the stereo working?" There was a long silence. Then ET said, "Tracy threw it out the window." They lived on the upper floor of an old apartment building. The stereo did not survive the fall.

Tracy also threw my flowerpot out of the window. In my loft, I had a pot full of flower bulbs. They were flowering when they were originally given to me. I had the plants for years and could not get them to bloom again. One day the children came into my loft when I was away. They threw the pot out of the window. It was winter, and the pot sat on the roof below for a few cold nights. I finally climbed down the fire escape to get it. A short while afterward, the plants bloomed! I thought it was a miracle. A friend assured me, "Bulbs need to freeze before they can bloom."

The Visit

It was 1:00 A.M. when I walked up the hill from the river. I had been fasting and reading for several days and could not sleep, so I decided to go for a late night walk down by the Hudson River. I was a little startled to come around the corner on the final approach to my building and see a gang of young men sitting in the entryway to my loft. A visiting cousin had been mugged outside my building a few months earlier by a gang like this. The only way into the building was being blocked. A couple of the men were drinking from bottles hidden in brown paper bags. They did not look friendly as I walked up to them confidently and said, "Hi, can I get in here?" One of the men said, "You live here?" I said, "Yes." They didn't move. I stood there in silence. Then one of the men said, "Can we come up and see where you live?" This was a difficult moment. It was late, the streets were deserted, there was no one else in the building, and I had been sleepy until I stepped around the corner and saw them at my door. I refused to give into my fear, so I shrugged my shoulders casually and said, "Sure, if you want to." I unlocked the door and led the way up the three long

flights of stairs. They followed behind, talking low and laughing. At one point, I heard a bottle hit the hallway floor. We continued up until we came to the door to my loft. I unlocked it, turned on the light, and invited the men in.

The door opened into the side of the loft where the living quarters were. There was a kitchen with a loft bed above it and a large living area. Two large windows looked out at the nighttime display of twinkling lights in Ossining, the town directly across the Hudson River. My loft ran the length of the entire building and was separated into two sections by a twelve-foot-high wall that went up to the decorative old rust-stained tin ceiling. There was one small door in the middle of the wall. Through that door was a huge studio, which at that time (just before I destroyed my work) was full of my large paintings. Standing in the living area where we had entered, one would not suspect that there was an even larger space beyond the door-way on the side facing the street.

The group of men looked around at my very simple environment. I tried asking them questions about themselves. They gave short, choppy, indifferent answers. They seemed guarded and hesitant to give any information. I think they were searching their hearts to know how to respond to me, since I was the vulnerable one and had risked so much in deciding to trust them and be kind to them. I sensed that they didn't know quite what to do now that they were inside my home. In their discomfort, they were getting more and more restless, making jokes and laughing recklessly. At one point, one man said, "We need to case this joint." I stood up and said, "Well, follow me. I will show you what I do." I led them through the door and into the studio. I walked into the dark room ahead of them to where the light cord hung.

I pulled the long cord that turned on the large bank of lights mounted on the ceiling. The room lit up and came alive with the hundreds of images that filled the studio. Very often strangers entering the studio fell silent when they saw the overwhelming amount of intense painted images that filled the space. Large paintings leaned against the walls. Hanging from the ceiling was a row of eighty paintings on panels, all life-sized (see pages 109–110, 114). They were strange human forms—certainly strange to these young black men walking in off the street late at night, stepping into a world so completely different from their own. Just the week before, a woman said to me, "It is an unbelievable experience walking in here from the busy world outside. It's like going down the rabbit hole in *Alice in Wonderland.*"

The men stood silently, and then one man self-consciously broke the silence and asked, "Wow man, did you do all this?" I said, "Yeah." I immediately felt the barriers come down and their hearts open! Then I was bombarded with interesting questions about my art and my life.

They stayed in my studio for the longest time, asking me to explain many of the paintings. They walked around picking out their favorites, calling each other over to see another, yet more interesting discovery. At one point, one of the men asked me if I was famous. I said, "No." Another man retorted quickly, "Shoot, he's famous to me!"

The men opened to what was good in their hearts. In the end, I felt that we shared a love and respect for one another. Just a few short minutes before, anything could have happened, and now we were friends. We all risked something in stretching our small, isolating limits and we all won. When I had answered all of their questions, they very politely left, thanking me as they went. As he was walking out the door, one man asked if he could come back and bring his girlfriend. Of course, I said, "Yes." My connection with these young men continued over the next several years in unexpected ways. One day several years later, I was walking through town when a young couple pushing a stroller stopped me on the street. The man said, "Hey, you're that artist guy. I remember you." Then he introduced me as his friend to his wife and told her all about my paintings. He wanted to know if I was having any art shows he could bring her to. In a few weeks, I was having the first show since I destroyed my work, so I took his address and sent him an invitation. I looked for him at the opening, but I didn't see him. Perhaps he came another day with his wife and child. Another time, another man who had been in my loft that night recognized me and went out of his way to introduce me to his girlfriend. He explained to her that he had visited my studio and told her what "great work" I did.

That dark night could have turned out much differently. I could easily have given into my fear, or the men could have done something rash, and the open human connection could have turned into just another fear-based story. I once read somewhere that "it takes great courage to experience great love." I am happy we all found our courage to express what was the best in each of us that night.

What is it in the human heart that will not violate something recognizably its own, something inherently innocent? Would we have to violate this in our own hearts first if we were to violate it in an external form? In a catalyzing moment, a holy recognition comes into play. We intuit something familiar and innocent, having to do with our own inner value. Therefore, to save that in another is to save it in ourselves. If this innocence of heart is violated, that one small act is no less than a violation of the universe. Perfection exists in every sentient encounter, and we can either be nourished by the encounter or depleted, depending on what we do with that moment.

Thoughts on the Matter

In the shadow lands of life's most terrifying experiences, something inherently noble in the human heart unexpectedly enters in and renders the voices of good and evil mute. Grace sets the mind in a hesitant, holy trance, and we are emotionally invested in doing what is most right and beautiful. If there is a healing grace to be relied on, isn't it worth risking our lives once and for all to establish this as a permanent feature in our conscious daily lives? We must risk everything to even come into the fierce proximity of its true power. But if grace is to become a fully dependable reality, it must carry us through the most frightening circumstances.

To gain access to grace, we must hold the proper tension between good and evil and remain in a state of fluid unknowing. We make manifest whatever we hold of unknowing through right, timely, creative action. We must be impeccably aware of inner and outer dangers and not become paralyzed by external circumstances. When we creatively intuit the heart's central innocence, first in ourselves and then in the world around us, we discover that this dangerous external world actually awaits the opportunity to express its love.

Fearful belief in the power of violence, along with the absence of a mature and disciplined innocence, create an environment in which violence can grow. In such an environment, we inevitably build walls to protect ourselves, which may shut out the natural flow of love and magic. Navigation within these walls demands constant strategy. Fear is our navigator, effectively justifying separation as it holds at bay any surprise encounter with grace.

As I was leaving a presentation on the video made recently about my life and art, an older man approached me and invited me to his house for Japanese tea. I thanked him and said I would come sometime. He was a retired economics professor who lived alone in a large house and had no family, and as far as I could tell he had very few friends. He lived just down the road from me, so one day I called and set a time to come to his house.

Entering the front door of his house, I had to walk by a line of defenses. There were door locks, which he locked behind us, an alarm system, and an enormous Doberman. Once we were locked in and settled in his perfect, beautiful, well-controlled environment, he brought out the tea. I was instructed to be very careful of the rug as I was handed the most perfect cup of tea. I suddenly realized that this man was courting death amidst all this perfection. I was dying in his creation, and I had only just arrived! I sat quietly for quite a long time as he spoke, mostly about tea.

In a desperate attempt to add levity to his willful monologue, I finally interrupted and said, "If you did not have a concern in the world and you were living your most passionate joy, what would that look like?" He cleared his throat, reached quickly into his shirt pocket, pulled out some promotional information he had picked up about me, and said, "I had better find out more about you before I think about whether I want to answer *that* question! Why do you want to know that?" As he continued to read the information, I inadvertently betrayed my astonishment at his response by laughing. I said, "I don't think you're going to find the answer to my question in what you're reading! I want to know because I connect best with people through the dreams they hold for themselves." With a suspicious sideways glance, he gave a guarded, vague answer, drained and lifeless, about the "wisdom acquired by age, and the wise mistrust of the world."

He was clearly an unhappy, lonely man. But he had, after all, invited me over. There must have been a small openness to something that he thought I represent. I made every attempt to establish a connection through that small opening. I wanted to share a little piece of joy in what was otherwise a very stifling situation. I gave the visit two hours and tried in many careful, gentle, thoughtful ways to create some deeper interaction. Given enough time and space, I am usually able to connect with people. But despite all the attention and care I gave this attempt, *nothing* happened! It was so unusual an encounter that I found it fascinating. When a person opens to deeper conversation or even gets angry, these are signs of life. But when nothing happens, this is most interesting. I thought about the visit for days afterward.

What personal beliefs, behind an intelligent and calculated system of relating to the world, create the conditions in which nothing can happen? The experience illustrated for me the effects of buffering oneself from a direct encounter with one's fearful limits. I was left wondering where those limits are in myself. What internal dialogue slowly allows the gravitational pull of comfort to position us at such a safe distance from life's surprises as to eliminate them? Fear-based comfort can become deadly safe—the agent of a slow, sorrowful death. To position our lives so that nothing happens requires an enormous amount of attention.

A wonderful Peter Weir film, appropriately called *Fearless,* deals exquisitely with the paradox and power inherent in the death experience. The main character, played by Jeff Bridges, survives a plane crash and becomes victorious over fear and death. After that transcendent experience, which has taken him through his worst fear, he walks boldly into everything that frightens him. Living dangerously close to the edge, he heals a woman who survived, but lost her baby, in the same plane crash. Following outrageous confrontations with many of his limits, he is still unable to complete his journey and heal himself. Finally,

his wife brings him back from the edge of death, literally and symbolically. She saves him by breathing life back into him. His journey has taken him full circle. He is then able to reinhabit his life in the world with his wife and child. The film beautifully illustrates the enormous transformational healing and magic that can happen only in our direct, fearless confrontation with death. To allow life to *happen* when we are engaged in a full and unexpected encounter with danger is to trust with our lives the magic, still place of safety that is always available. The conscious, perfect order of creation fully equips each encounter with everything we need to survive.

To get a glimpse of this perfect order and let it work on our behalf, we must agree at a deep level to accept the possibility of death in every dangerous event. We must be willing to die at any time, exactly where and when death occurs. We are free from the power of death when we make the fearless choice to trust and to experience everything in this experimental, evolutionary process of embodied life. The notion of "life or death" does not fit into the equation of a universe that doesn't distinguish the difference. Physical creation, with death written in the microscopic font of its DNA, is a minor detail in the timeless big bang of the soul's continuous outward expansion. Our universe constantly scrawls ETERNITY in cosmic graffiti all over the illusory walls of matter. ETERNITY sprayed straight from the can, in blue—God's territorial reminder that temporal matter belongs to Her. In our fearful comfort, we quicken matter's return to dust with every attempt to scrub away our blue eternity.

We would prefer not to be reminded of anything beyond our immediate birth and death as we build retaining walls at both ends to keep matter in place. The fact is, no matter how many walls we build, or how many ways we set up reality in our own best interest, death still gets in the door—a skull smiling at the futility of our efforts. Death is the old friend, glad to see us, coming and going through our house as freely as a child. What we may have forgotten is that we invited this joyful innocence to dance right along with us when we signed up for physical existence. We can smile joyfully, like a skull and like a child, as we courageously dance with what is written in our DNA.

Lao Tzu says, "Merge with dust and be renewed." Maybe we do this by living up to our original agreement that death is a part of life. To live consciously in relation to death is to know when to throw death a bone. Once death has been given its due, life is once again sanctified and returned gloriously into our hands. This cyclical, natural process is essentially who we *are*. As willing participants, we can stay mindful and attentive to this miraculous turnaround from death to life. Doing so, we become cocreators of the shimmering substance that we perceive as beauty in matter.

The miracle of human beings living and dying beautifully in the worst possible circumstances demonstrates the grace that resides in the death experience. We can discover our most poignant and powerful identities in the most powerless circumstances. Grace is the incongruous magic of fullness becoming empty and emptiness becoming full, in spite of every human advantage or disadvantage.

Power Places

One of the lessons and gifts of fasting was to find nourishment from other sources, such as showers or reading. I spent long hours reading at the library—mostly biographies and autobiographies. An important element of the process I was going through was the absorption and deeper understanding of the feminine, both in the collective consciousness and in myself. Yogananda said, "In God's eyes we are all feminine." Men have such a difficult time because we cannot let go of control. We cannot allow ourselves to receive from a source less defined and more knowing than ourselves. Receiving life force in its subtle aspects generally comes more easily to women, or more particularly, to men or women who have consciously opened up to their feminine aspect.

The most important books that I read on this subject were the diaries of Anais Nin, and surprisingly, the autobiography of Marilyn Monroe. I think Marilyn's story had importance for me because of her sense of purpose and the way she lived it out in her unusual life. To this day, something in her story awakens in me a deeper sense of purpose, although it is a mystery to me as to why. Perhaps it is the way her innocence seemed to have been carried by forces larger than her own. At pivotal moments in her life, something essential in her particular journey would be restored, in spite of her often destructive and unconscious behavior.

At times I spent the entire day at the library looking at pictures. I found nourishment in taking in the great photographs and paintings of the world. On one occasion, the "nourishment" I received from a book surprised me. The book shape-shifted and became literal nourishment! One early morning hour during a particularly long fast, I was having a difficult time with hunger. The door to the street below was locked, so I knew there would be no one coming with gifts of food. I was feeling so weak. I thought, "Even God can't help me now." I just wanted to eat. I was angry with God and feeling abandoned. I had not slept very much

during the night. I was tired, and I just wanted to live like a normal human being or leave the earth completely!

The friend who originally ran the yoga center next door left a large collection of books there when he moved to California, and he told me I could take what I wanted. I left them in place but occasionally read them. I didn't have the strength to read that morning, but I knew that books had energized me before, so I went to look for one to read. When I stood before the bookshelf, one particular book caught my attention. I picked it up and it didn't look very interesting, so I put it back. I continued looking at other books, losing interest and energy as I went. I was about to give up when the first book caught my attention again. Frustrated, I grabbed it off the shelf and went into my studio. I sat at my little table with the book. I was hungry, upset, and discouraged. I did not want to read, but the book was all I had. I surrendered to my fate and obediently opened the book. There between the pages was a five-dollar bill. The book fed me!

In our abundance, we lose sight of the fact that life is about energy in its multidimensional forms. Hunger taught me more about energy, or power, than any other learning source. To find ways to power was a matter of life or death for me. My exploration in this area showed me that there are indeed places and moments of real power. The places are there, but the gift of power inherent in them depends on right timing. Just to be at a place of power is not enough. To be there with right timing creates a fully empowering experience. The place and the timing together create a third and larger dimension. This removes the gift of power from a purely materialistic manipulation of its ways.

Once when I was hungry, I rode my old bicycle down to the park along the Hudson River, parked my bike, and went for a walk. As I walked along the public path, I began feeling weaker with every step. I stopped to rest and found a return of energy. As I began to walk again, I immediately felt weak once more. I took a step back and felt more energy. The effect was so immediate and apparent that I had to pay attention. As I looked to my left, I saw an animal trail cutting through the brush, so I walked in through the opening. In a clearing there was a huge boulder that had broken away from a cliff nearby. The rock was about ten feet across and had a flat, tablelike surface. I climbed on top, and there in the grain of the stone was a large, perfect circle! I looked very carefully at it because I could not believe it had been created by nature. The circle was *in* the stone. I remembered Leonardo da Vinci's drawing of the proportional man standing in a circle. I lay down in the circle like a star, spreading hands and feet, touching the circumference above and below. This relaxed me completely, my empty body filled, and energy was restored.

Healing the Bloodline

Healing the family bloodline is the most important work we can do as individuals.

—Patricia and Macy, contemporary Native American teachers

Until I destroyed my art, I was completely unaware of how much I had re-created my father's life! As a young man, my father was badly burned in an accident involving gasoline. The left side of his face was burned. His ear was badly scarred, and the scar ran down under his neck. He was a handsome man, and as he got older, the scar was hardly noticeable, but when he was young and interested in dating, the scar presented difficulties for him. My father was married once, before he met my mother. He was young when he married the first time, and his wife was an exceptionally beautiful woman. I have heard about her beauty all my life. When my father joined the military service during World War II, his wife left him for another man. From what I can piece together, my father then had something of a breakdown. Several years later, his first wife was killed instantly when the car she was driving was hit by a train.

I know now that the strange power my father always had over me came from his knowledge that my life mirrored his own. At a deep level, perhaps even unconsciously, I was completely predictable to him. I *was* his story, and I could not free myself from its grip. He could not free me because he could not free himself. My father did the best he could do, but he passed the family shadow along to me.

We grew up in a poor, mostly black neighborhood. There were many casualties among the young people I grew up with. Heroin was probably the most devastating. When the racial tension and heavy drug use of the sixties had just begun, we moved out of the neighborhood. I watched most of the black children I grew up with eventually go the way of heroin, as they became adults.

As was my father, I was seriously injured when I was young. At sixteen, I blew off two of my fingers while making a bomb. This event did not make my life as a self-conscious teenager any easier. In high school, I was a terrible student. I spent as little time as possible in school. I would check in and then slip out the back to ride off on my big British motorcycle. No one seemed to care. My parents were uneducated themselves, and they weren't very concerned about my education. They gave me the occasional token lecture about "the importance of studying," but I knew it was not important to them, nor did it matter to me. When I was in high school, I began doing heroin and other drugs, like many of the kids in my neighborhood and social class. I was completely lost, and like most lost young people, I did not know it.

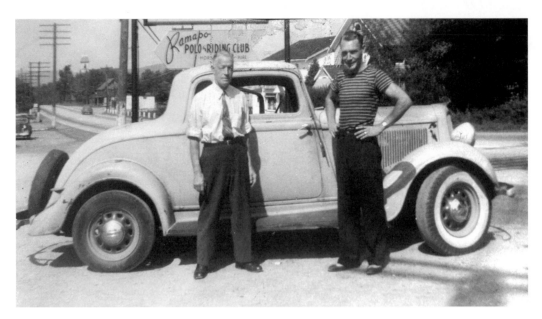

My father with his father.

Like my father when he was my age, I fell in love with a beautiful young woman. Shannon was considered by most of the boys in my school to be one of the school's brightest and most beautiful girls. I adored her, and we had a sweet, passionate, and reckless relationship for the next two years. She did everything right. She was an artist and an honor student, and participated in the school's activities. Her parents were educators who lived in an upper-class neighborhood. She was everything that I was not, and her friends could not understand what she was doing with me. I was not sure myself!

When she finally left me, I was devastated. I could not get over her. Just the thought of her renewed the devastation. The drugs I was taking and the loss of love left me completely confused and lost. I came closer to death after she left than at any other time in my life. The pain continued for many years, no matter what I did or how many new relationships I immersed myself in. Eventually, I tried to become what it was I loved about Shannon. I know that I had a natural talent for art, but I believe that it was because of her that I actually became an artist. I went to college, and in my first year I was placed on the dean's list. I became extremely driven as an artist, producing an enormous body of work.

But my life was not my own. Shannon and my father were the unconscious engines that drove and created my life. Fifteen years later, when I decided to change radically, I intuited the need to let go of everything in my life that was driven by external forces. I had to find a new way of creating my life, based directly on a one-on-one relationship with God. If I could not

find that relationship, I saw no reason to be on the planet. All of my willful attempts to realize the impossible vision I held for myself—a vision not my own—led me nowhere.

Not long after I destroyed my art, these external influences reemerged a final time and expressed themselves powerfully. Their force brought with it an epiphany of insights, a resolve, and a new freedom. I intuitively knew I was to live the celibate life at this time. Working on my own self-awareness and deeper personal understanding was all I could do. I knew that being with a partner would only be a distraction. I was not ready to explore relationship, although it continued to be a great temptation.

At this time, a beautiful woman entered my life. She was a dancer who visited me frequently, coming across the hall from the dance studio after rehearsals. I fasted constantly, and she would bring her homemade bread to me. Her warm and attentive presence was more temptation than I thought I could resist. My life was too hard, and she promised salvation. That is the message I was getting in my weakness. I knew the very thought was a sellout. It was the ego's scramble for the refuge and comfort of yet another beautiful woman. I felt overpowered with the force of this temptation. To add to this struggle, Shannon, my first love, also reemerged into my conscious mind with the original force and power she had always had over me. My weakness for women had compounded and was stronger than ever. I was scared, and I was having a very difficult time controlling this weakness. I had placed my life on the altar, and I was allowing the gods to do what they wanted with me. I did not understand why this was happening to me now.

One day at the height of the confusion and pain, I headed down toward the river for a walk. There had just been a downpour and everything was soaked. I walked by a storefront where a radio blared the words, "When the rain washes you clean, you'll know." I knew I was not washed clean. I found a shiny new penny on the ground. Looking at it, I remembered reading in an astrology book that copper was the metal related to Shannon's birth sign, Taurus. As I walked, I came to an inlet going into the river. The pain and confusion were overwhelming. I stopped and sat on the small bridge that crossed over the inlet. I found a surprising comfort in staring without focus into the water. Then I noticed that the way the water rolled over the rocks looked like a woman's body. I thought, "God, why are you showing me this? I am struggling enough with women." All I could think of was Shannon. I felt a strange, overpowering mix of love and anger at myself and at her. The pendulum that had been swinging since we parted ways so many years ago was making its final few swings before stopping completely. Back and forth—I hated her; I hated myself.

When the confusion became completely unbearable, I simply surrendered and let it all go. That was all I could do. I knew in an instant that it was myself that I could not forgive! I

threw the penny into the water and cried. I said out loud, "God, don't kill her." I didn't know why I said that. The moment was an epiphany, and thoughts came rushing in. I knew my father had had this same moment in his own life, and then his lovely wife had died in the train wreck. My father could not forgive, and some feminine aspect of his life died in that accident. The compulsive attraction to my dancer friend was the same compulsion that led my father to marry my mother. He had no choice but to marry her. I knew all of these things instantly. I also knew at that moment that I had a choice, and I chose celibacy.

Four days later, I received a nondescript postcard with a Florida postmark from Shannon. I had not heard from her in years, and had no idea where she lived. The card said that she had recently fallen into an inlet that swept her into the ocean, and that she had almost drowned. She didn't know why, but she felt that she needed to tell me this, and that she had thought of me when she was most afraid. That was all the card said. As strange as it may sound, I knew that she would have died if I had not found forgiveness, just as my father's wife had died. I knew this to be true, and that knowledge and the self-forgiveness set me free from the power that my father and Shannon had over me.

A few weeks later, I went to upstate New York to visit my parents. The moment I walked in the door, I knew something was very wrong. My mother looked scared. My father looked like living death. As a young man, my father had been an alcoholic. He had not taken drink for as long as I could remember, but now he was drinking heavily. He was sneaking out to buy whiskey and then hiding it in the garage. I was told he had been drinking day and night for several weeks straight. Everyone in the family was afraid. Feeling the urgency of the moment, I walked straight up to my father and said clearly and forcefully, "If you want to drink yourself to death, you go right ahead, but don't think you are going to take the rest of us with you!" My mother looked at me with terror in her eyes. I turned quickly to her and whispered, "It's okay Mom, trust me," then I walked out of the house.

When I returned the next day, my father looked terrified. He was trembling from the alcohol and was afraid to look at me. When I finally spoke to him, he said, "What you said yesterday really hurt me." I sat down on the couch with him and held his hand. I said, "Dad, I want to tell you a story." I proceeded to tell him the entire story of the family shadow. I spoke of the insights I had, how I had re-created his life, the death of his first wife, Shannon, everything! This was a very strange story, and to my amazement, he uncharacteristically listened to every detail with unwavering attention.

Then I said, "I think you had to marry Mom, and you have been a good husband. You have paid your dues." He seemed nervous and relieved, but did not say a word. Someone finally

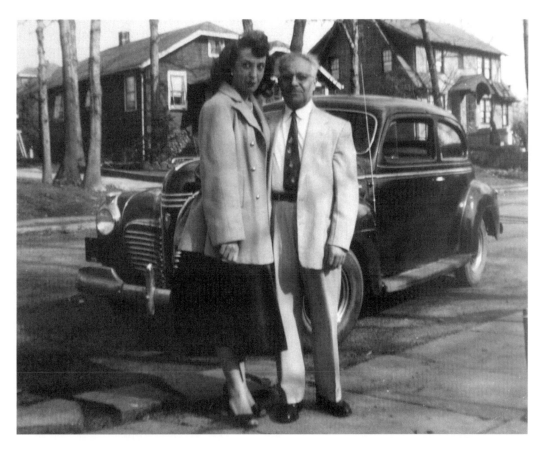

My mother with her father.

knew his secret and could forgive him, so he could forgive himself. He never took another drink, and we did not speak of this occurrence again until many years later, when I was talking to my mother about her old-world Sicilian father. He was abusive to my mother and beat her until she was twenty-one; then he stopped. She held a lot of anger about it and could not forgive him yet.

The story goes that when my mother was twenty-one, she came home late one night after dating the man who was to become my father. Her father was waiting and ambushed her as she walked down the path to their house. She had had enough of his beatings and fought back. She won the battle and held him down, whereupon he broke down and cried! That was the end of the beatings. Shortly after that, my mother married my father and left home.

The only time I ever heard my mother speak tenderly of her father was when she told me how bad she felt about defeating him in that fight. She cannot recall even one good memory of her life growing up with him. I found that hard to believe, so one day I asked her to try to

remember one good moment that she had with her father. She could not. I persisted, and my mother got annoyed with me. She said, "Why are you asking all these questions?" My father, sitting on the sidelines, said in a dreamy voice, "That's like when you told me the story about Lillian." He was referring to his first wife and the story I had told him. I was amazed that he was speaking of that event! I looked at him surprised, and he looked away nervously. He never mentioned it again after that.

The power of the bloodline and the depths to which new dimensions can open once we have healed the bloodline are far-reaching and mysterious. Each one born into the many generations of a family's line builds on the light or on the shadow of that lineage. The torch gets passed either way. Each of us depletes or contributes to the power of the family container in an ongoing way. We draw on the family power for strength, and we buckle under it when the weight of the heavy shadow gets passed to us. The person out in front, who has contributed the most healing and love to evolving the bloodline, holds the torch of the lineage. This is not necessarily a matter of choice, and we need not be aware of this dynamic to take up the torch or to pass it to others.

I have never identified very strongly with my family or my bloodline, but that did not matter. None of us can disassociate from our family of origin. It is wise to be aware of the qualities of the bloodline, because then we can be conscious of what we are up against and what we can draw on for strength. For example, I think it is interesting that I come from a line of inventors and machinists on my father's side. My father tells stories of working in his grandfather's machine shop as a child, with his father and brother. The shop did fine machine work and created machines for other businesses. My great-grandfather was commissioned by someone in the British royal family to drill a hole through a very large, rare diamond. This precision operation required great care so that the diamond would not break. My great-grandfather made a machine just for this job. The machine dipped a special drill first in olive oil then in diamond powder. The drill barely touched the spot in the mounted diamond to be drilled. Just enough pressure was applied to drill the hole a tiny amount each time the drill touched the diamond. The machine apparently ran night and day for quite some time until the diamond was drilled completely through.

My great-grandfather's machine shop had a reputation in the world of machinists. Once a small sewing needle was sent to the shop from a well-known German machinist as a boast and a challenge. The needle had been drilled through lengthwise—no small feat! My great-grandfather met the challenge by first threading the hole drilled by the German machinist and then by making a tiny bolt that fit into the threaded hole. Then he sent it all back to the German company.

Steam Engine (detail).

Somehow the men of my father and grandfather's generations got lost in the shadow cast by the previous generation's brighter light. Both my father and his brother dabbled in machinery but did not do much with their genetic foundation. Alcohol was also present in the bloodline, and they both battled with the weight of its destructive force.

It is no accident that working with machinery comes naturally to me. I love creating and inventing mechanical things, and my most recent creations are as much inventions as they are art pieces. The interactive art pieces that I have been working on for the last several years have many mechanical devices with lots of moving parts. Buttons, bells, buzzers, and motors activate the devices. My most recent mechanical creation is an eight-foot "being" powered by a steam engine. The steam engine is seen through a window in the heart area of the piece. To start the steam engine, a fire is lit in a small chamber in the pubic area of the being. As the engine runs, a little goddess figure dances in the heart. This piece has several other mechanical and interactive devices that run simultaneously. The power of the bloodline often translates as that which we

love to do. Blood carries in its flow a way of finding its own in the space outside ourselves, as if attracted by a deep magnetic force.

A friend who does adoption work told me the most amazing story. A young woman placed her child with an adoptive family from out of state. She chose the family from information and photographs she was shown by the adoption agency. She met with the adoptive parents a few times while she was pregnant, but she did not know where they lived. The policy was to keep that information confidential. When the young woman finally gave birth, the adoptive parents were there and took the child home with them immediately after the birth. The mother had no further contact with the adoptive family or her child. Over a year later, the woman was in a crowded shopping mall some distance from her home when a small toddler who had lost track of her parents came up to her and put her arms around the woman's knees. The child said "Mommy" as she grabbed on to her. The young woman said, "Oh no darling, I am not your mother." When she looked up to find the child's parents, she saw that they were the same people to whom she had relinquished her child! She actually was the child's mommy!

The film made about my art and life in 1979 was shown in various locations, some in Europe. I heard that there was a Wennstrom in the audience at a Stockholm museum showing who wanted to know if I was in any way related to him. It turned out that we are. A cousin of mine had been corresponding with distant relatives in Sweden. She gave me the address of someone there who was related on my father's side of the family. I wrote a letter to this man, Magnus Wennstrom, and found out that the man at the museum was a relative of his. At that time I wondered if there was a connection to be made, a link to the spirit of the bloodline. This correspondence was a small attempt at that possibility.

For me to have done this was unusual, as I have always been the one in our family with the least interest in familial ties. Even as a child I was more or less on the outside of my family system and was probably considered the least loyal to the tribe. I am the only family member who lives far away—on the other side of the country—and I depend very little on family interaction. But something in the bloodline is larger than any family identity. The deep and mysterious responsibility to blood itself keeps us engaged, whether we consciously choose to participate in the family system or not. Some of our essence is in the very spirit of the bloodline. Personal involvement within the structure does not matter. What does matter is that we become conscious of our family shadow, which is something that all families have. I once heard Robert Bly say, "Beware of the man who thinks he had a happy childhood." This is the man or woman who has not faced their shadow.

When we can undo the family shadow for ourselves and stop it, we stop it for generations to come. I believe the Christian theory that when one person in a family is saved, then the whole family is saved. To me this means that if one family member faces the shadow, then the shadow is discontinued within his or her family system. It does require grace for this salvation to be effected. It also requires the wisdom to know what we are up against and to take responsibility for our part in it. Once we know the shadow and feel and see its effects, then we can call on the necessary grace. When we have done this work and returned to the family, we can no longer continue the unhealthy pattern. That inability is what changes the family as a whole. The one who knows the particulars of his family's dysfunctional pattern, but who now holds a vision of health for himself, can effect real change in the family system. When we have undone the family shadow, we can loyally carry the torch for the bloodline and move forward with something good that the spirit of the lineage has always contained.

Shortly after I wrote the letter to Magnus Wennstrom, the distant relative in Sweden, I received a letter back. He was in his eighties. He sent me an engineering journal that he had published, on managing slag ponds in Sweden, along with an invitation to visit him. I felt that Magnus was a man with integrity, someone who had contributed something good to his bloodline. He was nearing the end of his life, and I felt, through the magic and the timing of the occurrences, that an invisible torch was somehow passed on through the connection. The communication I had with Magnus and the Wennstrom who turned up in the Stockholm museum corresponded with my own process and the epiphany that healed my own family shadow. For the first time, I found a real connection to the miracle of the bloodline.

Held in the Arms of the World

I gave my mattress away to an aging Indian woman who had been sleeping on a hard surface and was having back problems. It was about the last thing I had left in my loft space worth bothering with. The twelve-hundred-square-foot loft was divided into two large spaces. The studio faced the noisy street three stories below. The living area was quieter and had a view of the Hudson River and the large prison on the far riverbank in Ossining, New York. In spite of its sad, dark reality, the prison looked like an exotic golden kingdom when the last of the day's sunlight fell on it.

The studio that had been filled with my large paintings was now empty. My close friend Deborah had sent someone by to talk to me about using the studio. He gladly offered to pay the low seventy-five dollars a month rent I paid for the entire loft. The timing was perfect, as I had no money to pay the rent and it was due. He took the studio, facing the street. I stayed in the side facing the river.

With my rent miraculously taken care of, my life went deeply inward. I hardly spoke for over a year. Many visitors came, sat in silence, and left. Sometimes I spoke, but mostly I did not. The unwritten rule seemed to be that I would not speak out of discomfort or fear of silence. I would speak only when I felt that somehow a compassionate word might help someone I was with. Fasting, silence, and reading defined my life for several years. I fasted for so many days one year that I thought I would just fade away.

Several years earlier, I knew the famed German actress and singer Lotte Lenya. She befriended me and helped me financially as a young artist. She also gave me gifts. She gave me an old recording that she had made; it was a reading of "The Hunger Artist." The story fascinated me. I didn't know if the main character was a fool or a saint. The story was about a man in the circus whose art form was fasting. Each day great numbers of people came to the cage where he was housed and looked at him as though he were a strange animal. In amazement, they read the sign out front that announced the number of days he had fasted. Eventually, people lost interest and stopped coming to see him. The sign in front of his cage fell down, the number of days he fasted was forgotten, and everyone just ceased to care about the man. Still fasting, he was reduced to a crumpled little heap, lost in the pile of straw on the floor of his cage. Although the world had forgotten him completely, he still believed in his art enough to continue fasting.

The story haunted me and stayed in my mind during the time when I was fasting so much. I wondered if I had received the recording because my lot in life was to be forgotten, and my story would become that of the hunger artist. I didn't know if I was giving myself to foolishness or saintliness. When we no longer use the world as a reference point, the tendency of the mind is to focus on little signs along the way that may offer guidance, especially in times of doubt.

That was how my inner life went while I was living in the Nyack loft, until one day a man appeared. He was carefully inspecting all aspects of our beautiful, yet old and run-down building. He wanted to buy it. The building was full of individual loft spaces used by artists as studios. A dance studio and yoga center were across the hall from me, and a bookstore and a pizza shop were downstairs on Broadway. Everyone in the building was a little nervous about a new person owning the building. He might change things! I think he was just a man wanting

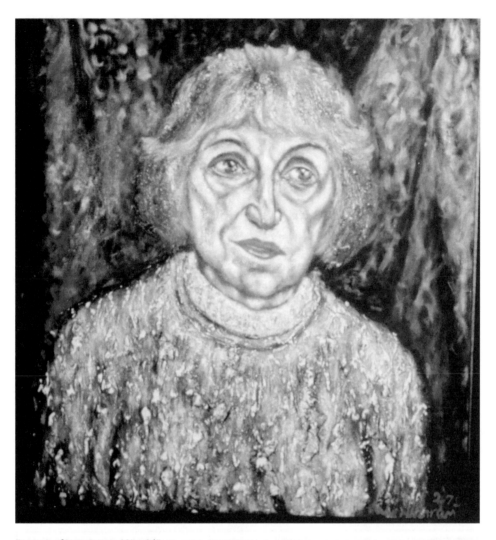

Portrait of Lotte Lenya. 32" x 24".

to buy a building, and he didn't know what he was getting into. He did finally purchase the building, and he assured people that he wasn't going to change a thing.

He was most interested in my beautiful space. I was the only tenant who lived in the building full-time. One day there came a knock on my door. It was the new landlord. He said, "You are going to have to leave. I would like to live in your space." I asked, "How soon do you want me to go?" He said, "As soon as possible." I inwardly said a prayer and walked straight out the door, leaving what little of my possessions remained. All hell broke loose in the building! Everyone thought he had thrown me out. I was gone so I knew nothing of the anger and conflict that followed. Everyone was just looking for a reason to pounce on him.

Now they had their "justifiable" reason! I ran into the new landlord shortly after this occurred, and he told me what had happened. He told me that he had been in a car accident, and he was sure it was related to the stress of dealing with the problems created by my leaving. He asked me to help, perhaps by talking to the others in the building. I came back and helped the poor man make the transition by talking to everyone on his behalf. I assured people that he did not throw me out and that he was really a nice person who had every right to buy the building. They could stay in the building if they would just work with him. It was strange to be comforting others about their housing problems when I was on the street.

That was the beginning of life in the arms of the open world. It was very difficult living this unsettled new life. But interestingly enough, I never spent a single night on the street in the many years I lived without money. Many wonderful people helped me. In retrospect, what I find most amazing is that most of the people who helped me told me that they felt guilty. They felt that I gave them more than they could give me in return! I never fully understood this, but it was of great comfort for me to hear this. Somehow, what I was able to give was enough. I was fully present with others, listening with an open heart. I was fully, unconditionally there for all who came into my life. I also added creative touches in the houses I stayed in. I did whatever I saw needed doing. I even learned to cook and became quite good at it.

At times in this twelve-year period, the world was not there for me, or me for it. At times, the physical world seemed to fail, and I failed it in return. My life was not about the world; it was about God. When I had to let go of something, it was always the world that was the first to go. I was not able to attach myself to any comfortable situation. I walked away from a situation if I thought it no longer served everyone involved. I never felt like my life and actions were so perfect that the world loved and helped me consistently. Sometimes people were threatened by what my life represented in relation to their own. They had a personal need to keep me and what I represented at a distance. The nature of the ego is to see only its own reality. Any other reality— certainly one as strange as my own—was seen as a threat. I understood the threat—I lived with it. As long as I did my own work in the area where that fear came up in me, I could forgive. It was hard at times to be so misunderstood. It is human nature to misunderstand what we most fear about the unknown, and we have all fallen into that small-minded trap. But when the world seemed most against me and all seemed lost, something would always come through, just as I needed it. I was saved by something larger than the imperfect details of a given situation. I could not save myself nor could I depend on anyone to save me. A third, unseen entity ultimately held my life in balance, and I came to rely on this as the only thing in my life that was at all constant.

I had accomplished so much in the past with my will, and I continued to struggle against surrendering that will. I once read that "the highest use of the will is to eliminate the will." When we transcend the will and trust unseen forces, we are held in the arms of the world.

Learning to Fly

I was helping a friend through a sad and painful divorce. He was moving to Florida, two thousand miles away. He begged me to come with him and help him through the difficult passage he was facing. I had no place to be that was very solidly in place, but I was not sure Florida was where I should be. Because he was so insistent, I finally said, "Yes." A few days earlier I had also been invited north to a home in the Catskill Mountains by the father of a teenaged boy who was alone most of the time because of another divorce. I had a special relationship with this boy and wanted to help and be there for him, but I was not sure that was what I should do either. While my friend took an afternoon nap in preparation for our drive to Florida, I babysat his grandchild, a sweet little boy named Jason, about five years old. We talked and played games while we waited for his grandfather to awaken.

While I tried hard to be fully present with Jason, internally I was distracted and torn as to where I should go. I had said I would go to Florida because my friend was so insistent. I had doubts, but I had decided to trust that insistence and go with him. It was difficult for me to say that I would do something and then change my position, but living the life I was living, I had to let go of absolutes. I could not pretend that I was in control. I had to constantly allow myself the possibility of an immediate change of direction. I felt that my life depended on it. I knew that if I made the correct choice within myself, everyone I was involved with would benefit as well. Feeling that I may not have made the correct choice, I was silently praying for guidance. Do I go north or do I go south? At one point, Jason looked at me very seriously, took my hand, and said, "Jerry, come with me." He wandered around a bit with me in tow. He didn't seem to know exactly where he was taking us. He finally headed for the parking lot. He directed me to sit down on the hot blacktop in the Indian summer sun. I did. Then he looked up quietly at a flock of geese flying overhead. He looked for a very long time. Then he said, "See those geese? They are flying north to lay their eggs."

I flew north to spend the winter in upstate New York and care for a young boy!

Big Don, Little John

I spent one cold and snowy winter living without power or water, heating only with a fireplace in a big drafty country house in a remote area of upstate New York. I was there at the request of my childhood friend Big Don, whose life was falling apart. He asked if I would take care of his fourteen-year-old son, Little John, for the winter while he spent most of his time down in the city working, in an attempt to pull his life together. When Don and I were younger, we had a special friendship. We grew up in the same neighborhood, and I always felt the need to take care of him, even though Don was older than me. Something about Don easily provoked my empathy. Once a man caught Don stealing something out of his car and punched him. When I saw his huge black eye, I embarrassed myself by crying. It is interesting. Even now I occasionally have dreams about Don. In my dreams, I try to keep him from harm. I often dream that Don is hurt or in trouble, and I wake up crying because I can't help him. One wonders about the karmic and deeper connections between people. Why do I have such dreams about some people and not others?

At this point, Don was living a reckless life. For a while he had everything going for him; he had a beautiful wife and son. He still owned the large house in the country with a glorious view of a beautiful stretch of the Catskill Mountains. But it looked like that, too, might be lost in the financial troubles he was having. Out in front of his house, Don had a special rock from which he could view his mountains. He often sat, royally, on this glacially placed rock. It was like a box office seat—the best seat in the house with the most perfect view. I was always touched to see him wander out at dusk and sit quietly on his rock until the sun disappeared. Sometimes he sat out there after dark, looking at the astounding display of stars, which you can't see much of in the towns and cities. Don was a loner, even as a child, and he was always an outlaw. He was a civilized outlaw, however, which is why I liked him. He was kind of a lovable Jessie James.

A young street punk once crossed Don by stealing something out of his van. Don found out who did it in short order. The young man knew that he had been found out, and the stolen items reappeared immediately. Shortly after that, Don took me to lunch at the local bar. When we walked into the bar, the thief was sitting at a table having lunch. He looked up as we walked in and when he saw Don, he froze. I was not sure what was going to happen. Don had heard that the man was trying to buy a hot dog stand to start his own business, but had no money. About the moment I thought that the poor man was going to faint or die of

fright, Don walked up to him and said, "I heard you were looking for a hot dog stand. I found one for you. Let me help you out and buy it for you until you can get back on your feet again." The man looked as though he were going to cry. Don had a big heart, and people generally loved him for it.

Early in his life, Don got involved with some fringy organized crime people. He was into cocaine, both using and dealing, and a variety of other illegal activities. Most of the people he hung out with were involved as well. People around Don were beginning to disappear. He was warned by someone higher up to steer clear of certain people, and he was told to watch his back.

Don was told to kill a fellow wrongdoer who had upset the wrong person. By the rules and arrangements of the game, "he deserved to get whacked." Everything required to carry out the hit was put carefully in place, and most of the fifty thousand dollars of blood money was advanced to Don and was warming his pockets. But Don faltered; he could not murder a fellow human being. All things considered, when he told me this story, I felt strangely proud of him. This was undoubtedly Don's lowest point as a human being. It was probably also the point where he had the most to gain within the ranks of his criminal network if he could have carried out the orders. He could not kill, not even in the despair and drug-fog of his present condition. His big, sensitive heart was not cut out for the business of murder. But by returning the money and attempting to walk away, he'd placed himself in the path of trouble.

I knew Don's Italian boss, Tony, and never really trusted his friendly, I-can-give-you-the-world generosity. Everything had a hidden price with him, and he could spot need or greed like a predatory bird can spot a mouse a hundred yards away. Whenever I saw him, I felt that he was trying to hook me. He knew I was important in Don's life, and he wanted power over me too. He knew I was an artist, and he tried to use that to hook me. One day he told me he had "found" a truckload of art supplies and asked if I was interested in taking some of them off his hands. Another time, he said he had "found" some paintings by some famous guy. Unable to remember the artist's name, he proceeded to describe the paintings in the most comical way. He described them well enough for me to figure out who the artist was. I said, "You mean Picasso?" "Yeah, dat's da guy. I got som-a his paint-ins I picked up. Maybe you wanna see dem, see what you can do wit' dem?" I just smiled and said, "Maybe," but I never took him up on his offers. I knew that wanting anything at all from Tony was the equivalent of handing him your soul.

Don was enamored with Tony, and as a result, Tony held a piece of Don's soul hostage. Don was very much under his influence and emulated his ways. The *Godfather* movies made

it very fashionable to associate with mob guys at that time. Don loved to talk about Tony and tell the stories that only insiders knew. Tony went to jail a few times, and while there he learned to play bridge very well; no one could beat him. Don told me that Tony would go to the bridge parties at the various halls and senior gatherings in the Bronx and hustle the little old ladies. He played bridge so well that he walked off with all of their money.

Don was trying to pull away from Tony, but since he worked for Tony, he was losing everything in this separation. It got progressively worse as the winter wore on. Don could no longer afford his beautiful house, and he hardly had money enough to maintain his car so he could make the long drive back down to the city to work. He had done something illegal with the power company, and they shut off the power to his house. This meant that the pump that brought the water to the house no longer worked. These were the conditions under which I spent the winter at his house, looking after his magical son Little John.

One day, shortly after I arrived at Don's house, he seemed worried. He kept walking over to the window and looking out to see if someone was coming. Finally I said, "Don, what's wrong? What's going on?" He said, "It's Tony, he's pissed at me." I asked what he had done to make Tony mad. It didn't seem to be anything very significant. Don had taken a small thing that he probably shouldn't have taken, but I sensed that it was more than that. There was an underlying power struggle going on between Don and Tony. Tony took it personally that Don was trying to pull away from him. I said to Don, "Look, it's your life and you can do what you like with it. I think it is good that you're getting away from Tony. Your life is a mess, while he takes everything for himself and lives in luxury." It was clear that Don was scared, and I was feeling angry with Tony. He was a petty tyrant who lorded it over people.

Later that afternoon, a big black Lincoln Continental pulled into the driveway. It was Tony, with his wife and oldest daughter. Don warned me not to say anything about their conflict as I went out to greet Tony and his family. I said, "Hi Tony, have you come up to spend a beautiful day in the country with your family?" He said, "Yeah, I got some business with Don so I thought I'd come up with the family." Finally Don came out, but stood some distance away by the side of the house. I walked over to Don to see how he was doing, as Tony and his wife and daughter wandered around the yard and talked about the beautiful view. Don seemed very scared and nervous, while Tony huffed around the yard like an old alley cat establishing his territory. At one point, Tony walked over and stood on Don's special rock. A ferocious surge of energy awakened inside of me. Don saw the shift in me and said, "Don't do it, Jerry. He'll kill you!" When I hollered, "Hey, Tony, come here!" Don literally ran away! He ran off into the surrounding wooded area and disappeared.

Tony was standing about a hundred feet away on Don's rock. He looked at me angrily as he jumped down and walked over to me. As he approached, I said, "Who in the hell do you think you are, pulling in here with your big Lincoln Continental, acting like you own the damned place? Don can't even afford the gas it takes to go down to the city to work for you, and you come up here flaunting your wealth! So what if he took a little piece for himself? Look how much you take that is not yours! Don loves and respects you. Why do you treat him like this?" Then I quickly put on my best innocent face and waited for his answer.

Tony just glared at me, speechless. I wasn't sure which way things would go. His face was red, and he looked extremely angry at me. I had seriously violated the rules of respect, and I did it in front of his wife and daughter, who were standing by his side. I immediately felt the emotional support of the two women. They felt my love for Don and realized I had risked everything for him. Tony was looking pretty selfish from the women's point of view, after what I had said about him. They glared at Tony, waiting for his answer right along with me.

Tony faltered, saying, "I don't own this car; it's a lease. It belongs to the company." (He owned the company.) "Hey look, Don is family. I love the guy. But he shouldn't have crossed me." I said, "Yes, he shouldn't have, but you know we all have to take care of each other. Life's too short." And then I joked, "especially in your neighborhood!" He laughed proudly. I had won him over! I smiled mischievously to hide the fact that I was shaking in my boots. The women became very animated with the energy that had been released. They showered me with their kind attention and talked nervously.

Tony never did have his talk with Don that day. Later, as Tony drove down the driveway to head back to the city with his family, they passed me walking up. Tony stuck his head out the window and said, "You're one crazy son of a bitch, ain't you?" He laughed uproariously as his Continental spun out, and then he drove off down the road.

Later, I walked into the local pub, knowing I would find Don there. He was sitting at the bar, hunched over his beer. He turned as I came in and said, "You are *one crazy son of a bitch!*" That seemed to be the term of endearment of the day for me. I had the feeling that they were both happy to have things resolved and forgiven, so I didn't mind being the catalyst. Don and I had a beer and laughed about the whole thing. But our laughter was a little more nervous than it might have been under ordinary circumstances. After that event, Tony's omnipotent power came undone in Don's eyes. They stayed friendly, but Don eventually found other work and disassociated from Tony for the most part.

I stayed on, taking care of Big Don's son for the remainder of the winter. Don came up from the city only on occasional weekends, so Little John and I were alone for most of the

winter. Little John and I were still getting to know each other. I felt I was slowly establishing his trust and cultivating a deep friendship. One day Little John's mother came up from the city to spend the day with us. She and Don had been divorced for several years. Now that they were no longer together and didn't expect anything from each other, they seemed able to spend time together quite easily.

The four of us went out rather early in the morning to spend the warm, winter Sunday together. It was a strange and magical day. As we drove by a beautiful, old, classic New England church, I saw that a service was just beginning and the last of the people were making their way inside. I said, "Hey, let's go to church." There were objections and excuses, mostly having to do with their present attire, but I convinced them to stop and go into the church with me. We were all wearing street clothes. Little John had on torn jeans, and his shoes of choice that winter were big leather boots. Little John was not so little. He was actually big for his age, and very strong and healthy. The church doors were closed by the time we turned the car around and parked. When we entered, the church was quite full. I noticed the minister eyeing us as we walked in, perhaps with a little judgment, I thought, but I was not sure, so I gave him the benefit of the doubt. As strangers to the church, I think we all felt a little self-conscious entering the aisle to sit down. The church was very quiet, and we made a good deal of noise walking on the creaky floors as we made our way to our seats. Just as we were about to sit down, Little John, who was not fully awake yet, tripped and went crashing into the pew, causing several of us to crash with him. The pew, and all the people on it, rocked and made a huge noise, which caused everyone to turn around and look at us. To make matters worse, Big Don reacted to the crash with a loud, "Jeeesus! Look-a-dis-kid-will-ya!" At that point, a Down's syndrome child in the congregation stood up and began clapping, as if the clowns had just walked onstage and taken their bow. His mother unsuccessfully attempted to quiet the child, but could not. Feeling like a bunch of bungling idiots, we had to laugh at ourselves and the ridiculousness of the situation. I had been well-intentioned, dragging everyone to church that day, and I felt on good speaking terms with my God, so I just sat back, happy that we were all there together.

When things finally settled down, the sermon began. The minister started by talking about hopeless, lost sinners who come creeping in darkness into the backs of churches, fearing the brightness of the light of day. (It was dark in the church, and we *were* in the back.) Sinners— unclean, and in need of salvation. He went on to say that he could not help these poor sinners. He could do nothing to save their poor wrenched souls, but perhaps Jesus might show mercy on them and cleanse their sins away. The minister was beginning to bug me. I thought, "Look, Jack! I'd be willing to bet my bottom dollar that I have given as much of my life to establish a

relationship with God as you have. How-the-hell pure and holy do you think you are anyway?" But we sat and behaved ourselves as the service continued, we four wretched sinners.

Then suddenly, the Down's child slipped out of the grasp of his mother's hand, jumped up, and ran to the front of the church. He stood in front of the pulpit where "god" in heaven was giving his sermon, and began mocking the minister's every gesture in the most exaggerated and comical way. The pompous minister was very theatrical to begin with, and as the child exaggerated his gestures, he looked ridiculous. I understood why the kings of old gave court jesters free rein within the royal kingdom. The gods seem to laugh at all of us at times, and any smart king would have known enough to participate in the laughter of the cosmic joke.

Despite every attempt to control themselves, and in spite of whispered reprimands and repressed giggles from the adults, some of the children in the congregation began to laugh at the antics of the Down's child. When the child's mother attempted to retrieve him, the minister stopped her. He held up his hand with great bravado and said, "No ma'am, I am okay. This is a child of God and he is welcome in my church!" Then the flustered minister continued with his sermon, but it headed seriously downhill from there. The Down's child rode the sermon right into the ground, dragging the poor man behind.

Having drained the sermon of its seriousness, leaving it in puddles on the floor, the holy child went back to his seat. Our inspired, protective ally now offstage, we crept out the back door of the church. People were so focused on and embarrassed for the preacher that no one even heard us creak the floorboards as we left, sins intact. Bestowed with the blessings of the holy Down's child, I felt that we inadvertently walked off with the horded blessings of that stingy old church.

We made uneventful stops at two more rather sleepy churches that day. Our final stop was at a little storefront Baptist church. It was the simplest and most beautiful service of the day. I loved the way the service carried the group energy. It was a snappy, lively service, with people moving their bodies and clapping their hands. People from the congregation spoke out spontaneously and perfectly in order. The things said and the songs offered began to formulate a living poem. This continued to build almost systematically with each new, inspired contribution. The deep poetic meaning behind the words created an unseen body that you could feel as it began to lift off the ground. By the time the service ended, we were, as a whole, off and flying!

When we were through making our spontaneous pilgrimage to the churches, we ended our morning with a hike at a beautiful state park in the Catskill Mountains. Little John and I

seemed to gravitate toward each other's happy company. I had the feeling that his mother felt guilty about not seeing her son very much and was threatened by our natural, easy closeness. All that day she attempted to control him in ways that I felt were more about power than about a real and healthy connection. She loved her son, that was clear, but due to the circumstances of their lives, she could not be with him very much. We parked the car and walked down a steep hill toward the park's trailhead. To the right of where we walked was a four-foot-high wall with strips of metal mounted into the cement on top, spaced about four feet apart. I thought that they were probably placed there as a safety feature to keep people from climbing or walking on the wall. Just on the other side of the wall was a hundred-foot drop-off, sculpted out of the granite by the river below. As we were walking, Little John jumped up onto the wall, and everyone froze.

Little John looked mischievously at me. I had been his partner in crime and daring all that day, and I could see he wanted to know if I was in on this outrageous caper as well. I made a quick assessment and felt that he was attentive to the dangers and in control. It was a risk, but I chose to trust his sense of things. I loved his outrageous break for freedom, above and away from the petty world on the ground! I jumped right up there with him, and we began running the length of the wall, hooting and hollering and jumping over the metal dividers as we went! We ignored the yelling of park ranger and parents alike. It was worth the risk. When the length of wall ran out, and Little John and I jumped down, we were exhilarated, bonded, and laughing nervously at the dangerous and defiant act we had just pulled off. We continued running into the woods to avoid getting reprimanded by the park ranger.

Little John and I spent a magical winter together in that big cold country home, and we did it without electricity and running water. We showered and drew water from a neighboring summer home that belonged to a relative of Don's. Little John left on the school bus every morning and I cut wood, kept the house warm, and prepared food for when he got home. I was even able to bake bread in the beautiful and functional brick oven built into the fireplace. The fireplace and oven had been built in classic Italian style by a tiny Italian man whose claim to fame was that he had worked on the restoration of the Tower of Pisa to keep it from falling over. Whenever someone noticed the bread oven, the story was told that every day for lunch the little Italian man ate an entire quarter pound of butter. He would slice the butter and put it on crackers as one normally would with cheese.

That winter in upstate New York was probably the most physically demanding winter I ever spent anywhere. But the gifts of that winter were equal to the difficulty. I experienced

some of the most beautiful and magical times I ever spent with a young person. We spent our nights and free days sitting in front of the constant, essential fire, talking and staring into the glowing coals. In the fire we saw images that were poetically related to the things we talked about. It was as if our conversations were divinely directed through fire, smoke, and imagination. Conversation seemed to emerge from the images we saw in the ashes and the glowing embers of the fire. We experienced pure grace, sacredness, and deep sharing, safe and warm before the fire, as the cold winter snow blew just outside our window. The fire was our crystal ball, and the synchronicities of conversation and imagery were miraculous. We talked mostly about God and the mystery that surrounds us.

I couldn't wait for each difficult day of gathering wood and carrying water to end, so we could meet in the evening and once again share before the fire. The stories of our magical times began to leak out to other members of Don's family, and others wanted to join in. One of Little John's cousins came to spend a week or two with us. Tessa was sixteen. She had gotten into trouble down in the city using drugs and stealing, and she was thrown out of school. Her parents sent her to the country in the hopes that we might help straighten her out. I falsely prided myself on seeing the good and the magic in people, but I was humbled and completely at my wits' end trying to connect with Tessa! You could not believe a single thing she said. She complained constantly about everything, smoking and pouting the entire time. Little John really loved her and did everything he could to make her happy. The only joy she expressed toward anyone was purely out of manipulation. She was a very bright child who could manipulate anyone. By the time her victim figured out what was really going on, Tessa already had what she wanted. This was often a forbidden pack of cigarettes or a secret, long, expensive phone call to the city.

In very short order, I was praying to God to show me what this child was all about, because I had no idea. I found everything about her to be impossible. By the time the second week of her stay with us rolled around, I was all but ready to give up on her. I felt defeated and frustrated. Little John and I felt that our magical nights before the fire were being absorbed into her constant, smoke-filled bad attitude.

As her first week with us wound down, her father came up with Don for the weekend, to see how Tessa was doing. He ended up spending most of the weekend out somewhere with Don. On Saturday night, Don and Tessa's father went out. Little John, Tessa, and I sat quietly in the dark, watching the fire, when something shifted. I felt it and saw it immediately in Tessa. She was almost glowing. Little John picked up on the shift as well and began to make nervous jokes about Tessa. Tessa remained unshaken by the joking, but I sensed something important

in the shift and asked John to stop bothering her. I wanted to give space to whatever was going on for her.

Tessa began speaking in a very dreamy and poetic way. She talked about different planets and how people lived on them. She talked about happy, normal, and scary planets, and what kind of people lived there. At one point, Little John, half in jest, asked her what planet I lived on. Without skipping a beat, she said, "Jerry lives on a planet surrounded by water, with many nice people who wear flip-flops." She even mentioned the first name of a friend of mine, and said that this friend lived on my planet. (This person now resides on Whidbey Island, where I live.) She went on talking in a low voice, making unusual and wise sense. The intense gravity and focus with which she spoke demanded the same from her listeners. I believe that is why Little John was uneasy and agitated. He couldn't meet the demands of Tessa's newfound powerful focus.

I had to let go of all my limiting ideas about who I thought she was. I sat mesmerized, as if at the feet of a strange and mysterious wise woman. I was willing to give her whatever attention she required to help hold her wonderful presence. I took in what she was saying like a welcome poetic flood of deep, channeled truth. Occasionally I had to quiet the remarks Little John was making. At one point he said angrily, "*What* are you talking about? She's just faking." Tessa never flinched; she just kept up her clear, innocent stream of consciousness. Finally, at the end of this unusual and surprising evening, she said, "Daddy's coming home now, somebody just ate a worm." Little John once again said, "Tessa you're crazy! What are you talking about?" Tessa then snapped out of her altered state and just beamed a smile, pleased and energized by where she had just been. I hugged her and told her that she was a true poet, and that she should write her poems down because they were incredibly beautiful and deeply moving. I said, "Tessa, that poet is who you are."

Tessa and Little John continued sitting on the couch, chatting and giggling, and I stared into the fire thinking about the astounding things Tessa had said. Soon we heard a shuffling at the door, and her father and Don walked in. As he came in the door, Tessa's father said, "You wouldn't believe what this guy just did at the bar. He ate a worm!" Apparently some bottles of good-quality tequila come with a worm in the bottom, and a Mexican tradition requires the person who empties the bottle to eat the worm.

I had made the mistake of limiting Tessa to her rebellious teenage behavior. I humbly had to accept the fact that this world is far too mysterious for my own limiting ideas about correct behavior. If God decides to show up in the disguise of a rebellious, annoying teenager, it was not for me to judge. That evening established a wonderful, respectful connection with Tessa for which I was grateful.

Late one afternoon when Tessa was still with us, a shiny black Volvo pulled into the yard. It drove right up on the lawn and into the view from the large living room windows. It appeared that this driver desired to be seen and was willing to eclipse the view of the beautiful mountains to accomplish that. The car sat for a minute, the door popped open, and no one got out. Little John said, "That's Suzy." After a short while, I went out to the car to greet her. I had dated Suzy years earlier, when we were in our teens, but I had not seen her for many years. She was currently a friend of Don's. Suzy was drunk and asleep on the folded-down car seat with a large and nearly empty bottle of wine next to her. She had driven the hundred-plus miles from the city drunk. After about an hour, she came into the house. I made her coffee, and we sat around and talked for a little while before I started dinner. She had come up to spend the weekend away from a life that was getting progressively more difficult. I welcomed her and told her that Don was not there, but she was free to stay with us if she liked.

Suzy was a tall, thin, attractive woman. She had a job as a public relations person for a large corporation. Her job required that she take important clients out to lunch, wining and dining them, to interest them in doing business with her company. I gathered from what she said that the amount of drinking that went on at the luncheons was an occupational hazard. Suzy spent the night and the next day, and it proved to be an interesting visit all around. As the following day began to get dark, John, Tessa, Suzy, and I independently gravitated toward the warmth of the fireplace, and ended up sitting on the couch in front of the fire together. Somehow an old stethoscope appeared, and the children tested me to see if I could control my heart rate. They were impressed when they thought my heart rate slowed, but I don't believe that it actually did.

At one point in our game, Little John said, "Jerry, you be the doctor!" I said, "Okay" and took the stethoscope. I had been stalking the opportunity to talk more to Suzy about her drinking and perhaps go a little deeper into the reasons behind her excess. I plugged the stethoscope in my ears and placed the sensor on Suzy's head, saying, "Hmmm, Suzy drinks too much. We are going to have to fix that for her, I think." Suzy began to cry, and I felt a deep compassion for her. I continued to intuit my way while she was emotionally open. There was a mason jar sitting on the coffee table. I said, "Alcohol is poison. We need some stronger poison to counteract the power it has over Suzy." I picked up the jar and said, "Let's find some poison things to put in this jar." The children searched the house excitedly for things to put in the jar. They came back with nail polish remover, bleach, motor oil, mayonnaise, drain cleaner, cornflakes, cleanser, and more. We threw them all in. Little John and Tessa made strange faces and said how disgusting it all looked with each additional ingredient. Suzy's lipstick was the

final ingredient. As I threw it in the jar, I said, "This will keep the poison from passing by Suzy's lips." Suzy wept quietly as she watched.

I put the lid on the jar and shook it all up. Then I took the lid off and let everyone smell the poisonous mixture. I said, "What do we do with it now?" Tessa said, "Drink it!" Then Little John said, "Yeah, you're the doctor, you have to drink it if you want to fix Suzy!" I had just read about a Hindu mystic who ate red-hot nails when he was told to. I felt that something was unfolding that was very important to Suzy's healing process. There was amazing emotional energy around this game we were playing. With a racing heart, I closed my eyes, silently said a prayer, and held the jar up to my lips. Just as the liquid touched my lips, Little John grabbed it away and wiped my mouth with his shirtsleeve. He said, "Let's bury it." With great enthusiasm for this interesting adventure, we all filed out the door, found a shovel, and buried the jar. We agreed to keep the sacred burial location of our noxious, dark treasure a secret. We would use the memory of this event and this place as a powerful prayer for Suzy to draw on whenever she needed help with her drinking problem. We agreed to send her our love whenever we thought of her, this spot, and this day.

The gray winter had given way to the early spring sunshine, which was beginning to warm up the cold air. Spring was just around the corner, and our beautiful, hard-earned winter together was coming to a close.

Little John missed his father. As close as we had become, he needed his dad, not me. I was so different from Don and his friends, both in my beliefs and in the way I chose to live my life. I think Little John felt torn between the two extremely different worlds. He felt equal gravitational pull from both directions, and he was confused. I wasn't sure my world would win out, or whether it should, for that matter. It was his life, and he ultimately needed to go with the most alluring influences he was offered, conscious or unconscious, choosing or not choosing. As much as I wanted somehow to save him, I knew I could not. Even if I had thought I could, I wouldn't have known how.

He knew I was leaving soon, and he felt the need to disconnect from me. In an attempt to be more like Don, he began pushing against me and what I stood for. He needed to explore other possibilities now that I was leaving. I had spoken so much about the magic and the grace in life, and he had seen much of this mystery unfold himself. I was often the one to make the connections, but he had his own sense of the mystery and would often point out a poetic moment that I had not noticed. He was in an interesting and hard place in relation to his father and me.

One day, Don quietly crept out of the house to go somewhere without Little John. Don didn't want to take him because Little John had been more demanding than usual. Little John

heard the car start and ran out, just as his father drove off. He ran after the car but couldn't catch up, and he returned to the house crying. I wanted to help him, but he didn't need me at that point. Decidedly, he had had enough of me.

The following morning, he woke up in a determined, rebellious, and dark mood. I could do nothing right and certainly could do nothing to help him. I watched with curiosity, trying to figure out what was going on for him. Not knowing, I gave him all the space he needed. Everything went wrong for Little John that day. At one point, he threw a stone angrily at a tree, and it bounced back and hit him in the shin. It was as if he had been completely disempowered by his own rebelliousness. By the end of the day, he was in tears. Later that night, as we sat by the fire, he requested a head rub. This was a comforting family tradition for him, something he would ask of his mother. As I sat stroking his head, he told me what had been going on for him that day. He said that he was not sure there even *was* a God, and he had decided to make a conscious effort to shut God out. He wanted to be like his father. He was tired of me talking about God, and he didn't think my life had enough physical benefits. I didn't own anything, and he wanted to own things. In his small way, he tried to prove that there was no reality to God by pushing against his own experience of the mystery. Apparently it didn't work. He told me that his entire day went wrong. Everything he tried to do did not work out. He felt bottled up and ineffective with every attempt to be in full control of his life. He kept getting angrier and angrier, until by the end of the day, he was in tears. Now he said that he knew there was a God, and he was "stupid" to think otherwise. I assured him that he could create any kind of life he liked and he could do it with God. I also told him I would be in his life as long as he wanted me there, but that I had to go away now.

This event created a deep and lasting connection between us. He is now in his thirties, and although he lives a chaotic life, he stays in touch with me. He calls or writes me at the most sensitive junctures of his life and continues to tell me that that winter was the most important time of his life. He tells me that he needs to spend time with me so that he can be put back in touch with that sensitivity. The wonderful thing is that it is not me that puts him back in touch. It seems to happen even before he contacts me. By the time he contacts me, he has already made his return to center. He calls to report to a comrade. He has his own pull in that direction, which I believe came out of his defeat when he wrestled with his own, unseen angel that difficult, culminating day. The sensitivity to God that he established at that rebellious moment remains fixed, appearing in his life in a cyclical, timely way. He depends on it, and it comes through when all else fails. Our time together that long winter remains a precious and holy secret between us now. We meet there as longtime friends, humble and not knowing, even if

only through a silent moment over the telephone. We trust each other at the deepest level because of what we *don't* know about what we share together.

I have told this story many times to parents who come to me for advice about difficulties with their teenage children. My wife and I don't have children, so I don't know much about raising them. This story is all I have to offer by way of advice and all I have to go on as a template for successful relations with young people. My advice boils down to this: *Be a living relationship to your own mystery, and your children will do the same.* They will absorb this relationship into their body memory naturally. A relationship with God does not need to be an external demonstration. If we persist in pushing the idea of God, our ideas will turn into nothing more than well-intended propaganda. Living spirituality is not an overt lesson in god-liness. It has to be lived naturally in the most commonplace, indigenous regions of daily life. It is the one transmission we cannot impose or pretend into existence. For the most part, if it is not alive and well in our own lives, it will not come alive in our children's lives. Children will see what is there, real or unreal. They naturally love what those around them love, if it resonates with the deep nature of their souls.

Maya

Maya, as defined by the Hindus, translates as *illusion*. The Hindus believe this world is all Maya. When Maya entered my life, she brought everything that is most challenging about the external world with her. I did not know it at the time, but I was spending my last days as a painter in the studio when she came into my life. My friend Deborah dropped by one day to see me, and said she had just met an Indian woman by the name of Maya. She said that there was something very beautiful about Maya, yet also something lost and disturbing. She went on to talk about Maya's unusual, intense energy. Deborah seemed to think I could help the woman, and asked if she could bring her by to meet me. I said, "Yes."

Deborah returned the same day with Maya and another woman. Both were in their early fifties and were surrounded by a feeling of death. I had just finished a large painting that had a strange face looking out from its center. When Maya walked in the door, I knew it was the face that I had just painted. She walked straight up to the painting and stared at the face.

The two women were extreme in their inability to stay focused. They both talked at the same time. Maya tried too hard to please. She tried to say all the right things, but she had a strange, forced, yet elegant style. The other woman avoided all attention, moving and talking mindlessly. She literally hid her thin, toothless face behind her hands when I looked at her. They were both quite distracted. I felt that the newness of the situation they were in, combined with their personal discomfort, was causing them to spin out of control. I knew I had to do something fast, or the moment would be irretrievably lost in chaos.

I don't know how to describe exactly what I did. I think I mostly survived. I focused all my attention on Maya first. I reached out with all the will I had available. I overwhelmed her chaos with a barrage of willful, focused love and kind words. With this attention, she visibly calmed down. I felt as though I then reeled her into the safety of my own center. Nearly exhausted, I turned to the other woman. Abandoned by Maya, she cowered in the corner like a strange and pitiful skeleton hiding from the light. When I spoke to her, she quite literally flew out of the studio, flailing her arms as she went.

A few days later, Maya told me that her friend had died. I never knew her name. Death seemed to surround Maya when I met her. She told me that when she arrived at the woman's dingy apartment, shortly after the three of us met, her friend was lying dead on the bed. Someone who claimed to be the woman's relative was going through her scant belongings. As this person was leaving, she cursed the dead woman for being penniless. Then she told Maya to "dress her and make her naked body decent." Maya was terrified of death. Dressing the woman was a horror for her, but she did what she was told. Maya carried an inexpressible burden.

Shortly after I met Maya, Deborah arranged to pick me up in her car to bring me to Maya's house for the first time. Deborah arrived late and in a rush. Maya had invited us over to talk about her difficult life and about something in particular that was troubling her. I felt fine when we left my place, but as we drove to her house, I started feeling a heaviness that did not make sense. When we arrived at Maya's apartment house, Deborah parked the car in the alley and rushed into the meeting with Maya, for which we were late. The heaviness was so overwhelming that I could only sit completely still and let it run through me. I sat there for well over an hour. I felt that it had something to do with Maya. At one point, I saw through the corner of my eye that someone was looking in the car at me. I could not even break my focus long enough to acknowledge them or see who it was.

By the time Deborah returned, I was just beginning to feel that something had shifted. I explained to Deborah why I had not come upstairs, and I asked her what happened with Maya. She told me that the moment she walked in the door, Maya broke down, and that she cried

the entire time Deborah was there. Deborah said that it felt like a huge burden had been lifted off Maya's shoulders. I still don't fully understand what happened there, but I knew that Maya was in my life. I committed myself to helping her, and I felt that the process had already begun in its own way. Maya wanted every minute of time I could give to her, mostly because she feared being alone. I gave her all of the time that seemed helpful to her process, but I also had to draw limits.

My connection to Paramahansa Yogananda (Ananda) also sealed my commitment to Maya. I had been studying his teachings for many years before I met her. I loved his story and I longed for a link to his spiritual tradition. When I went to Maya's house for the first time, she had several pictures of Ananda on her walls. I asked her about them, and she said that he was her parents' guru. Her family visited his compound in India every summer as she grew up. She particularly liked the goldfish in his large fishpond. She told me that Ananda called them up to the surface by clapping his hands. The fish appeared to be petted and fed. Ananda occasionally asked Maya to pet the fish with him, but she never would. I had the feeling that she was a little afraid of this great man. I am sure her mind was agitated and uncontrollable even then. She had amazing, agitated mental energy. It was so intense that it was difficult for me not to be swallowed up by it. Even though her life had been reduced to chaos, a powerful energy still ran through her.

Maya was not what I had in mind when I prayed for a link to Paramhansa Yogananda. However, I honored what I was given. I thought it was interesting that my close friend Deborah was leaving for India to visit a very great teacher, and I was here with the namesake of India's word for illusion, who seemed to be the very embodiment of illusion. I felt it was all too perfect to be accidental.

Maya was an only child. She grew up wealthy, spending her time between India and New York City. Her mother had a high-ranking position with the United Nations, and her father was a medical doctor. Maya spent her days socializing, and she had an air of refinement about her. She never had to do anything that she did not want to do. She had clearly been a very spoiled child. However, her world crumbled when both of her parents died within a short period of time. Maya was alone with each of them as they died. Her father had a stroke in the bathtub and called to Maya. Naked and convulsing, he looked into her eyes as he died in the tub. She found her mother dying on the couch shortly afterward; she, too, had had a stroke. I believe that this is where Maya began her frantic run from anything that looked like death. She raced toward anything she thought was life. The result was that she found death at every turn. Accepting Maya into my life was like accepting the illusion of death. She gave me the opportunity to confront my fears on a regular basis. I now know that meeting Maya was a precursor to the death I was about to experience—the death of my personal world as I knew it.

Maya was like a child in many ways. After her parents died, she inherited their fortune. She knew nothing of the harsh realities of the world, and she certainly didn't know how to handle money. In her run toward "life," she hosted huge, expensive social gatherings. Relatives borrowed money from her and did not repay her. She could not stand to be away from a party atmosphere, so she bought friends and activities. In a very short time she was penniless, homeless, and abandoned by everyone. The only remnants of the high life she had once known were a stack of beautiful silk saris that had belonged to her mother and an unusually heavy gold bracelet that she wore constantly. The bracelet had been put onto her wrist as a young woman and could not be taken off. Her clothes were ragged and she lived off of Social Services in a run-down, roach-infested old apartment building.

Terrified, Maya believed that everything around her died, and it did. People avoided her, and I understood why. She had an extremely agitated, uncontrollable persona. Her fear of death was unconsciously unloaded onto whomever she was with. It was clear to me that she could not do otherwise. This aspect of her personality is the most difficult to explain. I have never known anyone quite like her. She made people dislike being around her. An invisible character in the epic Hindu tale *The Ramayana* killed by shooting invisible arrows. That skill was solidly in place in Maya's self-destructive unconscious. It was as though her ego was saying, "If someone has to die, it will have to be you, not me." I believe that Maya's extreme fear of death caused her to express herself in a way that felt like a deathblow to those around her. When someone acted out of his or her own small human weakness, Maya delivered her deathblow and then was as shocked as the other person at what she had done. The look in her eyes almost said, "I know I just did damage, but please don't abandon me." Then she would become overaccommodating.

I don't know if I can explain what she did any better than this. I felt the sting of that moment more than once, and I ultimately saw it as my own error. I knew that she had a hair-trigger response and was unable to control herself. She taught me to stay out of the way and to be present and attentive. Because of the damage she did, she was pitifully lonely. I was determined to remain her friend. As I stayed with her process and continued to care about her, I was able to watch that destructive edge soften over time.

After I destroyed my art and changed my life, Maya's house became a gathering place. I met with small groups there when people wanted my help or just wanted to talk. There, Maya drew death to her door once more. One day a new person arrived at one of these gatherings. She said she wanted to meet with me. She had cancer and was dying. She did not want to suffer the inevitable end that she had imagined; she wanted to die her own way. So she asked her friends to contribute any leftover barbiturates they might have sitting in their medicine

cabinets. She wanted to make her death a ritual transition. Maya was very upset and frightened about this and didn't want to be near the woman or her death. I insisted that the woman be allowed to come to the gatherings. A short while later, the woman carried out her own death. Maya would not even talk about it.

One day I heard that Maya was in the hospital. She had had a stroke and was in a coma. I went to the hospital to see her. The nurses eyed me strangely when I asked about her. Obviously, I didn't look like a relative. Maya was dark-skinned, short, and round. I think that they were wondering what my connection was to this mystery woman. I convinced them that I was a good friend who had come to see her and bring her flowers. Finally they allowed me into her room. There were no other visitors. I sat beside her. She was more still than I had ever seen her. My heart went out to her. She had suffered so much in the latter half of her life. Through a stroke, she finally had found a way to rest, here in the intensive care unit of the hospital. I was in a very quiet place as I sat there listening to her breathing, thinking about her sad and lonely life.

At one point, I thought, "Maya, do you just want to die and leave this sad life of yours?" Agitated, she immediately stirred and turned her body over, facing me with wide eyes! Then she closed her eyes again. Her movement startled me. I thought the moment was funny and knew by her response that she was not through here yet! She did awaken a day or two later. After her stroke, she was given subsidized housing in quite a nice housing complex. The edge was off of her intensity after the stroke. She lived out several more years of a tired but more peaceful life.

Black Luminous

Winter was coming; it was getting colder. The year before, I had given my gloves to an old black man by the name of Lester. Lester lived in the building next door, on the same floor as mine, so our windows were at the same level. Our view was the same, but we looked out onto different worlds. When Lester and I saw each other on the street, we greeted one another and smiled. I liked Lester and I had a sense that he liked me, but we never knew quite what to say as we passed on the street or met at the entrance to our buildings. From the dining area of my loft, I could hear Lester singing the blues through the wall as he splashed in his morning bath. Sometimes I heard him fighting with Louise, his wife. They were a sad and beautiful combination of characteristics. Lester and Louise looked alike, and appeared to be in their late sixties.

They both had the unusual look of the Kalahari Bushmen—androgynous, with short, beady hair and pinched, smiley faces.

I was fascinated by the lidless garbage can that Lester set out in front of his building each week. It was always filled to the brim with empty gin bottles and discarded cigarette packs. Somehow, I admired the fact that he did not attempt to hide this from the world. I thought most of us probably would have. Lester and Louise sat in their upper-story window, drinking and smoking, every day, it seemed. Their window looked out onto the street below, and Lester called out to the people he knew as they passed by. I was often touched by the warmth and love I heard in his gravelly old voice as he acknowledged and insulted his friends.

Like deities looking out from the upper realms of a crumbling old Tibetan tonka, Louise and Lester sat three stories up, blessing those on the streets below with their loving attention. As people in the community passed by, they often looked up to Louise and Lester's window to see if they were holding court that day. They were there together for many years.

One day I realized I had not seen Louise for several weeks. Eventually I heard Lester tell someone on the street below that she had died. Then it was just Lester alone, sitting in the window, drinking and smoking, blessing the people passing by.

I came upon Lester shoveling snow out in front of his building. He was blowing on his hands, trying to warm them. As I walked by, I handed him my gloves. He courteously refused. I could see that he wanted them, so I insisted. I felt I owed him that much for the gift I received whenever I sat in the chair closest to the wall, with my morning cup of tea, and heard Lester singing in the bathtub. Listening to Lester sing stirred my imagination. I felt privy to the recurrence of an original blues moment—the sacred moment of inception when the blues was first conceived. The sacred essence of the blues passed through my wall in those early morning hours. Lester's song was a lonely prayer in the temple. I was the church mouse, listening unnoticed, savoring the tiny blues-seed, which contained original DNA, faithful to its origin. Here was the quiet suffering of an old black man who sang the blues for no one but himself. My only payment for the pleasure I received from this covert activity was the very deep gratitude, love, and respect I felt for Lester.

Giving Lester my gloves was a small personal ritual, the placement of a talisman on the altar. It was an offering to a black man from a white man. He was a respected, soulful patriarch to the black street community, and I wanted to pay homage to him.

I grew up in a mostly black neighborhood on Homer Lee Avenue in Spring Valley, New York. It was known as the Hill section. In that neighborhood, the white families were the minority. Lester's singing somehow brought back memories of my childhood there. Mr. Woods

owned a small private club in the neighborhood; he called it a "juke joint." Mr. Woods was said to be rich because he had his own septic pumping business and a shiny new truck that always smelled bad, no matter how much he shined it. Mr. Woods had one eye. The story was that he had been badly beaten by a gang of white men. I heard from the other kids in the neighborhood that this was why he didn't like white people. His "juke joint," as he called it, sat a short distance from our bedroom window in the building next door to us. My young, black friends and I would peek in the steamy storefront windows at night while people were dancing, to see if the rumors we had heard about the notorious John Earl were true. We had heard from the older kids that our hero, John Earl, danced in the club with his fly down and had sex with the woman he was dancing with. John Earl was so cool that the women didn't even know what was happening! He could also play the bongos very fast, which entertained and impressed us to no end. When we younger children banged around on anything that made a racket, we compared it to "playing bongos like John Earl."

After his son Elijah Bagley Jr. died tragically in a car accident, things seemed to change all around for Mr. Woods. The juke joint shut down. Word around the neighborhood was that Mr. Woods was running it illegally and might go to jail. We were sure he was being shut down because the handsome and cool John Earl was getting the entire population of young women at the club pregnant on the sly.

Mr. Woods was a bit of a womanizer himself. He finally threw over his aging wife for a beautiful young girl from Mississippi. She was less than a third his age, and was his rapidly advancing and expanding "secretary." She moved into the other house across the street that Mr. Woods owned. Shortly after she moved in, his wife left him. Mr. Woods's new girlfriend was also the sister of my best friend, Sammy.

Sammy was different from the blacks I knew who grew up in the North. When he moved from Mississippi to our neighborhood, he and I quickly became best friends. Sammy was so different because he never had the opportunity to relate to white people on equal terms. In the beginning, our friendship was a very strange mystery to him. I went out of my way to assure him that things were different here in the North and that we could be friends. In the South, he was accustomed to crossing over to the other side of the street when a white person approached on his side. Now his best friend and constant companion was a white person! We spent a lot of time playing at my house. Until he met me, he had never even been in a white person's house before.

When I first met Sammy, he informed me that his dream was to have a bicycle. That was certainly an easy dream to fulfill in our neighborhood! I was quite handy mechanically, so I quickly pieced a bicycle together for him. I gathered what I needed from the collection of

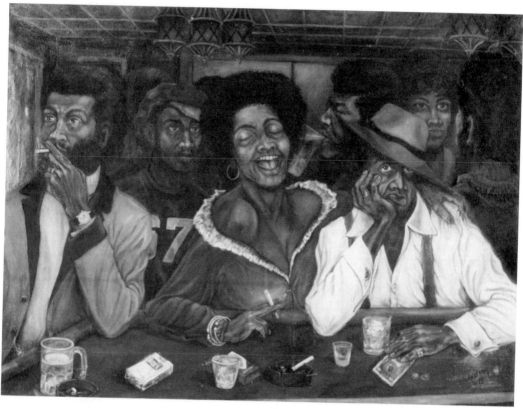

Neighborhood Bar. 3' x 5' (1973). Life size and still existing.

broken and abandoned old bikes left for dead in the vacant lots and abandoned buildings around the neighborhood. It was Sammy's very first bicycle!

There was some danger in putting together a bicycle from parts found in the neighborhood. If someone recognized a fender, or another insignificant little part, from a bike that they once rode, they tried to reclaim the entire working bicycle. Worse than that, if they were bigger than you, they might slap you around first for stealing their bike before they took it from you. Sammy was new to the neighborhood and a little naive, so to protect him from having his new bicycle "reclaimed," I kept my creation simple and left off the unnecessary extras. Finally, with a little red paint that I stole out of my father's shop while Sammy kept watch, the bike was rendered unrecognizable. This covert activity and the gift to Sammy clinched our friendship. I had risked something on his behalf, and now we had a secret that we both had to keep to protect one another.

While I lived in that community, a part of me longed to be black. I wanted either to be fully accepted by my community or to live in an all-white neighborhood. Inhabiting the holy

ground of life's in-between places was, and is, challenging. It seems much easier to belong fully in one place or another.

Lester reminded me of Sammy and our innocent, loving friendship. When I saw the warmth with which Lester greeted his friends, I remembered the difficulty of being in between worlds. Somehow as children, it is easier for us to know that there is no separation between the souls of human beings. As adults, we must make a determined, conscious effort to override and work through the social and historical layers that create separation. To do this, and to return to that original innocent quality in which you simply know that separation does not exist, is the important, personal work of life.

My parents' best friends, Chink and Dot Van Dunk, embodied the beauty of this wholeness. While I was growing up, they were the only regular guests to come to our house, outside of the occasional visit from a relative. Mr. and Mrs. Van Dunk were racially blended people, and as such, they made the in-between place real, in flesh and blood. Their beautiful coloring, features, and personalities were the product of many generations of mixed blood. The Van Dunks embodied the best of both worlds. There is a book about their bloodline called *The Ramapo Mountain People*. Anthropologists appreciate this "tribe" from Rockland County, New York, as a beautiful and unique people.

As I was growing up, they were unquestionably family to me. When Mr. Van Dunk would take me fishing, it was the highlight of my life. And Mrs. Van Dunk was the reason I loved to spend time in the kitchen, preparing food with my mother and her. The Van Dunks have been in my life since I was born and still are. Just a month ago, shortly before my mother died, I sat in the room with her when she informed Mrs. Van Dunk over the telephone of her diagnosis: "Six months or less—cancer!" Mrs. Van Dunk broke down so completely that she had to hang up the phone and resume the conversation several days later.

To have the gift of closeness to black culture as a child, and then later, to experience the real world with all its unwritten and assumed limits, is a bit like getting a glimpse of heaven and then not being allowed to enter. This may have been a reason that I hardly spoke to Lester. I knew that the reality that I had known as a child was nearly impossible for adults, certainly for adults with no personal history to build on. Sometimes doing nothing is the most effective form of doing. I felt I risked interfering by even offering my gloves to Lester!

Smiling, feeling the love on the inside, and not actually speaking to Lester, was a kind of self-imposed, respectful penance for all things white. It was a way to feel close. A way to *be* "I-am-sorry." A way to say, I accept responsibility for everything white that stands between us, and I will not add one thing more.

Margaret Mead at the Dump

Winter was coming on, and I needed a coat. Gloves would have been a luxurious extra. My coat had been sacrificed to the hungry ghosts of Halloween in my attempt to make costumes for the poor neighborhood children. The children asked me weeks before Halloween if I would help make costumes for them, and I said I would. I thought it would be simple. I could paint their faces and improvise capes and other props, and then let their imaginations fill in the spaces. In the days approaching Halloween, the children came to my loft daily, excited about their costumes. I had begun gathering material for that fateful day. When they came, they argued over who was going to be the first to be made up. This should have been a clue as to what was to come.

Halloween finally arrived. I did not see the children all that day. It was late when they frantically hammered at my door. There were six children; their numbers had increased. They were wound up and ready to go out trick-or-treating in the six "real" costumes I was supposed to make in about five minutes! In very short order, the costume creation party degenerated into utter chaos!

The problem was that by the time Halloween rolled around, the children had well-established, fixed ideas in their heads as to what heroic characters they wanted to be. They also knew exactly what those characters were supposed to look like! Superman, Spider-Man, Batman, and Batwoman were just some of the characters they demanded I instantly create! With my limited supply of costume material, I tried to accommodate their requests. Everything I did, however, failed to please them. In a desperate attempt to interest them in other possibilities, I grabbed my winter coat and cut it up to make the youngest boy look like a hobo. I thought that surely I could please the youngest child! But as he watched me cut up my coat, the child had time to think. With my coat in ribbons, he decided he didn't want to be a hobo, he wanted to be Batman, and he wanted a "real costume." Frustrated with me for not making them all Super-somethings, the children finally left. With the beautiful ability that only children and the childlike have to shift and move into the next exciting new moment, they did leave happy. They were more inspired by the candy that awaited them out in the Hallows' Eve than by anything that I had to offer.

I was coatless and I was learning to trust that the Hallows would supply all that I needed as well. I must admit, I was not always as adventurous or as enthusiastic as the children about what awaited me when physical reality seemed to falter.

There was a public dump site not very far from my loft. I took truckloads of refuse there several years earlier when I began gutting and remodeling my loft space. I thought I could find

the coat and warm clothes I needed there. It would amaze most people to see what gets thrown out. In a country with such abundance, even the poor are often too proud to simply go and take what is available at the dumps. Probably as a result of greed and guilt, dumps and markets are making this infinite source of useful goods more inaccessible. It is as though, as a country, we were trying to hide our garbage cans full of gin bottles and cigarettes, the evidence of our addiction to more of everything. To make usable trash unavailable is the immoral manipulation of supply and demand.

Guilt, however, can also create wastefulness. My mother has always had the strange habit of tearing a garment before she throws it away. It's like an assisted suicide. I remember asking my mother why she does this. Some of my questions annoy her, and this was one of them. I think this little personal ritual of my mother's can speak to something in all of us. My mother felt guilty about throwing away still-useful clothes. She tore them as a way to feel exonerated. Now the clothes were torn and therefore no longer of use to anyone. I believe that the real voice, the one of conscience, the one deep inside, whispers, "This object that you are discarding is of the earth and sacred."

There is a wonderfully wise Hindu tale on this subject. A great Hindu saint took the last cup of oil from the pantry of a poor farmer. The saint explained to the farmer that he needed the oil to cook for the hordes of people about to arrive at a religious celebration in the local village. The farmer assured the saint that the little oil he had to offer would never be enough! The saint took the oil and poured it into a cup, filling it to the brim exactly. The people arrived in great numbers at the celebration. The saint busily cooked food for all of them all day long. He continued using the original cup of oil that he had borrowed from the farmer. The farmer realized that he was witnessing a miracle. The oil did not run out! When the celebration was over, the saint and the farmer returned home, pulling their cart full of cooking utensils. The farmer, unable to contain his curiosity any longer, finally asked the saint, "How is it that you did not run out of oil after cooking all day long?" To answer the farmer's question, the saint picked up the same pan that he had been using to cook that day and poured the same amount of clean new oil out of the pan and back into the cup, once again filling it to the brim. As he did so, he said, "What you take, you must put back."

I felt the support of unseen hands the day I went to look for a coat at the dump. Living my life the way I did, I was exploring unknown territory. "Without support, we will fail," says Lao Tzu. The form of that support is unique to each of us as we travel on our individual journeys. I looked for signs along the way to lead me on and assure me of a deeper meaning behind my intuitive wanderings. I needed to see the structural bones that went deeper than appearance

and held the mystery solidly in place, more by quantum miracle than by engineering. All that is required to discover these invisible bones is the courage to rest the full weight of embodiment on them. They form when we rely on them to be there.

I thought I would make it easier for myself by going to the dump on a Sunday, when it was closed and no one would be around. But I still had the residual pride of my former self-image, and I had serious doubts about being there. For some reason, while I was at the dump that day, Margaret Mead (the great anthropologist) came to mind. Perhaps the nature of the mind is such that we remember an experience involving "the most" when we are feeling "the least." Several years earlier, Jean Houston brought Margaret Mead to my studio to meet me and to see my art. This was a very exciting day for me as a young painter. It was an honor to be in the company of her great soul. I felt a nice connection with her, and she immediately took an interest in my work. She wanted to bring a museum curator from Copenhagen to see my art the following week, in the hopes that he, too, would take an interest and perhaps show my work. When he came, he did not seem to like my paintings. He said something about my being a "Monster Painter." I knew that the term *Monster Painter* was used to describe the work of a group of Chicago artists, but I knew very little about them.

The last time Margaret visited my studio was shortly before she died. She said something that day that stayed with me. As she was leaving, she turned, smiled, and said, "It is good to see there is a religious artist emerging in the world." At the time, I did not fully understand what she meant. The word *religion* had connotations that I did not identify with as an artist. I did feel pleased, however, that both Jean Houston and Margaret Mead were interested enough in me to support what I was doing. In retrospect, twenty-five years later, I realize that Margaret saw the spiritual direction that I was headed in before I did.

Thoughts of Margaret Mead and doubts about my life merged the day I went to look for a coat at the dump. I thought to myself, "What would she think of this religious artist now, here—at the dump? A religious artist with nothing, looking for a coat!" As I had that thought, I looked down at the pile of garbage I stood on and saw a picture of Margaret Mead staring back at me from an old newspaper. There she was, smiling at me. Perhaps at that moment I simply needed to believe that this was a message, something mysterious guiding my life. Seeing her picture had that healing effect on me. I received the support I needed, and I felt it was spoken in a language that I could understand. There is a noticeable mystery in place. As humble and as low is the descent we make in our search for the sacred, that is the measure of the heights we can reach in our approach to heaven. That elevated day at the dump I also found a beautiful coat and all the good clothes anyone could want. I even found gloves!

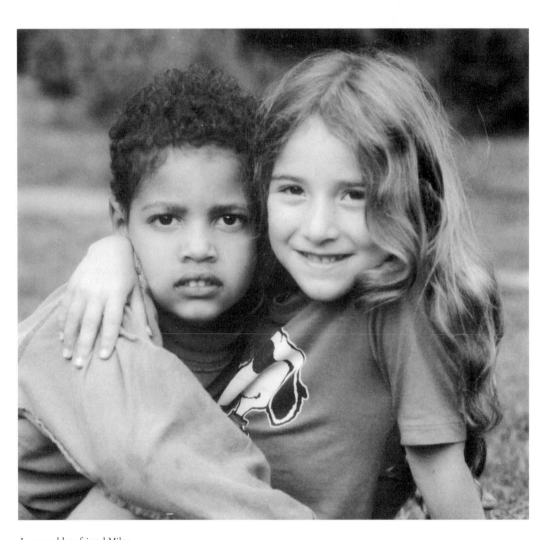

Lucy and her friend Miles.

Third-Story Signs of Life

An Unlikely Heaven

The process of fasting was changing for me, and I no longer had the energy to stay focused like I had in the past. I had just fasted for several days and was feeling very weak. Trying to figure things out in a reasonable way just did not work for me. I discovered, however, that the nature of the mind is to try ceaselessly nonetheless! I wondered, "If I am supposed to remain here on this earth, will physical comfort never be granted to me? Is there something basically wrong with being embodied? If so, will I eventually learn to live on air, as some Indian ascetics are alleged to have done?" I was beginning to believe that living a spiritual life made physical life impossible.

At one point, realizing that my thinking was taking me nowhere, I wandered over to my window and stared out onto the street below. I saw a small circle of people chatting and enjoying the warm Sunday afternoon. Central to this gathering was a small boy, held in the arms of his mother. He was sweetly occupied with eating an ice-cream cone while the adults talked enthusiastically. They were not directly paying attention to the child. However, everyone occasionally stopped talking at once to notice the beauty of this child. He was surrounded by love and was perfectly content with eating his ice-cream cone. As I watched the child slowly and sloppily negotiating the huge cone, an overwhelming emotional surge ran through my being. Just as that happened, the child looked straight up at me. Our eyes met for a long moment, and then he smiled at me coyly, with what looked like wisdom. Then he shyly looked away. The unexplainable, overwhelming beauty I experienced in that simple moment brought me to tears. Just seeing that child being held and loved, and watching him eat his ice cream, made the world an inhabitable place. A new sense of physical reality entered me. I knew that a

larger reality would hold my embodied life and keep me on the planet. I knew that I would eat and that I could physically exist on this innocent, good, feminine earth.

The constant fasting I had been doing finally came to an end when I thought I could not fast one more day and still survive. I often went to a spot down on the banks of the Hudson River. For me, this was a place of prayer. It was difficult to get to, so no one went there. You had to traverse an area of marshland, carefully walking on bogs and driftwood carried in by the high tides. I called this special place the Death Spot because I frequently found dead animals there. I imagined that it was sacred even to animals. I had read stories about elephants and the special places they chose to die. Just so, animals seemed to go to the Death Spot to die. And so, metaphorically, did I. I went there when I felt most dead within myself. I went to let go, reconnect, and find answers, and I usually found them. I went on this particular day with the dilemma of excessive fasting weighing heavily on my heart and body. I felt I couldn't do it anymore. As I sat on the beach praying, the tide slowly went out. It left little piles of seaweed and driftwood as it ebbed. As I watched, a pile of debris on a log caught my attention, and I walked over to it. I noticed a rock that I thought at first was a potato. Beside the rock was a stick with a bulbous end that looked like male genitalia. Fasting and celibacy came to mind. I threw the stick into the river and said, "God, you can keep the sex, but I have to eat if I am going to remain on the planet!" With a sense that my prayer had been answered, I returned home.

Once back at my loft, I decided to sit and meditate on what I had received in answer to my prayer. I was truly in an altered state from fasting and from walking the long distance to and from the river. I went into a half-dream place. Like gently dripping water, one small drop of memory fell into my thoughts and saturated them. I saw my father walking out of a room with a large box of bananas. As a child, I loved bananas. We rarely had them in our house, and when we did, they were special to me.

The rest of the memory came to me in full measure. I was in the car with my father. We had gone out for a drive to look for a cardboard box that he needed. We went to the grocery store where my mother shopped. My father asked the man at the counter if he had a box we could have. He told us to go out into a little garbage room on the side of the building and take what we wanted. I returned to the car while my father went to look for a box. When he came out of the little room beside the market, he was carrying a box full of overripe bananas. I couldn't believe my eyes! I feasted on those bananas!

As I was flooded with this memory, I suddenly knew where to find all the food I wanted! I was a vegetarian, and here in the food the grocery stores threw out were fruits and vegetables

of every variety. That is how I ate for about two years. So much food was available that I could save the best for other people. I gave my friends perfectly ripe mangos, avocados, and other special treats. I also brought boxes of produce to the poor families who lived in the neighborhood.

During this time, a large sum of money was stolen from a Brinks truck. Armed with assault weapons, several gunmen held up a Brinks truck in Nyack. Several policemen were shot in the attempt to capture the men. It was a real shoot-out, like something out of a movie. As the police were approaching the getaway van to search it, out of the back came the robbers, guns blazing! I remember hearing the gunfire at the time it occurred. I later heard that several of the men escaped on foot, after the shoot-out left two policemen dead.

One of the supermarkets that I went to for produce was a stone's throw from where the shoot-out occurred. One day shortly after the robbery, I was out in the little room that held the discarded food when I heard something outside. I thought maybe the people at the supermarket were going to tell me I couldn't take the produce anymore. When I opened the door, there were three policemen with guns drawn and pointed at me! They told me not to move. A policeman went down on one knee in the I'm-going-to-shoot-you-before-you-shoot-me position. I was completely startled as I walked out that door! I thought, "Is cutting into the profit margin by putting garbage to good use such a serious crime in this country?" After the policemen thoroughly interrogated me, I realized that they thought I might have been one of the robbers. One would imagine that after they robbed a Brinks truck and made off with bags full of cash, the robbers would have at least gone to McDonald's with their bags of money and purchased a Happy Meal. Though slightly rattled, I was, in the end, allowed to go merrily on my way.

Food was available to me now, and I was in heaven. After going so long on eating so little, it was truly a divine experience just to be able to eat when I wanted! I was completely involved with endless, guiltless eating. I ran into a friend on the street I had not seen in a long while. She said something that made me laugh and feel a little self-conscious. She said, "I think your being here in the world with us, and living the way you live, is so important, but I've also worried about you. It's so good to see you plump and happy." Eating and sharing the wonderful gift of food allowed me the luxury of true earthly happiness, at least for a little while!

One day I went into the city to see my friend Deborah Koff-Chapin's art show. I spoke very little at that time. It was unusual for me to be in such a public setting where, naturally, people chatted and expected you to do the same. Deborah was a close friend,

and I felt it was important to her that I be there for the opening. I was sitting in the gallery where Deborah's show was held, surrounded by old friends, most of whom were creative, ambitious people. This was New York City, the Big Apple, the very seat of worldly, accomplished manifestation. Deborah was there, artist Beno Kennedy, oboist Nancy Rumble, as well as several other artists and friends. The conversation turned toward the creative projects everyone was working on. Hopes, dreams, and creations were all spoken of. I sat and listened.

After everyone had spoken his or her piece, Nancy considerately turned to me and said, "Jerry, what have you been doing?" In the silence that followed, I had the feeling that everyone else in the room was wondering the same thing. I had been the most manic and driven painter in the lot at one time. Friends knew that I had turned inward, and I had been fasting and practicing silence for several years now. After feeling into the question, I said the only thing I could say—"Eating."

Still Molly

Molly stood so still, I knew she was my teacher. As I looked out to the street from the large window of my third-story loft, I saw a young woman standing so still that she drew my attention. The animation of the surrounding lives and the swirling of street traffic brought to mind a time-lapse film I once saw in which hordes of people were making their pilgrimage to Mecca. The only still place in the flowing human blur was the center. Human beings who sought a link to the divine flowed around the stillness like blood. Molly was stillness like that.

I heard a knock at my door and opened the door to the smiling face of Ann saying, "Oh, you're here." She wanted to bring by some friends of hers. She thought I might be able to help their catatonic daughter, Molly. They were waiting downstairs on the street, and Ann wanted to know if she could bring them up.

Molly was a tall, blonde, beautiful young woman in her twenties from a well-to-do Connecticut family. She had gone to South America a few years earlier with the idealistic hope of doing good in the world. She fell in love with a powerful tribal leader there. The details were unclear, and her family lost touch with her for a long period of time. One day, a year or so later,

her parents received an urgent call from a stranger, telling them to come and get Molly. She was in trouble. Her loving father immediately boarded a plane and flew to South America. He found Molly and brought her back to their home in Connecticut. Molly was in a catatonic state and at the brink of death when he found her. She was extremely thin, her skin was flaking off, and she cried often but did not speak. She stared at the ground or out into space. Her tears rolled out from somewhere very dark and deep.

When Molly and I were first introduced, she looked up at me slowly, and a faint flicker of light came into her eyes. She reached in her pocket and handed me a jar of herbal cream her parents had given her for her flaking skin. She said nothing. It touched my heart that her response was to give the only thing she had at the moment. I hugged and thanked her, slipping the jar of cream into her pocket as she disappeared back into her silent inner world. I wanted to help her if I could.

When Molly went anywhere with others she was always led around by the hand. She went along docilely with whoever led her. She stood perfectly still if people stopped to chat or if she was left alone. She had no will and no apparent desire to reenter the world.

I was fascinated with Molly. Her complete detachment from the world seemed to give her fluid access to depths of soul that most of us know little about. She was wide open, without boundaries. When I sat quietly with her and sank into the depths right along with her, I was able to share the sacred space she inhabited and was trapped by. At times, after a long silence, she would slowly look up at me. Her eyes seemed to smile and say, "What are you doing here?" Then she would fade and disappear, as though she were a quiet mysterious fish that barely makes a ripple as it touches the surface and returns to the depths of its unfathomable darkness. I honored Molly's right to inhabit the silent, inaccessible depths of her natural healing process. But I also fiercely stalked her demons.

Being with Molly was like being with a seriously injured child. I wanted to be in the silence and reverence that her condition demanded, but I also wanted to help heal the injury. Molly's silence held a paradox. Her deep inner life, which sought healing in silence, pulled her toward wholeness and health, while its shadow side inadvertently pulled her toward death. I felt Molly could easily go in either direction. I knew I came with a similar, dualistic package in my resolve to help her. I honored her silence in the gentlest of ways, while a ruthless, wild, fierce protector—dangerous to Molly's inhabiting ghosts—lurked in me. I was a focused, relentless hunter, waiting for the chance to pounce on them.

I have never experienced a fully attended encounter with another human being, difficult or easy, that has not offered the possibility of a shared blessing. Molly came with the gift of

stillness, and I needed to learn from that stillness. She delivered this gift just by being with me. Molly needed the grounding of those who stood solidly on the earth around her. I had the feeling that Molly was leaving her body and heading toward heaven. Her proximity to heaven solicited a reverent response from those around her. Anyone aware of her condition immediately entered and maintained the space of that reverence.

One day when Molly had been dropped off at my place, I decided to take her out into the world. First, we went to the art studio of a close friend of mine to see his paintings. As I watched her try to connect with the paintings, it became clear to me that Molly could not connect with the energy that holds form in place. All her energies were dissolved and absorbed into the vast depths of her dark, inner world. She was not able to call up the will to grab and hold onto the literal world. She was lost and drowning in the abstract, fluid, emotional currents running through her. She seemed to try, but there was no energy left to establish a hold on physical reality. I sensed that she needed a clear and defining act through which the world could get a foothold in her consciousness.

When Molly and I left the studio, we met up with Ann, who had originally brought Molly into my life. The three of us went for a walk in a beautiful wooded area behind some old abandoned buildings. Like everyone around Molly, Ann walked on eggshells the whole time she was with her. As we walked through the woods, I puzzled over a mix of thoughts on this strange, sad, frustrating situation. Molly's father would be picking her up soon, and I wouldn't see her again for a long time. Our time together had come full circle, yet it seemed incomplete to me.

In that urgent moment, my confused thoughts shifted into a focused, determined prayer for Molly, for me, and for all that was unresolved, unknown, and in need of healing! As we walked along, we came to a mountain of glass bottles. I imagined that someone who had once lived in the abandoned buildings nearby had dumped them there. When I saw the pile of bottles, I spontaneously made a long leap over to the pile, landed with both feet solidly on the ground, and shouted, "Hey, Molly! Look!" Startled by my interruption to the silence and sensitivity, Molly snapped to attention. So did Ann, who looked on in horror as I whooped it up, throwing bottles against the trees, smashing them in all directions. Glass was bouncing dangerously back, flying everywhere! I kept it up, shouting, "Hey, Molly, watch this!" until she was giggling uncontrollably. Our eyes locked, and we were off the ground and flying, coconspirators in a final, outrageous, empowering act of defiance to the silent tyranny of an oppressive, ghostly death lord!

I did not see Molly again for well over a month after that day. Her parents called and invited me to their house for dinner one night, by Molly's request, I was told. When I arrived and saw Molly, I could not believe the change! Before dinner, we all went for a walk around their lakeside home. Molly's behavior was outrageous! She behaved like a hyperactive, mischievous child, jumping on my back, begging for piggyback rides, literally dancing down the street, and talking nonstop the whole time. Her behavior was extreme.

After dinner when Molly and I were alone and had time to talk, I said, "Molly, the change I see in you is wonderful. I just hope you don't throw the baby out with the bathwater. You know, you are my teacher in the realm of quiet inner beauty too." She just looked shyly over at me and became more centered and quiet.

Life changed for all of us after that visit, and I did not see her again. I heard later that she had returned to college. In the attempt to understand what had happened to her in South America, she focused her studies on occult influences and dark practices. But this study proved too difficult for her still fragile condition. She changed her focus and took some time to recover, but she did plan to finish school. My own life changed, and I never heard anything more about Molly after that.

Rodney

I was about to head out to have breakfast with a friend one morning, when I wandered over to the window of my loft to look out and get a feel for the day. I often did that when I was about to enter the world. This day I saw a very dark-skinned, fine-featured, young boy wearing a shirt too large for him, sitting on the curb below my window. He looked to be about ten years old. The extralong sleeves of his shirt came in handy, as they extended over his hands to keep them warm. His left hand held a full half-gallon of vanilla ice cream, while his right hand was wrapped around a small wooden spoon. He was sitting on the curb eating a half-gallon of ice cream for breakfast. The strangest thing in this unusual, early morning scene was that he also had a ten-pound, plastic-wrapped, uncooked, Butterball turkey sitting on the curb beside him. I thought, "Lunch, perhaps."

As I left my building, I went over to the child, introduced myself, and asked if he would like to come have breakfast with my friend and me. He told me that he couldn't because he

had to take the turkey home to his mother. His name was Rodney. I asked him where he got a turkey and such a large box of ice cream so early in the morning. He told me that his friends the police gave them to him. I said, "Wow, they must like you." He said, "Yeah, I'm going to get a gun too." I asked, "What do you want with a gun?" With his imperfect grasp of language, he said, "What do you think? I'm going to 'detect' my family!" He told me that he had to eat the ice cream now, because the refrigerator at his house didn't work. He said his mother kept shoes in it.

Then, continuing to eat his ice cream, he asked, almost as a challenge, if I wanted some. He said that he had another wooden spoon in his pocket if I did. I said "Sure" and to his absolute delight, I sat down on the curb next to him, pulled my sleeve down over my hand like he had done, took the spoon, and ate. He laughed at me the whole time. I said, "What's so funny? I *like* ice cream!" When the comedy routine ended, I thanked Rodney and told him that I had to go meet my friend.

As I was about to walk away, he said, "You live in that building, don't you?" pointing to my building. I told him I did. He said, "I seen you before. My friend told me you're an artist. I'm an artist. Can I come visit you sometime?" I said, "Sure" and pointed up to my window to show him where I lived. He said, "Maybe I could have breakfast tomorrow at your house." I said, "Sure, if you like," and said good-bye, thinking he would probably never come. I continued down the street and left Rodney to finish his gourmet breakfast.

The next day, late in the afternoon, I heard a knock at my door. It was Rodney. We talked for a while and became friends easily. He came to visit me about once a week after that. I introduced him to some of the other artists in the building and to many of my other friends.

One day he came to show me a new pair of jeans the artists downstairs got for him. Several people in my building helped take care of Rodney. He was completely lovable, and everyone responded immediately to his happy enthusiasm and laughter. I sensed that he was trying to rise above the heavy weight of his shadowy world and his sad, poor family. His mother was a diminishing beauty with black, sharp, beautiful African features. However, she was drunk every time I saw her. As a single parent, she depended too heavily on Rodney to help hold her life together. Rodney had an older brother as well, and I am sure it was an enormous struggle for her to raise two boys in their impoverished situation. She was doing the best she could. Rodney came to me upset at times. He would wake in the morning to find some strange, often drunk man sitting in his kitchen. His home life sounded difficult, chaotic, and unpredictable. I did as much as I could for him, often taking him along to meet people when I was invited somewhere.

Rodney asked if I would attend a school function with him. He was not allowed to attend without a parent or guardian. I agreed. When we entered the school, a group of young girls giggled and pointed at Rodney and me. Rodney was so black and I was so white that I thought perhaps they were laughing because I was too white to be his father. Apparently Rodney knew the girls because he went over to talk to them. He came back smiling. He told me that the girls had asked if I was the Fonz. I asked who that was. Rodney explained that the Fonz was a TV character who looked like me. Then he laughed at me himself and called me the Fonz! Rodney did not tell the girls that I was *not* the Fonz, so he became quite popular in a hurry. He seemed to love the attention. I stayed a while longer, and once I saw that Rodney was doing fine on his own without my celebrity, I whispered to him that I was going to sneak out to my limousine and go home. As I left, the girls watched and followed me at a distance until I was out the door and away. That mistaken identity happened once again when I was walking around in town. Two young girls kept staring at me, calling me the Fonz, and giggling. This provoked me to find out who the Fonz was. He did have my big nose, but I didn't think we looked enough alike for anyone to confuse our identities. The TV Fonz became more popular, and his name and face soon appeared everywhere. I think that the young girls were blinded by wishful thinking instead of seeing a real resemblance.

Another day my good friend Sally, who had a studio on the floor below me, came up with a woman whom she had just met by the name of Margie Brown. Margie was quite a successful improvisational performer, who played mostly to small audiences around the country. I would describe Margie as a healer. Her effect on people was magic, both on- and offstage. Margie had an interesting personal story. At the time that I met her, she was suffering from the onset of a degenerative disease. It may have been multiple sclerosis, or something similar. If an unpredictable symptom of her disease interrupted her while she was onstage, she included it in her performance. For example, if a muscle spasm caused her to fall, she would make the fall comical or would somehow fit it into the story she was telling. She had the most wonderful spirit, as a human being and a performer. She could rise above the adversity of her condition and turn it into a healing gift for the benefit of others.

The day I met Margie, she invited me to a performance of hers that night, somewhere in Connecticut. Sally and I decided to go together. Later that night, while I was waiting for Sally to arrive, Rodney came to my door. He was about fourteen then and was working through a rebellious stage, influenced by his older friends. Since I was a safe, older male who was a

consistent presence in his life, I became the test site for his experiments in newfound, cool, rebellious indifference. I was the available, uncool old fart he needed to push against to define his new independence. I understood what he was going through, but found him particularly annoying to be around that night, since he was so heavily into his bad attitude. Sally was due to pick me up, so in an attempt to break Rodney's spell of indifference, I invited him to come along with us to Margie's performance. He was usually enthusiastic about doing interesting new things with me when I invited him to. Not so this time. He came with us, but he maintained his distance.

When we walked into the beautiful old New England church where the performance was to be held, we were met and greeted by the pastor and by Margie, who was preparing for her performance. The pastor of this upscale, mostly white neighborhood, surprisingly, was black. I could see that this surprised Rodney as well, and that he felt pride in this fact, which I was glad to see. I don't think Rodney had many older, successful black men in his life as role models. He seemed very interested in meeting the pastor and finding out more about him. When I introduced Rodney to the pastor and started to say some nice things about Rodney, the pastor gave a quick obligatory nod and walked away. I thought that he had been rude to Rodney, and I could see that Rodney's feelings had been hurt by the pastor's curt response. This was an interesting moment, because Rodney had been ignoring me in the same way the pastor had just ignored him.

Margie watched all of this unfold and picked right up on the moment. She pulled a wad of bubble gum out of her mouth, quickly stretched it into two pieces, and stuck each piece on an index finger. Then she pulled out a pen and poked little face holes into the two wads of gum. Her fingers became two comical little characters, one indifferent and the other friendly. She reenacted the whole scene that we had just experienced in a miniature puppet show with all of us in it. In no time, she had us laughing at ourselves. It was pure spontaneous magic on Margie's part. She then went on to give a great performance before the large audience that had assembled. When the show was over, we returned home, healed and quite moved by the evening's events.

Rodney continued to visit me over the years on a fairly regular basis. One evening at about 9:00, he knocked on my door. He had been crying; he said he had a fight with his mother and was running away from home. He said the police were looking for him, and he asked if he could stay at my house. I told him that I really cared about him, but hiding at my house was not going to work. I said he could stay for a little while and cool down, but then he

was going to have to go home. I knew Rodney's birthday was in a few days so I told him that if he went home tonight and worked things out with his mother, I would have a birthday party for him and they both could come. I would bake him a cake, and he could invite some of his friends. Finally, when he had calmed down enough, I walked him home.

Rodney's birthday came around and I made him a cake and had a party, as promised. Rodney didn't get around to inviting his friends, so the party consisted of Rodney, Claire (his mother), and me. Claire arrived quite drunk and in a spooky mood. She looked around the room and out the windows as if a ghost was haunting her. She acted as though she was making sure that this ghost didn't jump out of the shadows to snatch her soul away. In an attempt to calm her and sober her up, I made her coffee and sat down to talk with her.

The moment I sat next to her, she turned on her seductive charms. It was sad to realize that this was the only way she knew how to relate to a man. Her seductive behavior was so automatic, and she could not understand why a strange man would be kind without wanting something from her. I reminded her that this was Rodney's birthday party and that is why we were all here. I thought it might be a good moment to go into the kitchen and get the cake, ice cream, and gifts I had for Rodney. First, I brought out the large layer cake. I had forgotten to bring a knife to cut the cake so I returned to the kitchen to get it. When she saw me walking back with the knife, Claire looked at me wide-eyed and frightened. She moved backward a few steps, as though she were in a scene from a horror film and said, "What are you going to do with that knife?" I laughed to lighten the atmosphere and said, "We're going to cut the cake. I made it myself—want some?"

Then we sat and talked and had our cake while Rodney opened his gifts. They stayed about an hour and were just gathering their things to leave, when Rodney walked over to the large open window of my studio and yelled down to someone he knew on the street. Claire and I were left sitting alone on the couch. She leaned toward me, glanced sideways to see if Rodney was listening, and whispered, "Don't tell Rodney, but I am going to die." I thought that maybe she had a terminal illness, so I said sympathetically, "Oh, what is going on for you?" She waved her finger drunkenly and shook her head to inform me that that was not the question. Then she said, "I just know I am going to die soon" and stared wide-eyed and spooky at me again.

A week later, Rodney visited me and told me that his mother had died! He would soon be moving to his cousin's house in Detroit. He didn't seem at all upset. I told him that I was very sorry to hear about his mother's death and asked how she died so suddenly. He told

me that she was drunk and that she fell down on the street and hit her head on the curb. The story hardly seemed believable. I was shocked! Shortly after that, Rodney did, in fact, move to Detroit.

I didn't see him again until one day, five years later, when I answered a knock at the door and found Rodney standing there. I hardly recognized him. He was tall and well dressed and wore glasses. I told him that he looked like a bright, young intellectual. He said, "Everyone tells me I look smarter wearing glasses." I said, "You have always been smart; now with your nice clothes and glasses, you look like a college professor." I was happy to see him and proud of him. I had wondered at times if he would even survive all that went on in his life.

Knowing Unknowing

As I looked out of my studio window and watched the children playing in the street below, I thought about one of my black friends from childhood—a boy named Rudy, whom everyone said was retarded.

He was one of about twelve children from a family that lived on the upper floor of a dilapidated, two-story old house right behind ours. Many of the children living there were also cousins or were related in ways other than as siblings. The large population of children in Rudy's extended family constituted a veritable playground full of playmates for me, all close to my age. Below, on the first floor of Rudy's building, two older boys lived with their father. Word in the neighborhood was that these boys were tied to the bed regularly and beaten with a leather strap by their father.

Rudy had an instinctual fear of this man and began talking excitedly in a high-pitched, frenzied voice if you told him the man was coming out of his house to look for him. We did this often, just to get him excited and ranting. We secretly feared the man ourselves, and perhaps needed to project our fear of the scary neighbor onto Rudy. We were essentially laughing at ourselves through the disjointed safety of laughing at Rudy's comical reaction. Rudy used his frenzied state and high-pitched voice as a defense when something scared him. Interestingly enough, it worked! He made such a public display of himself and of the person

upsetting him that people tended not to bother him for fear of his embarrassing reprisal. More than once, I saw violators who overstepped their bounds with Rudy become quite disconcerted at his reaction.

Children have a very good intuitive sense of where boundaries begin and end within the wandering range of the territory they stake out for themselves. There are personal safe zones in the neighborhood, which have different parameters for different children. Children make the choice to honor or overstep the boundaries of adults, depending on the adult's level of strength, weakness, intolerance, or kindness.

When I went to play with my friends from the upper-story apartment, I walked around to their yard. Each of the two apartments had an equal amount of yard space on opposite sides of the house. My friends' yard offered unlimited outrageous possibilities for the chaotic play of unsupervised children. Most of the children in the neighborhood were free to come and go as they pleased. They had very little supervision, provided that they didn't step on the toes of an adult and therefore suddenly get noticed.

The yard was abused and destroyed. It was a playfield of imagined stories and battles, littered with the broken glass of abandoned vehicles, old toys, trash, and debris. Its lawn had been pulverized and turned to dust long ago by the rough play of too many children in too little space. A natural paradise could not survive the many dirty little feet, romping and stomping on this small patch of earth with worn-out, two-dollar sneakers purchased, handed down, or stolen from our very own Shopper's Paradise, a bargain basement of poor-quality, cheap shoes.

The yard on the opposite side of the house belonged to the bad man with the whip from the downstairs apartment. His yard was a wide-open lot, full of weeds and junk. To the children, his yard had about as much appeal as the mute, gaping mouth of a dead werewolf—a deathly werewolf, tied down and whipped as deathlike and deadly as the man, with hair and nails still growing after death like the weeds in his yard!

His yard was no place for superstitious children, especially a "retarded" child like Rudy, who absorbed the array of half-truths and exaggerated stories perpetuated by mischievous neighborhood children. Rudy instinctively knew to stay out of the jaws of the questionable neighbor's yard, and for reasons real or imagined, so did the rest of us children. The poor man was always grouchy and therefore seemed dangerous to us reckless, happy children. He was a single black father, which was unusual in our neighborhood, and he lived in poverty. He was trying to raise two unruly teenage boys in a neighborhood where many of the young men did not survive long. The man probably did the best he could.

As I stood in my Nyack loft, looking out my window that day, my mind drifted cloudlike three long stories above the street, and I thought of Rudy. I wondered what becomes of unusual children like Rudy, who grow up in poverty. Where do they go and how do they survive? As children, we all laughed at Rudy, but we also protected him. Who protected him now? A kind of magic tends and directs the lives of the innocent and the mentally ill. Rudy had his own magic, and the neighborhood children accepted and intuitively understood his role.

I continued to stare out my studio window, thinking about Rudy and watching, half focused, the blur of people walking by. My eyes were drawn to an overweight black man lumbering erratically around the corner and into view. As I slowly focused on him, he stopped dead in his tracks and looked straight up at me. There was an instant recognition—it was Rudy, now a grown man! He continued to stare and then began shouting up to my window in his high-pitched, defensive voice, "You don't know me! You don't know who I am! You don't know me!" I was completely startled and caught off guard by the incongruity of the moment. It was so disorienting to have Rudy appear, on cue, and shout at me from the street below, just as he did when we were children. I had not seen him since I left the neighborhood as a young teenager. I turned away, shocked and slightly embarrassed, feeling I had somehow violated his privacy. I had no business calling him up for an appearance and deserved his frenzied response. After all, Rudy was usually in the right when he defended himself. Rudy and his magic were alive and well, and I was happy to see he had survived where many others had not. But this was not the end of the story.

Unusual and mysterious events occur when consciousness shifts into what I've come to call my space-out mode. Something changes internally, and a diffuse inner glow softens the literal detail. Then I sense that the space-out mode has slipped into place. I can arrive at that shift by riding my bicycle in slow motion. I ride very slowly, rhythmically peddling at a constant speed in a consistent, slow-motion rhythm. (I would not necessarily recommend this, having once been hit by a car when doing it.)

A day or two after I saw Rudy on the street, I went for just such a bicycle ride. I turned down a street that I had not been down before. As I rode along in my prescribed rhythm, I wondered why Rudy had shouted, "You don't know me," because I *did* know him. Perhaps when our eyes met at that unworldly moment, we saw that we knew each other, and it startled each of us, setting off Rudy's automatic, frantic defense.

I was contemplating the strange magic of the mentally ill and what it means to be "known" or "not known" in the deepest sense. At that moment, Rudy had not wished to be known. As I continued riding, thinking, and spacing out more and more, I came to a house where I saw a

rhythmically rocking figure in my peripheral vision. I looked up just in time to meet the eyes of a very thin, slightly deformed, retarded man, who looked up at the same moment as I did. He was sitting on the porch, rocking at the same pace that I was peddling my bicycle. Our eyes met in a long, merging, soulful silence. Then he lit up and began shouting, "You know me, right? You know me! You know me, right?" I smiled and nodded slowly, "*Yes,*" and continued my rhythmic peddle down the street, hearing his shouts fade more and more, the further away I got.

I had just had the experience of Rudy *not* wanting to be known, and here was a mentally ill man happy to be seen and known. I felt something divine between the two men's opposite responses. One man chose to appear, while the other chose to disappear. I knew Rudy, yet he chose to disappear. This man, whom I did not know, wanted to be known. It was a strange dance of energies, rhythmic and perfect. God emerged into the light of a soulful connection between two human beings, and God disappeared in the clumsiness of a human encounter. There is no way to determine which mood the gods might be in at a moment of human encounter. The magic of human interaction is in the open heart, which can allow the moment to be exactly what it is. We cannot understand or control the expression and variety of our soul connections with other individuals. Each connection is an exchange—a moment to participate in without the interference of any personal preference or desired outcome.

In the larger understanding of one who fully inhabits the present moment, there is equal value in being known and not being known. With the indiscriminate unknowing of children and the mentally ill we can say "You know me" or "You do not," and both will be in the service of something that Knows.

Raining Chocolate and Grace

I recognized the circle of young girls I saw out of my window, sitting on the sidewalk. There were six of them, ranged from about five to eight years old—sisters, cousins, and friends. The first day I met them, I was sitting quietly in my loft, reading, at the small table not far from the door. I heard what sounded like a chatting, giggling stampede coming up the stairs. Children have a way of stomping a step as they walk up stairs because their legs are smaller, and walking

up stairs takes a determined effort, which they fully apply, especially when they are excited. When I heard the characteristic stomping up the stairs, I thought it might be the small boys who often came to visit. Then I heard the noisy troop trying to compose themselves outside my door before they knocked. I heard shushes and whispers, then the knock, then more excited giggling. I opened the door, and they all immediately shuffled in in front of me. I said, "Hi." After a period of shy, self-conscious giggling, one girl said, "Chantal peed on the stairs." Chantal retorted quickly, "I didn't pee on no stairs, *GIRL!* You got dooky stains in your drawers, so shut up."

"I ain't got no dooky stains in *MY* drawers. You peed your pants! Look at your pants, girl!"

In an attempt to diffuse their self-consciousness, I interrupted their comical argument. I said, "Well, that doesn't matter. I'm so glad you all came up the stairs to see me." Chantal looked up at me shyly, smiled, and said, "I couldn't hold it in. I didn't pee on no stairs though." I said, "That's okay. It is hard sometimes, isn't it?" She had gotten a little too excited about her big adventure, coming to see some new person three long flights up, and she wet her pants along the way.

I recognized one of the girls. Sandra had been here with one of her brothers a day or two before for the first time and didn't say a word. Now, the fact that she had been to my loft before gave her the authority in the group. She was the one in the know, the chatty tour guide who proceeded to show the other girls around my studio. Underneath a small round table I had a music box, mounted with a barely visible, thin wire that came up through the tabletop. A small flowerpot containing a live flower held down the wire. When you moved the flowerpot, the music played. Children loved to play with it, and they always thought the flowerpot was the source of the music.

Sandra was quick to show the other girls this trick. She also told them that I fibbed and said the flower was singing. She assured them all that flowers couldn't really sing, and that I was just kidding. She told them that the music really came from the table and showed them how to wind up the music box from underneath the tablecloth.

Apparently, the boys knew that the girls had come up to see me on their own. We heard them yelling up the stairs, swearing and calling the girls names. The girls were getting upset, so I said, "Come on, let's see who it is." We crept quietly to the window and looked down. The boys were running into the doorway, hollering up the stairs, and then running out, hugging the wall combat style, as they had seen in the movies. I said to the girls, "I have an idea! Let's dump water on their heads!" They all squealed with delight at that possibility. So we went into

the bathroom, got a large bucket, and filled it with water. Then we went to our strategic post, lifted the bucket into place, and waited quietly for the perfect moment. The boys were about to make another audio attack. We timed it just right. They ran into the building yelling and got the bucket of water on their heads as they made their getaway back onto the street. It was a direct hit! The girls screamed with the joy of our success. I proudly became their hero and trusted friend after that.

This particular day as I sat by the window, I realized that I had not seen the girls for a while, and then I looked down at the sidewalk and saw them sitting in a circle directly below my window. As I watched them, I could see that they were playing very sweetly. In an almost formal way, they were passing a tiny box of candy around the circle, carefully taking one of the small candies out of the box, eating it, and passing the box along. In very short order, the candy ran out, but they continued passing the empty box, pretending to eat candy and laughing at each other's exaggerated enjoyment of the nonexistent candy. When I saw that they had run out of candy, I went to the kitchen and grabbed a large bag of miniature chocolate bars that someone had just given me. I dumped the bag of chocolates into a paper bag, twisted the top of the bag, and tied it to the end of a long string. Then I lowered the bag three stories down. They were sitting facing each other as the bag came in over their heads, straight into the middle of the circle. As it dangled, eye level, right in front of them, they hesitated for a moment, then they looked up and saw me at the other end of the string. The bag exploded with the excitement of twelve greedy little hands grabbing at once! Candy flew everywhere.

One day when I was in a very inwardly focused mood, the girls came through in a magical way and became my heroines. I had been fasting and quiet for several days. I was feeling extremely vulnerable and would not have chosen to entertain a bunch of noisy children that day. I heard the traditional stomping up the stairs, then the knock at the door. I considered not answering but decided to open the door and at least greet them. I said, "Hello" and started to tell them it was not a good time for a visit, but they weren't listening. They pushed through and all came pouring in. This was a group of boys and girls, some a little older. They seemed especially mischievous and unruly. I sat quietly, surrendering to the chaos of the moment as it continued in a downward spiral. The more I surrendered, the wilder things got. The children needed grounding; they were flying recklessly. It seemed as though things needed to get worse before they got better.

A friend who worked with emotionally disturbed children once told me that they calmed hyperactive children by giving them caffeine. The effects of the caffeine pushed them beyond

their hyperactive chaos. They overdosed, in a sense, on their own activity. Something in their psyche then shifted, and they became calm again.

That day, the visiting children were on the edge of that kind of extreme. They began (unconsciously, I believe) looking for a scapegoat to ground their reckless, scary energy. They seemed to know that someone was going to lose here, and each child did not want it to be them. In the chaos, I simply held silent, quietly surrendering more and more. Since I was the most passive, neither contributing to nor avoiding the chaos, I finally became the scapegoat. At that point, I felt tempted to just tell the children angrily to leave, but I sensed that I needed to trust this uncomfortable situation and stay present. I had invested a good deal in establishing friendships with the neighborhood children, and I did not want to be just another adult who ruled with frightened, and therefore frightening, authority. I sat quietly and became the nothing that they were all desperately trying to avoid. As their behavior became crueler and crueler, one of the boys called me something really nasty. A dead silence followed. They knew they had stepped over the line that marks fair play. They looked at me to see what I was going to do; I did nothing. I absorbed the insult, too, into my state of surrender.

Then one courageous, small voice spoke quietly into the silence. The youngest girl, Chantal, said, "Jerry is nice. He's my friend." She betrayed the chaos! For just a brief second, the destructive momentum turned toward her, but it had been undone. She sat in her powerful innocence, looking sweetly down at her shoes, holding her sure position silently. The other children relaxed, disarmed, and showered me with their love.

Linking the Mysteries

A friend needed a ride to the airport. She asked if I could bring her to JFK and pick her up on her return flight the following week. She offered to pay me the thirty-five dollars she would have paid the airport limo. I drove her to the airport but refused payment. However, she insisted on paying me and slipped the money into the ashtray of the car.

Her week away passed, and the day arrived for me to return to the airport to pick her up. I left early that chilly and rainy morning, giving myself plenty of time to arrive on schedule. As I turned onto the highway leading out of town, I saw a rather bedraggled, middle-aged man

standing on the side of the road hitchhiking. I stopped and opened the door. He got into the car and thanked me for stopping, then sat sullen, soggy, and smelling of alcohol until we neared his destination. As we approached the place where he wanted to be let out, I reached into the ashtray and handed him the thirty-five dollars my friend had left the week before. The man looked at me astonished, then to my surprise, turned his face away and began to cry. He turned to me and said, "Did God tell you to give me this money? Will he help me? My family has no food. I drink." When I looked at him and saw the slight glimmer of a small hope in his eyes, I answered, "Yes." At that moment, he needed a "yes," so knowing or unknowing, I gave it to him.

When I pulled the car over to let him out, he continued talking. I sat and listened as he told me his sad story—out of work, no money, hungry children. At that desperate moment in his life, he seemed genuinely repentant about his drunkenness. Finally, when he finished talking, he gathered himself up, wiped his tears, said "May God bless you," and got out of the car. I felt like I had just impersonated a saint by letting him think that God had told me to give him the money and had assured me that the man would be okay! How would I know? I hoped he would be all right, but I had no idea what would become of him and his family. He seemed uneducated, he looked and smelled terrible, and his front teeth were missing. It did not appear to me that he would survive the scrutiny of the workplace long enough to even be considered for a job. I didn't know what would become of him, so I simply held the vision of him and his family's innocence in my heart like a prayer. I thought of him often over the next month or so. His tears and his trust in the fact that I might actually be on speaking terms with his God had moved me.

Can we serve as intermediaries between individual human suffering and God when those around us get lost in life? I did not know the answer to this. I did, however, feel a strange sense of responsibility and commitment to that possibility. The attention I gave this person in my thought process was due to my doubts. When events unfolded in the car that day, I responded with a clear and perhaps overconfident "yes." My answer came from the heart. My "yes" was a small lifeline thrown out from one human being to another at a moment when all seemed lost.

Robert Johnson tells a wonderful story in his book *Balancing Heaven and Earth*. The story is about a traditional, unwritten law in India, which people just accept as commonplace in that deeply spiritual society. In India, one can approach another, at any moment one chooses, and ask the other to act as an intermediary between oneself and God. If you happen to be approached in this capacity, you must immediately accept responsibility and give yourself fully to that role, no matter what else may be going on at the moment.

Several months had passed since I had the encounter with the hitchhiker. It was now summertime as I sat looking out from my window one bright afternoon. Hundreds of people milled about on the streets and sidewalks below. The annual Nyack Street Fair was in progress. This was generally a joyful day for those who attended. Everyone came out onto the streets to see and be seen in the lightness of a festival atmosphere. Watching all the people, my thoughts went to the sad hitchhiker.

As I absentmindedly stared into the crowd, a conspicuous group of people stepped into view. What caught my attention about this particular formation of two adults and four children was that they were wearing rather fancy white cowboy hats. They appeared to be a family. All members but the mother had the same dark skin, and they all looked alike. The man in the lead was shorter than the woman. Except for that one step up in the row, the four remaining cowboy hats took one step down with each progressively smaller cowperson. From my vantage point, they looked like a family of ducks with their white heads bobbing along. The smallest duck kept losing his head, which would be retrieved, brushed off, and replaced by the next larger duck in the row.

As I looked closer at the person in the lead, I saw with astonishment that it was the man I had given a ride to on that cold and rainy morning several months back. The gloriously adorned lineup following him would have to be his family! Clearly, he was proud and in control of this joyful procession with their matching white cowboy hats. The sight of this funny little family out there on Broadway, defining themselves as a unit with their bold and unique fashion statement, lifted my spirits. This unusual man had twice blessed my life simply by showing up perfectly.

A Day in the Shadows

Living for years in a building on the corner of Broadway and Main Street, I developed a clear intuition of the deeper cycles of life outside my windows and a feel for the rhythms of the street. The full moon seemed to increase the intensity of activity. In the reflected light of a full moon, the restful darkness seemed less committed. Not fully able to settle into itself, the darkness acted out its shadowy life. Lunar influence and half-light seemed to create restless, unpredictable behavior out in the streets.

I awoke in the middle of one full moon night feeling vulnerable. A loud explosion followed by a crackling sound awakened me. My room seemed brighter than it should have been. The transformer on the pole just outside my window had exploded and caught fire. Soon there were sirens and fire trucks. A crowd of people came out of the bar across the street to watch the fireworks. I looked at the clock. It was 1:30 A.M. An interesting start to the day.

Later that morning, there was a jarring knock at my door. It was Kurt, an intense young man in his twenties who came to visit me often. A kind of balance is available in the watchful life, lived as much as possible without interference, in which even the challenging moments have a way of arriving with perfect and timely gifts. Steven, my poet friend, once described this incongruous condition well when he said of a mutual friend, "He is perfectly out of tune." Kurt's timing held that perfection—he generally arrived at my door at my most vulnerable times. But vulnerability is the soil in which real strength grows, and his excessive generosity and belligerence had a way of awakening strength in me that otherwise sat bored and inactive on the sidelines. For me, strength apparently needed forced, military-style exercise to stay attentive and engaged. So Kurt was my training officer and an aid to my strengthening process.

Kurt was small-bodied, troubled, demanding, and difficult. His offensive language spilled out in all directions, regardless of any peripheral considerations. He was angry much of the time; he had a love/hate relationship with all things male. He wanted to kill his father, who was, according to him, "a drunken bum living on the streets."

When Kurt knocked on my door that morning, I invited him in and offered him a cup of tea as I usually did. Clearly, if his behavior was any indication of life that particular day out in the world, this was an angry day.

On the days Kurt was open (which usually meant he was depressed), he asked questions and was receptive to any comments I made in my genuine attempts to help him. On those days, he generally left happier than he was when he arrived. However, between visits he would begin to mistrust the healthy vulnerability required for creating openness between human beings. As a defense against his vulnerable unknowing, he would *think* too much and chew to death all that we had said in our last visit. With the literalism of his very quick, intelligent mind, he eliminated any poetic meaning in the long-forgotten (by me) conversation that we had shared.

He arrived with defensive ideas about things I had said the last time we spoke. He also had ideas about what I represented in his mind, which it was up to me to figure out and

The Interactive Box Series

All pieces in this series are between six and eight feet high, and one to two feet across.

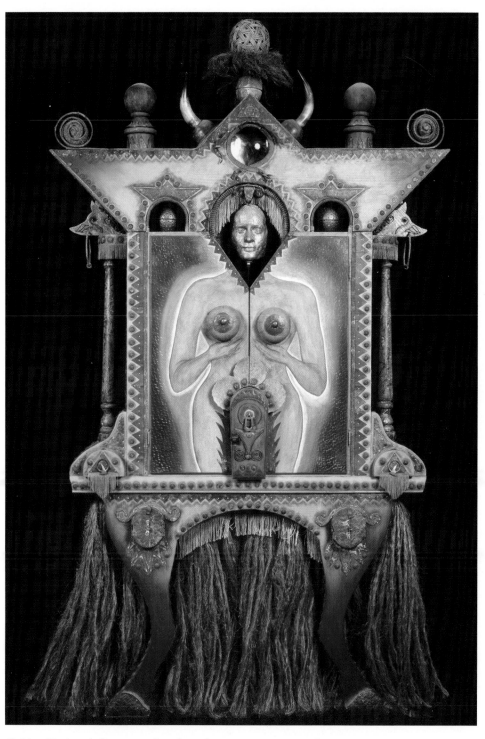

Goddess. Ringing a bell sets several mechanical actions into motion on this piece.

Grouping of five interactive beings (closed).

Grouping of five interactive beings (open).

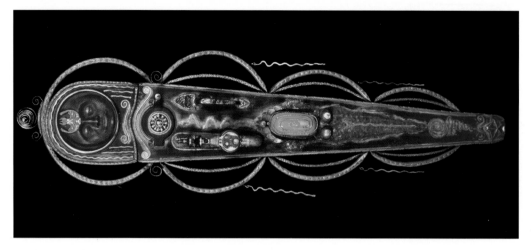

The Visit (closed).

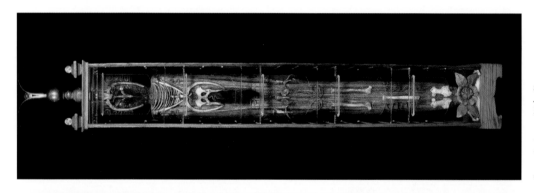

Lucy Animus (side 2).

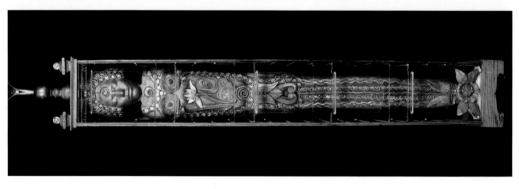

Lucy Anima (side 1). Turning the brass ball on top shifts sides.

100

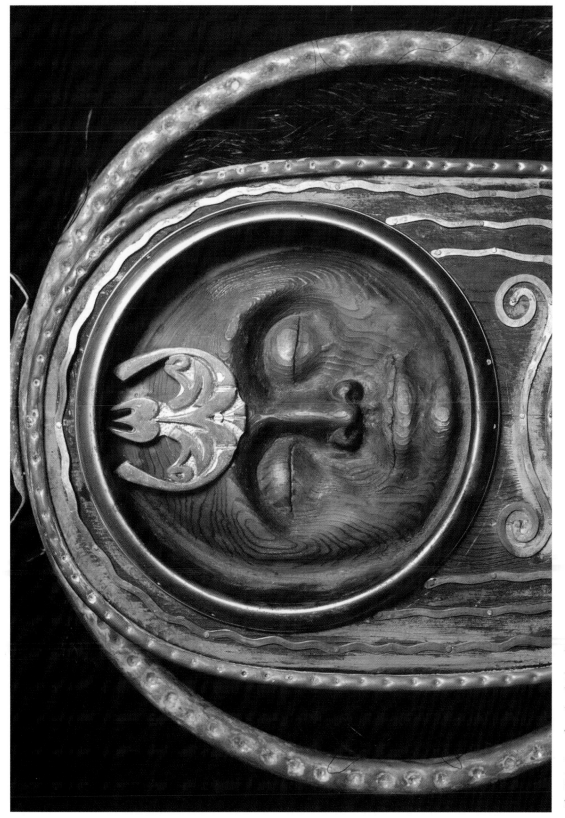

The Visit. Outer face detail (closed).

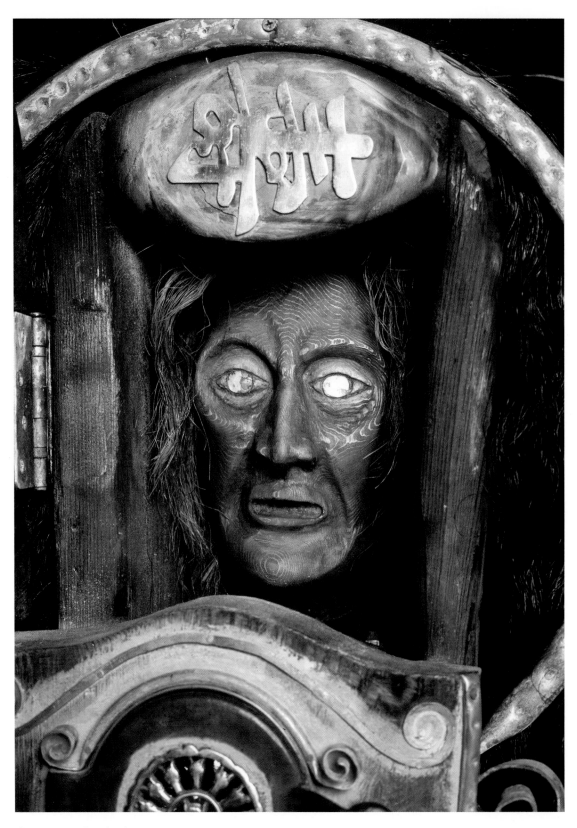

The Visit. Inner face detail (open).

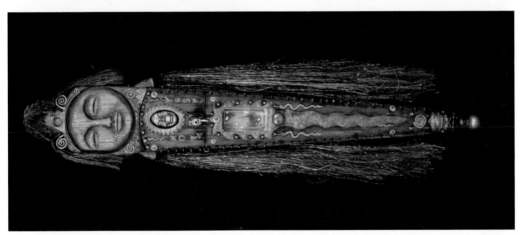

War. Pulling the trigger on the front of the piece shoots a starter pistol, which opens a door, revealing a smoking skull with a flapping jaw.

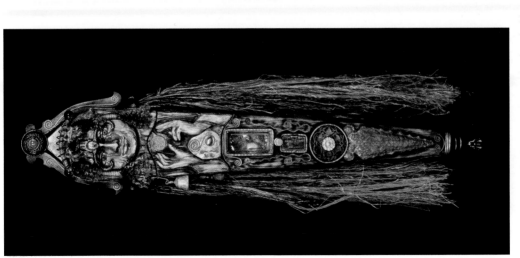

Peace. Ringing the bell opens a door and a dove holding an olive branch pops out. The piece also dispenses candy.

103

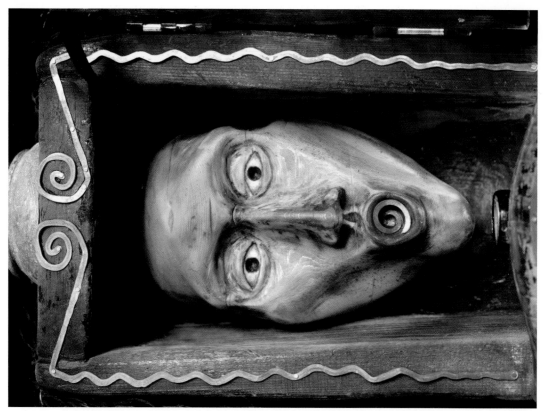

The inner face of *Ob!* (open).

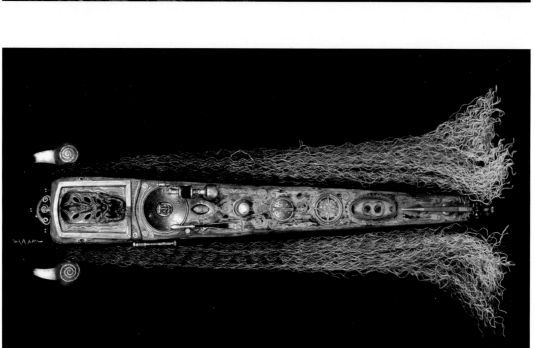

Ob! (closed).

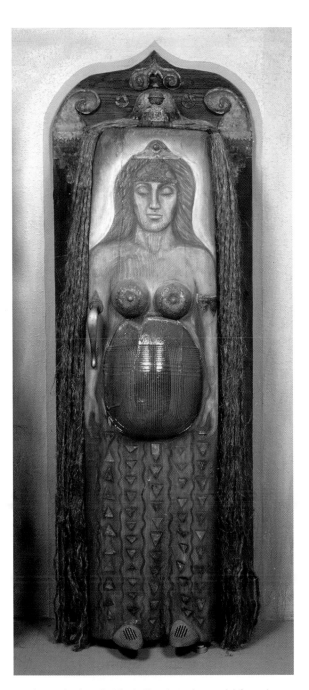

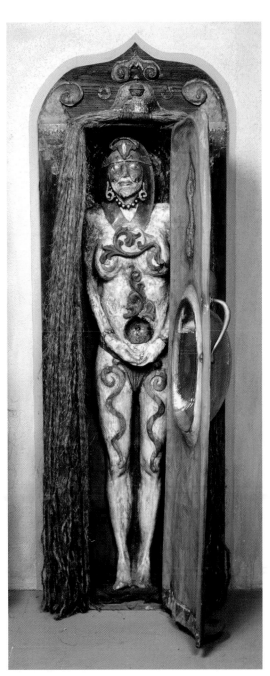

Birth-Death (closed). The belly is lit with a strobe from the womb of the inner figure.

Birth-Death (open).

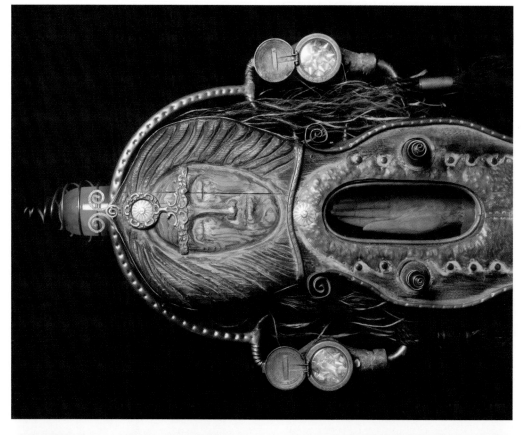

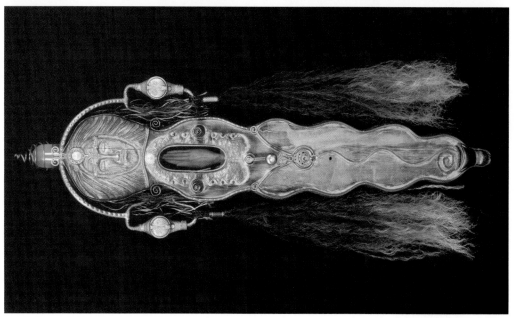

Waving Buddha, detail (closed).

Waving Buddha. Turning a crank waves the hand while a small Buddha appears and disappears.

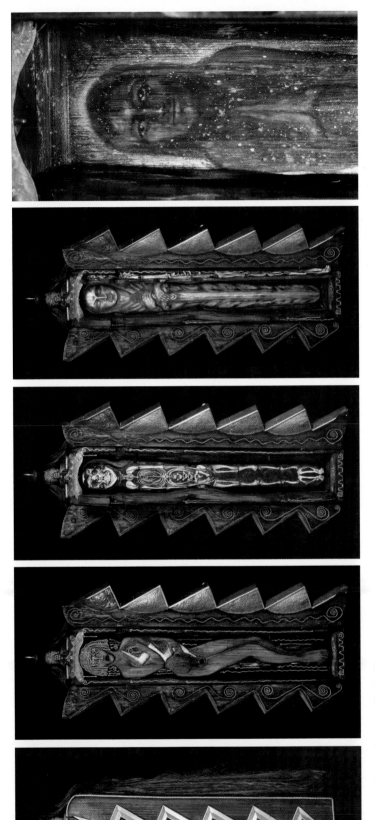

Lightning. The entire multileveled piece is 8' x 2' x 2'.

107

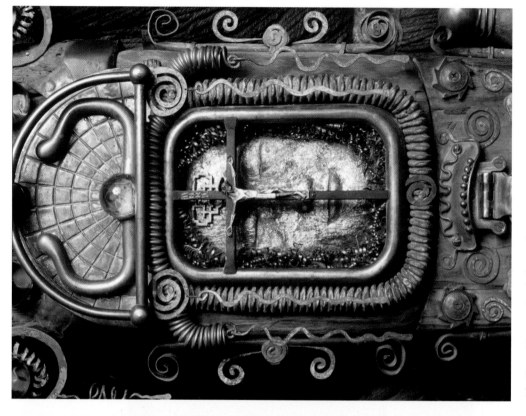

The Key to Heaven, detail of outer face.

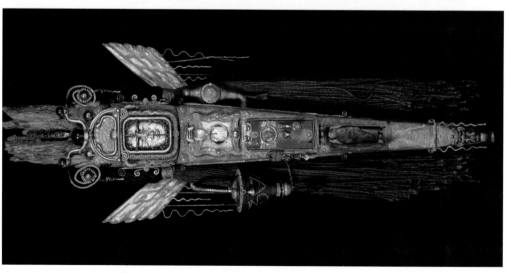

The Key to Heaven. A very complex piece that does many things, described in text.

The Angels and Demons Turning Series

1979 (work destroyed). All 80+ paintings from this series were human-scale panels, 6' x 1', painted with an angel on one side and a demon on the other. When hung from a pyramid structure mounted on the ceiling, they spun slowly, changing from demon to angel (see *Angels and Demons* hung, page 182). There were also an altar painting and a meditation platform that sat in the middle of the ten hanging panels. I called these installations "Temples."

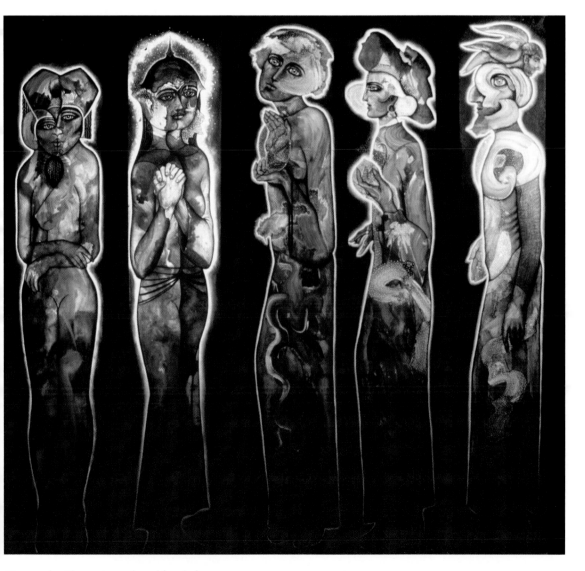

Five panels with merging male and female figures.

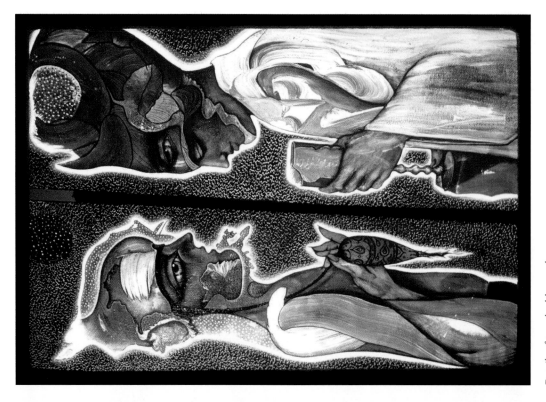

Details of two double panels.

Detail of a double-sided panel.

Marilyn and Jerry.

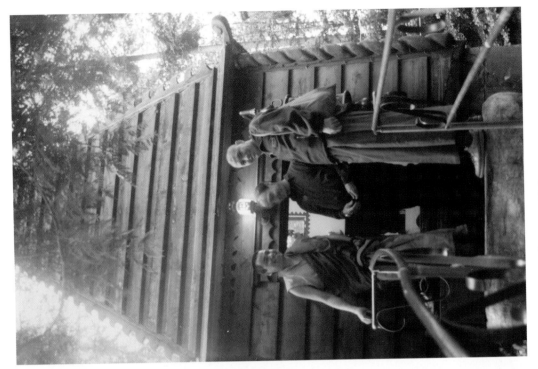

Gyuto Monks entering the tower with Jerry.

The Flaming Stupa.

disarm. His disjointed reliance on afterthought continually left him somewhere other than here and now. This made him feel unempowered, so he became belligerent. Ego, will, and aggression replaced reason. I do know that he tried hard and did the best he could. And I know that he had a big heart and was much harder on himself than he was on those around him. Kurt suffered a good deal. People avoided him. I think that is why I befriended him.

Kurt's habit of thinking about things later, rather than in the present, allowed for an effective, Zen-like approach in dealing with most of his anger. During this visit, I sat quietly while he angrily disputed all that I had said in our last meeting. On this strange day of lunar-reflected fullness I was full of shit, the spirituality I was attempting to live was bullshit, and it didn't work for him, me, or anyone else. I was a f-ing charlatan with no business giving anyone advice about anything. As his aggression peaked that day, I said, "Kurt, let me see your hands!" Interrupted and caught off guard by my request, he held out his perceptibly shaky hands. I held his hands and carefully looked them over. They were small and rough. He had short, thick, tobacco-stained fingers with almost round, spatulated fingernails. I said, "You have violent hands. Put them to good use so that you don't hurt yourself." Then I fell silent. He mumbled his disapproval of my senseless interruption and left, slamming the door behind him.

The day was coming to an end, and I was glad to see it go. I went to the window and sat staring out. It was beginning to get dark, and the streets were mostly empty. A strange half-light was casting shadows. I sat for a long while, attempting to quiet my mind and eliminate the noisy thoughts and feelings brought on by the difficult day. When I finally settled into a quiet moment, one unexpected mutant thought popped into my mind: "What if there was a violent act out on the street?" The moment I had the thought, I saw a man crossing the street and another man running out to meet him, wielding a metal pipe. The man with the pipe hit the other man on the head with it, stuffed it into the nearest trash can, and ran off leaving the bleeding man lying in the road. Immediately, several women came out into the street to help the injured man. They knew him and talked to him. One woman screamed at the assailant, calling him by name as he ran off into the darkness. The fight appeared to be a domestic quarrel between not-so-friendly friends.

The day slipped away into the shadows, ending violently, as it had begun. Jarred and shaken, I went to bed and dreamed about a time when I was held up at gunpoint in a dark alley years before.

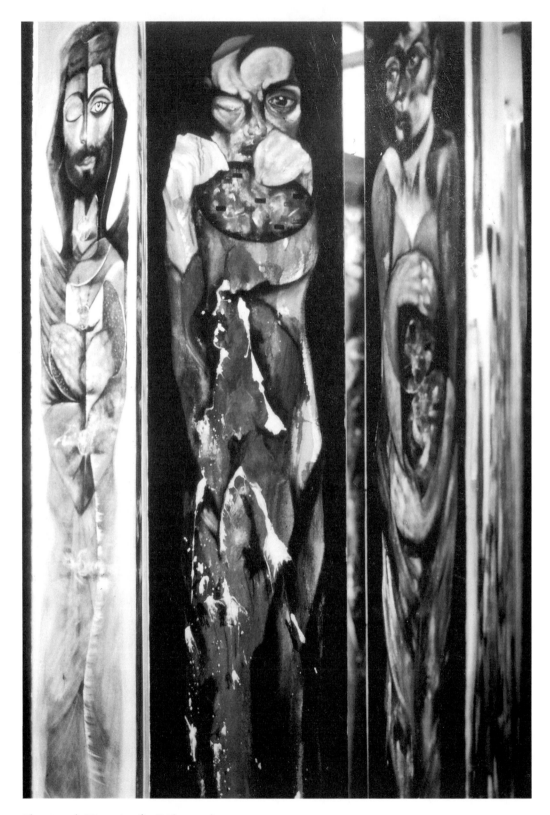

Three panels #2, turning, 6' x 1' (destroyed).

I didn't see Kurt for several days following that visit. When he returned, he was visibly shaken, looking at me suspiciously, as though I knew something that he did not. I said, "How are you? What's going on?" He told me that he had gotten into a fight and had been beaten up as he left the building the last time he was here. That discordant day seemed to have been filled with shadowy violence all around. It was as if the day itself was violent, and the unsuspecting people were acting it out.

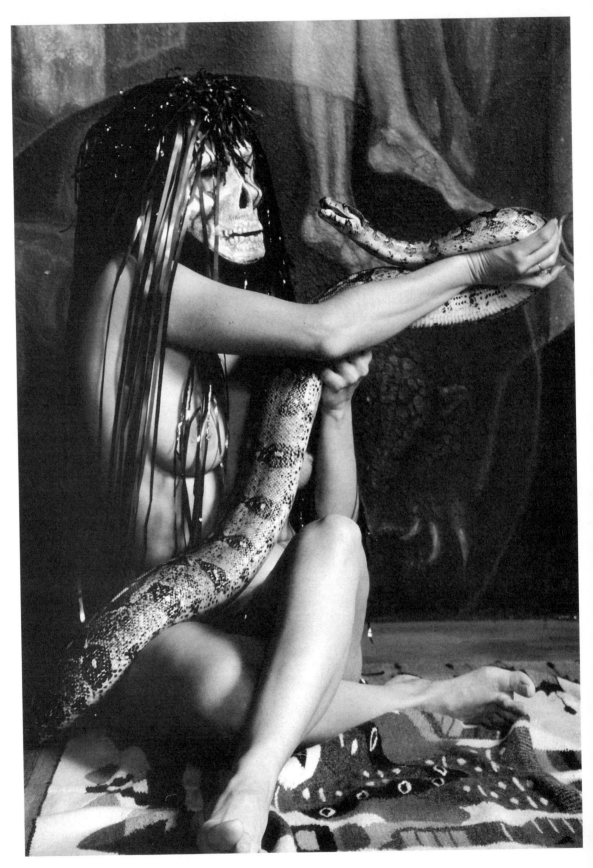

Marilyn with our seven-foot boa, Rosie.

Wild in the West

Formless

I continued to listen from within, learning to trust the ways of an unknown and formless spiritual path. I use the word *formless* loosely here. The path I followed had an unseen form. It could never have carried with it the progressive levels of understanding or the timely, saving moments of grace with their essential material gifts if it did not have its own vast, intelligent form. This fluid form was often terrifying to my small human mind, as it grappled with the all-inclusive expansiveness of infinite possibility. When our small lives open outward to include *everything,* how do we make sense of it? What becomes important or unimportant, and how do we determine those differences? I knew that an order held life in balance, an unseen glue that I could not possess. I did not understand it, nor could I find comfort in this order, because of its inherently illusive nature. I could only trust the glue to hold—trust it with my life—which is what I did.

The way life was unfolding did not fit any religious form that I, or anyone else, knew how to define. This trust was all there was. People who have heard a little of my story ask me, "Were you a monk?" or "What particular tradition did you follow?" Over and over I come up against the same moment of emptiness that I have encountered from the beginning. What am I to say in answer to these sincere questions? "I listened for the moments when *that,* which contains the vastness of *everything,* specifically led me, one small and searching individual, somewhere in particular!" I seem to answer that question differently every time it is asked. I listen deeply for what the questioner needs to support his own journey and I answer accordingly.

Most of us seek a new relationship to the vastness of everything, a glimpse of formless freedom, as we move along our spiritual paths. We intuit a mysterious power that holds us in

a particular way when we find the courage to risk, or when we give ourselves to a life that is more challenging and demanding than we have previously known. We seek this experience in many exciting ways: in the newness of a moment that pushes our comfortable edges, in fashions and trends, or in something dangerous like mountain climbing. It doesn't matter. We look for anything that makes us feel unheld, if only for one risky moment. Unheld by the collective and personal *known*. We want to be out on a limb, out of the range of human control. We want to feel the thrill of going forward against odds, risking it all, and surviving gloriously! We bring the mystery of this survival back to the tribe as a story—a precious gift to be shared, ritualized, and handed on to those not yet born. We want these myths to help the tribe survive the challenges of an unimaginable future.

My own story was still forming, and I was not sure if I would make it back to the tribe safely to tell it. I was not completely certain that I hadn't abandoned my tribe altogether when I leapt into unknown formlessness. I knew my tribe of fellow artists was threatened by my decision to destroy my art. Perhaps I was to discover a new tribe, a creative or spiritual order that I could give myself to. But I did not know how to choose such an order. If I were to find a new art form or seek out a religious tradition, how would I do that and what would it look like? I trusted that such things were up to God, yet secretly hoped that something might divinely choose me. I longed for a way to justify my strange relationship to the vastness that surrounded me. I had read many spiritual and religious books and was deeply moved by what seemed to be the essential truths common to various religious practices. If, in fact, one God was running the show, then I could not change anything significant by relieving myself of the burden of my personal interface with formlessness and taking on just another variety of worship. Worship of any other form was essentially the same as the path I had just abandoned—the worship of art.

As a spiritual path, art carried my life as far as it could within the limited scope of determined human effort and discipline. I knew I could not have given one more ounce of myself to art as worship and have survived. In retrospect, I honestly believe that my survival was at stake—certainly survival of the spirit, perhaps of the body as well. Ramakrishna has a wonderful parable about the vehicle of one's particular discipline. It goes something like this: When you take a boat across the river and you reach the other side, you do not drag the boat with you beyond that point.

I came to understand what the generations of artists preceding me had come up against: a point when the abstract, the conceptual, and perhaps even the formless presented itself as the spirit of their time. When we see nineteenth- and twentieth-century art from the perspective

of the twenty-first century, we apprehend that the golden thread moving through art history is making its way toward heaven.

First, the Impressionists released art from its sentimental fix on the literal, material world. With great courage, they explored what was formless and energetic behind the perfect depictions of flesh and bone. Next in art's heaven-bound progression came the exploration of the abstract and surreal dimensions. These artists trusted the approach to heaven by dabbling in the area of malleable spirits. Theirs was the disembodied human experience of the dreamscape. They blended open, fluid forms with solid, physical reality, inching their way a little closer toward heaven's gates.

Marcel Duchamp? He fits in somewhere and everywhere. He is a bodhisattva who knows no bounds. He was probably the first hungry shaman to invoke an antelope by ceremonially painting it on the cave wall. With great precision, he mischievously juggled art and magic, from the beginning of time no doubt. I am certain that, as an artist, he incarnates eternally, showing us how it is *really* done!

Jackson Pollock danced with the powerful energies of his raw, naked experience of art. He imploded—splattering and flying right over the wall, setting art down in an unexpected proximity to heaven. Bones dripping, he danced to the music of the universe. He trusted wildly, doubted, and died of exposure. Mark Rothko, too—veins slit and D.O.A., bleeding ever so softly into the canvas.

Then the wanderings of the conceptual artists. Impressively, they drove with no hands on the wheel, but they went more wide than deep. Nonetheless, their outrageous courage delivered art a little closer to a vast and formless heaven. Pop artists abandoned the direct pursuit of heaven altogether; instead, they indulged in the things that distract us from heaven, while simultaneously pointing them out as obstacles. Andy Warhol was the undisputed, flagrant King of Pop. No one will ever again get away with what he did. His preeminent position as the royal child of art assured complete forgiveness. Unhindered, with dominion over the material world, he took the best seat in the house, brought in all his friends, and then ravaged the place! His was truly a creative act of power, and America, seeking to justify its greed, hardly even noticed his mischievous smile.

Many of the truly great artists of the forties, fifties, and sixties, who so beautifully created the new expressions and explored the difficult spiritual terrain of formlessness, did not seem to survive their encounters very well. They skirted the formless black hole, and the best of them seemed to get pulled in and consumed by its gravitational pull.

There has to be a way, within the search itself, to survive the encounter. Within their limited control, physical and mental creation cannot contain a complete enough awareness to

allow the artist the full experience of the blast of formlessness. What if we were to align ourselves with the calm center of formlessness and dive right down the middle? Where would we come out, if indeed we came out at all? Creation obviously is pulling us in this direction. There must be an overlooked or unexplored larger dimension that can carry creation past the threshold of human expression, past the metaphoric death of form, and into a self-maintaining heaven where one can survive the creative formless encounter.

In my own exploration, I saw that what I had available as a human being and an artist was not enough. I needed a quantum leap, through a force larger than my own, to break my stalemate with formlessness. The final victory of this journey had to be so complete as to deliver *all of life* onto the solid ground of a sustainable new vision. Discovering this anew is, I believe, the terrifying and impossible task of the artists of each generation.

My immediate paradoxical stalemate was this: When form was in place, life felt like death, but so did trusting in a life that seemed to be an impossible vacuum. I experienced this vacuum in a very literal sense. It was all that was left after I gave away everything and abandoned my form of creative expression. This unresolved paradox left me open to a new spiritual form that might guide my life into an inhabitable atmosphere. Not knowing quite what to do to find this form, I stayed creatively open to all possibilities. I thought that perhaps I could enter a religious order if one were to naturally present itself. Wherever it took me, the allure would have to be that of courage rather than the fearful avoidance of formlessness. Courage was all I knew to use as a guidepost.

Something came into my life that I thought might guide me to a spiritual form. I thought that at the very least it would give me a clearer understanding of the path I was to take. Sister Adele Myers quietly entered my life and became my dear friend. Adele is a Dominican Catholic nun, an artist, and an extraordinary human being. She and David Weinrib, her creative business partner, started Thorpe Intermedia Gallery, which became the most interesting art gallery in our area. David was both an artist and a visionary. Thorpe was where the first video about my work premiered. Perhaps better described as an art *scene,* Thorpe Intermedia Gallery was located in the most unlikely place—the enormous womblike basement of the Dominican Convent in Sparkill, New York. How Adele established a gallery within the confines of a women's contemplative spiritual community was a mystery to me. Clearly, the extraordinary generosity and openness of this particular community of nuns allowed the active, noisy, and very popular art gallery to exist within its traditional religious walls. Adele had a humble, kind way of awakening those around her to inspired new culture. David and Adele had the artist's sensibility, and they brought amazing creativity into the gallery and into the shows

held there. In the late seventies and early eighties, a frenzy of creation was happening in the New York art scene. Through the gallery, those of us who lived on the outskirts of the city were given a wonderful opportunity to participate in this scene and experience what was coming out of it.

The merging of art and worship at the convent/art gallery held meaning for me. In many ways, art became the new church in the seventies! Our society's worship and money, once directed toward religious institutions, were now directed toward the salvation that art might bring. Artistic expression was the new language for expressing reverence, and artists were given free rein in its use. As the wisdom-keepers of this new church, artists could do no wrong! The more esoteric and vague the artist's concept, the more convincing of its mysterious, divine power to the doting public. The public was afraid they might persecute the artist who would be the next van Gogh. This left the art world wide open, with no healthy scrutiny. No one wanted to be condemned to the outside, holding poor Vincent's ear! While the new church held tight its reins, my own artistic worship began to crumble. To continue within the boundaries of art as I knew it would have been to leave my life in the hands of a pitifully failing god. As an identity, art had failed me; I believed it would fail others. I believed that the genuine pursuit of deeper meaning would be deadened in a society that continued to hold on to the bandwagon illusion of the false god of art. The enormous body of work that I had produced, and my hopes, dreams, and beliefs, became fodder for the creation of a larger understanding.

I also eventually had to let go of any hope of refuge in the safety and form of a religious organization. My connection to Adele and her gallery gave me the gift of a double-edged epiphany. It offered a strange liberation and prompted my reluctant return to the formless path I was somehow hoping to avoid. My work with Adele embodied the best qualities of a spiritual community. It was the most simple, valuable experience, yet in the end I was clearly not able to inhabit its form for long.

One day a friend took me with her to the Thorpe Intermedia Gallery. Adele needed help and asked if I wanted to help set up a new show. The gallery operated off of grants, and its many workers were paid fairly for their work. I had already given everything away, so I refused payment but did offer to help. The larger shows often involved significant changes in the arrangement of the space. Many people became involved in this process. Walls were built or taken down, and sometimes huge art pieces were moved, mounted, and arranged. Walls had to be repainted and an infinite number of details attended to. For this particular show, Adele and I worked closely together for several days, framing and hanging a large number of drawings.

I loved working with her. We worked in a mysterious, creative bubble. Having given up the world, I spoke very little at that time. As Adele was a nun, she was comfortable with silence. We worked together nicely, neither of us requiring much conversation other than to make occasional decisions on how best to complete the task at hand. The work involved fifteen-hour, trancelike days, which passed quickly.

In the intensity of our focus, external sounds and images seemed to drift by, in and out of consciousness. We worked in a dreamlike atmosphere. Noisy, energetic workmen arrived with their six-packs, chattering, hammer guns banging, and then disappeared. A young nun, overwhelmed with the task of painting a small section of wall, would come, fret, work for a while, and then go. A voice drifting over the changeable, fluid walls would bring to consciousness the surreal irony of David Weinrib, a Jew, directing the activity of nuns in a distant enclosure of the catacombs of a Dominican convent. All of this floating activity seemed to exist outside of the consistently creative bubble I was experiencing with Adele. At one point we looked up at each other, and she smiled and very quietly said, "Doesn't it seem like everything is going on around us?" Under any other circumstances, this statement would not have made a lot of sense. But I felt the shared reverence that comes when an undefined moment is perfectly understood without the spoken word. We silently and effortlessly worked on.

Living without money, I ate only what came by chance at that time in my life, which often amounted to very little. Fasting as much as I did, I often forgot about food completely. Then one of the nuns would magically appear with something nice to eat. The nuns' small community dog, Nawr (National Assembly of Women Religious), would wait patiently for the slow-motion crumbs to fall to the floor, and then he'd come over to explore. This was a conscious spiritual community at its best, and I loved being a part of it, if only for a short while.

I had to leave this perfection. Something happened right at the end of my work in the gallery that is just about impossible to describe. Perhaps it was produced by the conditions of little food, long hours of silent work, and the accumulated, prayerful momentum of a long-established Christian community. I don't know for sure, but I watched the world of form, convent, art gallery, art, and the company of other human beings fall away. Either it fell or I was lifted out and away from it. The liftoff was so complete and unworldly that the experience dissolved the need for forms, spiritual community, or art. I just knew that I was given passage to fly, formless. This is as much as I can say about the experience. I will allow the ineffable to remain so.

A Return to the New

The passage to fly took a literal form in relation to the gallery. When I stopped making art, I thought I would never go back to it again. I simply let it go. The film made about my art and life in 1979 was just being finished when I destroyed my art. The film was in the world on its own, separate from any further involvement on my part, so I had nothing more to do with it or with art. However, I still believed in the powerful potential of genuine, timely breakthroughs in art. I was simply at a point where my own artistic experience left completely, and I was done with art as an egoistic expression in the world.

I was certain that I had settled into a larger, all-inclusive, formless creativity, a form of exploration that I felt more alive in. I simply felt free of art as I had known it. Doing or not doing art was now all the same. Art held equal status with any of the other choices that a newly presented moment might offer. Interestingly enough, now that I was detached from it, the physical creation of art could reenter my life. At first it happened in small ways.

I remember the moment that I realized in a simple and newly conscious way that I was physically making art again. While walking down the street, I found a blank stamped envelope lying on the sidewalk and I picked it up. It had a piece of paper inside, so I thought I would write a letter to someone I had been thinking about. The stamp on the envelope was the head of someone important. I decided to draw a body to go with the head. Then I surrounded the body with an environment, which eventually became an entire scene. This simple act as an artist was a small seed, a rebirth of sorts. I knew that as long as I stayed in touch with this simplicity, then making art was just another healthy, creative way to dance with the angels, touching the physical world with aspects of that dance. I was familiar with this dance; it was a skill I had abandoned, yet it was fully developed, idling, and available. I find that the gods are very efficient beings. No aspect of life that we have invested with our hopes, dreams, and loving attention is wasted in the end. When we can release the personal identity that we so often impose on our chosen paths, and can give our gift into the hands of an alchemical process larger than our own, then our gift will be sanctified and returned. It will ultimately become infused with renewed life and power in the world. There is a wonderful Zen saying, "Die while alive and be completely dead, then do what you will. All will be good."

The tiny act of drawing on the found envelope was the beginning of creation's return flight into my life, sanctified. I was *doing what I wanted to do* in a new way. Since art was what I knew best, I brought it with me as a gift when I went somewhere to work with people, or

when I stayed in someone's home. The offering of this aspect of my life was not any sort of barter, a word people often use in trying to explain my life. Instead, it was a spontaneous act with no strings attached, done out of love. When I created art for someone, it was the natural, immediate response to the calling of a larger harmony. Response of this type and nonattachment seem to be prerequisites for the sacredness and magic of any real offering to God or human.

There are stories of Eskimos who spontaneously carved small ritual objects out of bone or antler. They carried their creations in their pockets, then left them behind or dropped them on the ground as they made their way to new territory, where they made new offerings to different spirits. The creative process, perhaps more than the objects themselves, served to empower their circumstances as they made their nomadic way to unexplored territory. The artifacts we see in museums are the mysterious offerings along the way to the unseen demons, gods, and goddesses. They are the spent shells and arrowheads—all that remain of the powerful mythic battles fought for heaven and earth. They are evidence of lives lived fully in the spirit and in the requirements of the moment's calling. The right and creative use of matter is to fully empower the living experience and to create objects of beauty in the service of enormously demanding mythic dimensions.

It is easy to indulge in the luxury of thinking that we have so many choices available to us when we decide what to do with our lives. Yet to be fully alive is to have both feet on the ground in the badlands of *no choice!* In this land, no deals are made; we simply make offerings and talk to God, even about the little things.

The form that art took as it slowly reemerged in my life embodied this immediacy. It required living unconditionally in the moment. This form of creating continues to be true for me, as I further explore it. The work that came out of my reawakening as an artist, beginning with that small drawing on an envelope, has certainly evolved. It has become larger-bodied and interconnected with every aspect of life (see pages 97–108). Since I possessed very little and lived out of a small backpack, I used what creative material I found along the way in the many places I passed through.

My artwork was accumulating in the world, yet it was invisible as a whole. It could only be experienced at the locations where I created it, often for only a short period of time. Some of what I created was not meant to last forever and would deteriorate. Like living beings, my works of art were born, lived their lives, and died.

Adele took an interest in my formless wanderings as an artist and wanted to incorporate what I was doing into an art show at Thorpe Intermedia Gallery. She approached me about collaborating on a show that would focus on the artwork created naturally in the daily lives of

artists, creative expressions that cropped up spontaneously in the noncommercial atmosphere of the living artistic environment. To express this immediacy, several artists were given the space to create installations just for the show, which came to be called Personal Touch.

It was no small challenge to gather the things I had done that resembled artwork. They were scattered about in various homes and other locations. Many of them were created as gifts; they were on the walls or in the lives of other people or organizations. Adele decided to photograph and display what could not be brought physically into the gallery. The photographs were blown up, framed, and mounted on a twenty-foot section of wall. I was also given creative free rein to do what I liked with the wall as a whole. We placed a kinetic fountain I had made in an alcove at the far end of a section of the gallery. The fountain was brought in from the New York Open Center in Manhattan. It contained religious deities dancing in circles, powered by water pumped from the fountain. The fountain had water-wheels, peeing angels, and a variety of other water-powered and electrical-powered activities. During the show, one very proper older woman stared at the fountain and said to me dryly, "Flagrant creativity." I wasn't quite sure if it was a compliment or an insult, so smiling silently, I remained anonymous.

When Alexander Calder was invited to have a show at the Whitney Museum in New York City, he arrived with only a roll of wire and a pair of pliers. To everyone's surprise, he proceeded to make wire portraits of the people surrounding him. He was creating his art show right on the spot! Learning about this, I was reminded of the way my own show came together at the gallery. I did not possess any of my art, nor did I have any art materials or a studio, so my show was created with that kind of immediacy. I loved the lighter-than-air quality this show had. It came out of nothing, and when it was over, my section of wall was painted over, the art pieces were returned to their owners, and everything that represented my particular artistic expression was turned back into nothing. This transient, carnival-like quality and the irony of all of these elements coming together in a Dominican convent brought to my mind the biblical proverb that refers to "the birds of the air that neither reap nor sow." I felt strangely like one of those birds, as without possessions or my own artworks, I was miraculously able to create the decorative display of an art show! Thus, I was moved to design my particular section of the gallery with a light-bodied, ephemeral, whimsical approach.

The personal touch I brought to this show involved a ridiculous variety of those proverbial birds of the air! I brought in plastic owls, crows, pink flamingos, and every variety of bird I could find or borrow. Some of the birds peered down from the top of the wall. I made several birdhouses in the shape of birds. There were framed pictures of birds, birds painted on the

wall, and flying birds hanging by strings from the ceiling. Finally, painted on the opposing abutments protruding out from the wall, were a life-sized woman and man, guarding the unruly menagerie of birds. For me, the show marked a celebratory stepping out as an artist into the external world again. It was fun, absurd, and for the most part, consciously meaningless.

A literal flight came to me by way of a timely and amazing gift. It was the Christmas season, and there were many people milling about Thorpe Intermedia Gallery the opening night of the Personal Touch art show. Adele walked up to me and quietly handed me a small, colorful purse in the shape of a fish, tied with a Christmas ribbon. She said, "Merry Christmas. This is from all the sisters." Then she disappeared back into the crowd. When I got home and opened the fish purse, I saw that it contained a significant amount of money. This magical gift allowed me to fly west to Whidbey Island in the Puget Sound, where I now live with my beautiful wife, Marilyn, our two cats, and another fish.

The fish appears over and over as a symbol in stories from around the world. Most of us have seen the small chrome fish frequently displayed on the backs of cars as a Christian symbol. And we've probably seen the humorous response—a larger Darwinian fish with feet, eating the Christian fish. The illusive, mythological fish has different meanings in other cultures. When a fish arrives in a story, it is often as a harbinger of salvation and new life. The fish swims mysteriously into the stories of both ancient and present-day peoples, bringing with it gifts, wisdom, or the wholeness symbolized by the sacred marriage. Perhaps this powerful fish magic blessed the fish full of dollars given to me by the Dominican women of spirit.

I used the gift from the nuns to purchase an airline ticket to the West Coast and eventually to the Puget Sound in the Northwest, where I found my beautiful island home. My arrival on the West Coast was a homecoming in many ways. What New Yorkers saw as my strange inner life (and it was strange even to me) was fully accepted and honored by the community in which I now found myself. My spiritual journey had made its way full circle, in the manner that only years of soul seasoning and grace can bring.

I received a deep imprint of practical, useful understanding from the demanding requirements of constant surrender. It was a total-body memory, like a ritual scar. The gifts and stories I acquired from this sacred wound were my compassionate offerings to friends who were in pain or confusion. I offered this freely as potentially useful information, as reference points to be used at the difficult impasses of their own spiritual journeys.

I gladly left behind the once necessary extremes of learning to surrender. I also left behind the years of constant fierce attention to the return to zero in the face of the overwhelming demands of infinity! I had lived this zero so completely that when I first came to Whidbey

Island and fell in love with this magical land, I thought that I would not be able to hold on and stay here. I moved here with no money; the contents of a small backpack were my only possessions. That was how I had lived on the East Coast, but there were new and strange gods in this Northwest—gods I didn't know by name.

I got very sick shortly after arriving here. In my fevered condition, I felt that physical reality was once again slipping away. I was sure that I would have to leave this land too, as I had left everything else I loved in my life. In quiet despair, I walked out into the rainy, cold, northwest autumn to visit a particular place of beauty for what I thought was the last time. I had felt a strong connection to this place right from the beginning. I hoped that perhaps this special place would recognize me as one of its own, as one who had bowed in awe to its majesty. I wanted Whidbey Island to reach out an unseen, loving hand and hold me down here in the place I most wanted to be.

I stood on a wall, looking into the fog and the water. A narrow culvert ran through the cement wall, carrying fresh water into the salt of the Puget Sound. It would have been an impossible opening for any salmon to negotiate, yet as I watched, one lone salmon tried. The fish looked so battered by its determined effort to get up into that little culvert. My heart went out to the creature, but I also felt my own self-pity. I climbed down the wall, closer to where this dramatic spawning ritual was being lived out, as I imagined it had for thousands of years in many more natural places. The human construction of concrete and steel the fish was attacking was probably what had caused it to lose sight in one of its eyes. I wondered what was blinding me and keeping me from seeing what I was supposed to do. What unnatural thing was I beating my head against, and what impossibly small space was I determined to inhabit, against the current of the ocean that presently held my life? I walked around to the eyeless side of my exhausted teacher. Carefully reaching out, I stroked its back gently with my finger and wished it well, hoping that God would do the same for me.

Money from the belly of a fish had carried me over the United States, and now I stood, solid and safe, with both feet in the territory of the new life. But I felt the powerful imprint, in my trained, obedient consciousness, of living for so long in the gravitational pull toward zero. In retrospect, I know that I was returning to the world. My life among the fixed and living creatures of the planet was unfolding. From the point of my arrival on Whidbey Island, I could manifest physical reality and it would hold. My arrival in the Northwest was the center point, the moment where the slack tide is completely still and begins to return its abundant waters. At the moment of stillness, there was no clear indication of what I should do. Should I give space to receiving the incoming tide or follow it out and participate fully in its empty

leave-taking? I wanted to give myself to the direction of the powerful, inevitable forces at work here, but slack tide is like a moment in which we can see with only one eye. With that one eye we see, without knowing, the present inactivity of omnipotent forces that might have just decided on the gift of abundance.

Opening up to a returning world required a readjustment. I had to readjust my wild sacrificial ways to the gentle demands of a new, kinder god. Perhaps this was a generous, abundant Northwest god of the reliable salmon people, a god who did not constantly demand his pound of fish. This god had plenty. In this land, fish with bellies full of gifts might quite possibly be the rule rather than the exception. Life here might not require the sacrifice and prayers of gentle nuns mixing potions of love and money. It might not need cloistered virgins to empower symbols of abundance in the shape of a fish, placed first on a Christian altar and then given secondhand to a hungry, formless man. And it might not ask men to become as dangerous to solid matter as the formless black holes in space are to stars.

I was starting a new life in a new land with a newly unfolding story. In this territory, the holy willingness to let things go seemed to bless them and gently, yet solidly, reposition them in life. Somehow, the very real, internal ritual of the sacrifice of what I desired from this world was enough to sanctify the dream of matter and bring it to life. Through detachment, dreams placed on the altar could exist in reality.

As I write this, fifteen years later, I must tell one more story about the power that zero patterning still has on my psyche. I thank the gentle, deeply feminine spirit of the earth for making the world of matter a beautiful human experience. I believe that our essential willingness to sacrifice matter for spirit is an expression of the masculine element of our being. Our mother, earth, is feminine, and far more generous and forgiving.

Just a year ago, my wife, Marilyn, and I were in New York for a film presentation at NYU. I had made arrangements weeks before to stay with Florence, an old friend, now in her eighties. She lives just outside the city in Nyack, New York. I had spoken to Florence on the phone once or twice over the years but had not seen her for more than ten years. She is a writer and one of the brightest, most intelligent women I have ever known, but Alzheimer's has begun to shadow her once sharp and beautiful mind. She did not remember we were coming and was away the evening that we were dropped off on her doorstep, suitcases in hand.

Nyack was where my loft had been—the place where I destroyed my paintings and most directly lived out my personal relationship with the void. The experience of walking those streets as I had walked so long ago, with the memory of having nowhere to go and the distant feeling that physical reality was slipping away, shifted my reality into a completely transpersonal

state of being. The transpersonal state is where I know to go when I am willing to "die" for the survival of the spirit. I don't know how else to describe this state. I have watched small animals caught by my cat go into that state of transpersonal being. I have also revived them with the basic materials of the earth—warm breath and love. I believe that this transpersonal condition, when experienced unconsciously, is defined by the medical profession as shock. Timed perfectly and made conscious, shock is giving oneself—body, mind, and soul—to the conditions necessary to effect resurrection in the truest sense of the word. It is the saving of the soul through grace when the conditions holding matter in place falter. There are no guarantees for the body in this world. Physical life or any excessive identity with the body ultimately becomes a useless investment. Death is relentless and unavoidable. As an inevitable cyclical event, the death experience offers the possibility of supporting soul life with or without the body. Paradoxically, the knowledge of how to give oneself to death with right timing renews and furthers physical life. This is the essential meaning behind the idea of resurrection. It is all a cosmic game of musical chairs, and knowing how to set to rest one's human efforts when the music stops is to find renewal and to win a seat in the best of both worlds.

Going into the transpersonal state in Nyack that day was very automatic and unexpected. Marilyn said to me several times as we walked along the street, "What is wrong? Where did you go?" All I could say in response was, "I am okay, don't worry." The fact is, I was already flying somewhere above the earth, flying for myself and for Marilyn. I knew how to survive and how to help others survive, and that was a mystery that would only lose power if spoken about once I was airborne. At least that is what I thought! The interesting and unexpected turnaround was that Marilyn saved me by staying on the earth and buying a new pair of shoes!

I had returned to Nyack after being away for many years, and I was in a different phase of life. We had credit cards; any of the six motels in Nyack would gladly leave the light on. I was in the hands of new, more permissive, worldly gods, who no longer required the full surrender of the earth as they had done previously in my life.

Earlier that day, Marilyn and I had gone into a shoe store to ask the whereabouts of an artist friend I knew years before. His studio had been above the store. About an hour later, when I was still trying to hide my altered state from Marilyn, she asked if I would return with her to the shoe store. She wanted to know what I thought of a pair of shoes she had seen and liked. We returned, and slightly dazed, I watched her childlike excitement as she put the new shoes on. There was something about this simple act—the woman I loved, eyes sparkling, was happy to be exactly where she was, both feet on the ground with shiny new shoes, standing naturally as only a woman can, on this good and feminine earth. Marilyn's simple, innocent

claim to walk this lovely earth with beautiful new shoes brought me to tears. I turned my head and stepped outside, my own two unpolished shoes back on the ground as well. Marilyn makes the earth inhabitable.

Island Light and Shadow

Coming to Whidbey Island in 1987 marked the completion of a circle from world to world, a return. It was my deliverance back into the world that I never really wanted to leave. Before this, I had only been to the West Coast, briefly, one other time. In 1970, I rode an old Norton motorcycle across the country and spent a short period of time in California. That visit awakened in me a dream of returning to the West Coast someday.

I came to Whidbey to visit my longtime friend, Deborah, who had been living here for several years. A summer festival at the Chinook Learning Center (now the Whidbey Institute) was about to begin when I arrived. Deborah had made arrangements for me to attend as an artist in residence, to work with adults in exploring creativity and art. This basically amounted to participating in all of the wonderful events and spending time in the Art Barn with festival participants. Armed with a variety of art supplies, my task was to help people bring their ideas into creation.

My connection with the Chinook community proved to be central to my new life on Whidbey Island. I met many generous people who helped me establish my place here and inhabit my role as a citizen of the earth. Fritz and Vivienne Hull, the executive heads of the organization, started the Chinook Learning Center in 1972. When I arrived in 1987, if the Chinook community were a living body, the heart of that body would have been Jim and Jo (Joann) Shelver. The path my life has taken on Whidbey Island would have been quite different had it not been for the kindness of Jo and Jim. I would like to believe that something special about me inspired their generosity, but the evidence would not support that claim. I was just one of many to whom they have opened their hearts and lives. They helped me establish a beautiful life on this island, and for that I am grateful to them both.

I felt both blessed and reticent as I connected with Chinook and explored the new territory of spiritual community. My own spiritual path had been forged in the solitary and pathless desert of personal inquiry. My path revealed itself through an unknown language, and it had

no religion and no community to contain it. While I remained available to others throughout my journey, I was alone in both the lowlands and the mountaintops of my spiritual quest. To depend only on God was simply one of the requirements of a life of faith, as I understood it.

Suddenly I found myself on the other side of the country, involved with a conscious group of people who were interested in spirituality and community. This was all wonderfully new to me—a possibility to be explored. This community gave me the gift of their deep acceptance; they honored my unusual story. Rather than seeing my inner work and sacrifices through a worldly lens as a loss, they saw them through a spiritual lens as an important gain. Over the years, I had managed to hold steady my faith, vision, and belief in this gain, sometimes under enormously challenging circumstances. It was enlivening to be surrounded by people who reflected back to me the importance of the life of the soul—the life I valued most. The treasures I gathered as I made my winding way along my particular spiritual path were now being valued and pressed into the larger service asked of me by these people.

As a spiritually based educational organization, the Chinook Learning Center modeled itself after a Celtic Christian monastic community that once existed on the island of Iona, off the western coast of Scotland. The Iona monastery was a center of advanced spiritual learning, started by Saint Columba in the year 563. The community was based on a powerful blend of Pagan and Christian elements that reportedly brought the heavens and the earth into balance. The monks came from many places to pray and to learn the ways of Mystery, drawn by the reputation Iona had as a truly holy place. It remains an important place of pilgrimage for many to this day. Modeled on the Iona monastery rather than on the intentional communities of the sixties and seventies, Chinook was a covenant community or a fellowship of consciousness. Its members, living in different parts of the world, were held together through their commitment to a common spiritual covenant.

Chinook had much to offer: acres of beautiful, protected forestland to gather on, several charming old buildings, an abundance of good people, and exciting, cutting-edge ideas. As an educational center, it was as good as any learning institution could be. Inspiring people with wonderful minds often came to speak and lead workshops—people who expressed new and interesting ways of looking at the world. The wonderfully supportive peripheral community was like nothing I had ever known.

Chinook had a close relationship to Scotland's Findhorn community, which I found most interesting. David Spangler, one of the original founders of the Findhorn community, was significantly involved in the early development of Chinook, providing spiritual direction. Spangler envisioned Chinook as a flywheel that would let people connect with the community,

be impacted, and then spin them back out into the world. Our beautiful island community is the result of that spin-off.

However, Chinook's inability to fulfill the deeper spiritual needs of people in the community was a little confusing to me. I stayed open and continued exploring what was possible in a spiritual community in general and especially here at Chinook. Because I had arrived here, I trusted that there was something here for me to discover. I found a friendly, but not significantly spiritual, resonance with Chinook's founders. This being the case, it was difficult to imagine how I could connect in a deeper way to Chinook.

In my first years on Whidbey Island, I felt I had entered into an interesting, undefined relationship with the Chinook organization by means of my involvement with people passing through. I saw a dying/rebirth process going on in the organization and defined it as such, just as I would have for an individual going through the process. It had all of the symptoms. There was a good deal of discontent, the covenant community had disbanded, and Chinook started coming undone shortly after I arrived.

Through a long series of difficult, and for many people, painful events, the Chinook Learning Center reemerged as the Whidbey Institute, with the original founders intact. After the turmoil and a lot of shifting around, I did not see that any real and significant change had occurred. If the existing system had not survived the transition, change might have occurred at a deeper spiritual level, and a real renewal might have been effected. This renewal is being asked of all of us at this time, individual and institution alike. Without it, nothing but the externals can really change.

The simple fact remains that we do not make very good gods. We tire easily with the huge effort to maintain omnipotent control of our lives and our creations. A holy death is a relief and a retirement plan of sorts, in which we effortlessly let our beloved creations be carried by forces larger than our own. The sacred wounding of a fully experienced holy defeat becomes the only real salvation for individual and organization alike.

Many people were reeling from and spinning off painfully in reaction to what was happening at Chinook. These people's first reaction was most often anger, along with a civilized, self-imposed silence about whatever they felt was unhealthy. The general rule in any well-intentioned organization is to show no anger and say nothing unpleasant, especially when the anger could fly out sideways and inadvertently behead some unsuspecting community member.

In my exploration I never found a healthy way to enter Chinook, and I was quite happy to remain on the outside. Because of this detachment, I was able to be of use to others who had

inadvertently gotten enmeshed. I held out to others the freedom and the disentangled perspective I held for myself. This left me deeply involved with the inner workings of the organization through the people involved.

The people who arrived here on Whidbey Island were receptive to the changing demands of the times. They were often leaving lives with which they had become disenchanted. Some of them invested all their hopes and dreams in the possibilities held out by Chinook; others just seemed to gravitate to the conscious support that organically developed in our small community. Their move to the island often initiated exciting and terrifying changes in their world.

A great, collective shift seemed to have occurred in general. Some people tried to identify this shift by naming it "the harmonic convergence." For most of us who were experiencing significant change, personal upheavals often brought with them challenging losses, and in the end, the potential for a wonderful, conscious, new creation. The skills one needs for managing the details of this creation are acquired almost entirely as the result of one's ability to let go of the past.

This is a powerful time and a powerful island place. Those who find the courage to fully traverse the shaky, shifting sands underfoot are the ones who contribute to the beautiful, emerging way. Whatever we may call it, many people are drawn into the service of this shift. Like others on the island, I am very much involved with new people who arrive and go through important changes. The work is the same now as it was when I arrived, although my circle of involvement has expanded.

When it is navigated with grace, change is always a creative process. My exploration into this process leads me to the conclusion that deep surrender to change is healthy, inevitable, and unavoidable at this time on the planet. If we are to pull through as individuals, as a collective whole, and as a planet, it is the most important work to be doing today. However, each individual has their unique timing for becoming involved in this work.

Before I came to the island, I trusted my unusual path, but I did not understand how the life I lived would be of service in the mainstream culture. In my journey, I came to terms with the mythic dimensions of my path. When something in our lives initiates this mythic journey, we tend to take it personally, because of the very real difficulty involved in letting go of that which we see as our life. To my surprise, I can now use what I discovered from that transpersonal point of view to help others. Now my move to Whidbey Island makes sense to me in relation to the "death process" I surrendered to in 1979.

This is the work we all must do before we can be of service in our world. A saying by Lao Tzu goes something like this: First, we must do our own personal work, then we tend the

necessary work of our family, then our community, then our world—in that order! Most of us go about that process quite backward, first jumping into the world and bringing our messy, unresolved issues with us. The attempt to do anything significant in the world before we have been deeply changed ourselves is a way to avoid real change. Good intention counts for very little in the mythic journey! Doing our own work *first* leads to our true and unique participation in the world we wish to serve.

The change going on in the collective is enormous; it has irrevocably shifted consciousness to a new level of intensity. The basic requirements of daily life have become impossibly demanding, especially in materially oriented countries like our own. The inevitable shortcoming of excessive materialism is now revealing itself. We have more now than we have ever had of things, comforts, and sensate distractions, yet in equal measure, we experience more discomfort and meaninglessness.

We all change together in ways that are not under our control. We cannot know the outcome of the difficult work we are required to do. We simply have to trust the process. What we can unconditionally trust about change is that ultimately *beauty creates beauty*. However beautifully we can stand alone in what feels like death is how beautifully we stand in the new life. Our courageous stance in the face of death creates integrity in its truest sense. We cannot impersonate true integrity.

Once a larger shift has taken place, we choose as individuals whether we will accept and fully turn into the change at hand. The longer we avoid the holy process of real spiritual renewal, the more we suffer uselessly. This is true both personally and collectively.

What is the whispering message of divine law trying to tell us? Once we arrive at the answer to this question within ourselves, we can direct the journey of our world toward a beautiful, collective reality. The gods do, indeed, whisper before they scream. The only real power we have to eliminate useless suffering in our world is to remain attentive, as in prayer, to the whispers instructing our choices. The challenge for all of us in the West is to hear the quiet instructions first, and then to maintain that listening in a screaming, material world. Deep listening is a fearless, creative response worth cultivating above all else. It is creation's priceless pearl, which can roll with us through the inevitable deathlike experience and deliver us back into effective life in the world.

There is evidence of this listening! Artists and other sensitive listeners among us are usually the receptors of subtle change. They hear the whispers first. There are many indicators of a conscious golden thread running through the emerging culture. I am most familiar with the thread of light revealed by art history. True creative expression, seen as a series of consecutive

art movements, is like the trail of a star as it shoots across the sky. It is meaningful creation written in light, evidence of something luminous and largely aware, moving across time. Creativity brings into form inspired, new reality. Perceived from a retrospective vantage point, art history is simply an evolving series of divinely inspired whispers arranged neatly in a row. Intuition of the language of the stars is given to anyone fearlessly willing to let go of the past and to open themselves to the emerging forces of the divine.

Literal creative expression is secondary. The most direct manifestation of inspired creative breakthrough may very well be the blast of formless direct experience alone! In a creative moment of earth-shattering awe, emptiness paints its final masterpiece in starlight. Artistic expression can only offer a hint of this direct experience.

When we have experienced the mythic dimension underlying all of matter, we are then able to link it to the creative life going on around us. A receptor of the whispering star trail, Dorothy Fadiman (the visionary filmmaker) had an interesting insight into the transpersonal dimension of my own small encounter.

A few years ago, Dorothy visited us. She watched the film that was made about my art and life in 1979, which has now been incorporated into the 2001 Parabola video. The film ends with me talking about destroying my artwork, letting go of my worldly life, and in essence, leaping into the void, which for me, is the ultimate creative act. After watching the film, Dorothy sat silently for a long time, and then she turned to me slowly and asked, "When exactly did you do that?" I said, "In September of 1979." She became very quiet again, then lit up and said, "I felt *exactly* when that shift happened in art too!"

This is not *my* story; it is *our* story! If it is genuine, my success in grappling with the whispers of the terrifying void is your success, and yours in listening to your own whispers is mine. So basically, who can claim as their own the big bang of an evolving story that belongs to all of us? We do, however, each have an essential part to play, and that part is usually more than most of us can accomplish in one lifetime. However, the conditions of this time offer us an especially good possibility to fulfill our part. I believe that this is a holy time, in which conscious participation in our own full awakening is very possible.

When my own whispering angels brought me to Whidbey Island in 1987, I was just beginning my return to the world, while most of the people I knew were exiting from their conventional involvement with the world. These people were attempting to simplify the excess in their lives. The ripe fruit of my own spiritual journey corresponded perfectly with the spiritual hunger I perceived around me. My usefulness to others was simply that which I had become. My small offering was the magic of letting go and my unconditional trust in what could easily

be perceived as devastation and loss. The simple understanding I had to offer was useful in the service of others going through the same collective process.

In my life in New York, the personal challenge that confronted me as I released my worldly life into the consuming emptiness was that of maintaining clear direction in a state of complete dissolution. I could not be sure that I was not dissolving completely into the void. I could maintain a small navigational clarity in the emptiness to which I gave myself only by staying attentive to the creative, defining moments of grace as they presented themselves. Grace opened the doors to the necessities of worldly life and the doors that offered deeper understanding. Grace pointed out the next step I was to take. It was terrifyingly simple!

The challenge in coming to this new island life appeared to be the reverse. But in the fullness and swirling flood of a world returning, my task was the same—to maintain a clear and accurate dialogue with grace. Either way—whether receiving the world or releasing the world—the important thing to focus on was exactly the same. How clear and well we communicate with our whispering God is *all* that really matters.

I must admit, however, that it was a nice change to be challenged with too much of the good earth's abundance, rather than to rely on the formless misty-above for what I needed! It is clear to me now that one condition could not have existed without the other. Therein lies the enormous, impossible paradox in the creation of a life in balance.

The personal difficulties of the people I was involved with often had to do with the loss of a sense of spiritual purpose. Many of these people were connected to Chinook. Few people found a spiritual center that they could deeply connect with for very long.

Establishing a connection with any external form, including an organization, must happen in a creative, alchemical way. Some small passageway needs to present itself. It is similar to the magical way we enter deeply into a work of art. I have watched people come into my studio and approach an art piece. I notice how they openly search for a way to understand and connect with it. Often, they finally enter through one small moment in which an intuitive recognition occurs. An image or a feeling provokes a poetic longing, or something recognizable blips on the radar screen of their heart. The opening of this portal allows entry into the whole of a piece.

I watch for such a portal as I attempt to define a new creation whispering to be born or determine what new direction I am to go in next. I trust the deeper resonance behind these poetic links when they occur. To the best of my ability, I do not go where that magic does not lead me. I searched for that kind of entry into Chinook/Whidbey Institute, and although I remained open, I never really found it.

This is an important time in our world, and wonderfully determined people are suffering through it with great courage. They are arriving at new levels of understanding and a solid faith in the unknown. These people truly inhabit the territory of the emerging consciousness. If even one human being can meet the requirements of full surrender and come through awakened and whole, then why can't two, three, or more? And why can't this group organize, teach, and hold firm to the holy science of what they have discovered? These would constitute the right basic requirements for an evolved, working organization!

What I speak of here is quite different from the work of many intelligent minds in our places of higher learning, where knowledge is most highly valued. I speak on behalf of soul work. Mind, however brilliant, comes along for the ride, most often arriving late to the inspired leaps of consciousness. The challenge for the intelligent mind is to adopt the healthy condition of *not knowing*. This is a nearly impossible task for a mind seeking control, power, or position.

I believe that what we once thought of as enlightenment is no longer reserved exclusively for the mystics. We have arrived at a point in our evolution where the conditions of enlightenment are required of all of us if we are to survive. Enlightenment is not a grand finale that leaves us blissfully risen, Buddha-like, above the suffering of the world. It is deep and unconditional surrender to what already exists and total trust in the larger inherent intelligence, which is willing to lead the way. To accomplish this is to die to everything we think is our personal identity, however intelligent, successful, and noble we think it may be.

Marilyn and the Madrona

The Chinook Learning Center housed a small restaurant called the Madrona, situated in the little ferry dock town of Clinton, Washington. The Madrona was a nonprofit organization created to benefit our local Waldorf school. It was in Chinook's Dodge Building (now the Clinton Union), and it was staffed by volunteers.

The first time I visited the restaurant, someone asked me if I would like to help in the kitchen. The restaurant had a nice feel, and I loved Jo Shelver, who ran the place then, so I said, "Yes." I spent that day helping out, meeting people, and working hard, doing endless piles of dirty dishes. As I was leaving, one of the people who worked there asked whether I could fill in on Tuesdays on a regular basis. I fumbled for an answer. A regular schedule had

been alien to me for so many years that I did not think I could make that kind of commitment. I lived in the moment, maintaining the ability to leave the ground at any time. That is what my life seemed to ask of me, and I was ever ready for that possibility. Although I wanted to help out, I was not sure at that point that I would even stay on Whidbey Island, so how could I possibly tell anyone I would be somewhere on a regular basis? I said, "Well, I am here now; if I am here then, I will be." I showed up that Tuesday, and returned on a regular basis for at least a couple of years. For the most part, I loved the grounding of doing something on a schedule. It was nice to be a component of a world in place, serving hot soup. However, I was uncomfortable at first. I felt so routinely apparent and public. This was more external an expression than I was accustomed to. I once asked a very down-to-earth, pregnant friend if it was hard to be pregnant. She said, "Well, being pregnant makes you very apparent, and everyone knows what you've been doing." That's a little how I felt working in the restaurant.

The days turned to weeks, and eventually I managed the restaurant. I opened and closed and recruited volunteers. It became something of a community club. Friends jokingly called the restaurant Jerry's Baghdad Cafe, a name taken from a poignant, whimsical film that was out at the time. The Chinook offices were upstairs from the Madrona, and over time I got to know many new people who frequented the restaurant. The restaurant was a place of human interaction, prayer, tears, laughter, and incidentally, good food. I had the freedom to stop what I was doing at any moment and be with someone who needed to talk or go for a walk. I felt that the restaurant was there to serve those human connections. The restaurant needed only to meet its expenses, which it didn't always do. I gave many a free meal or cup of coffee away, or a special ice-cream sundae to children. I loved being able to give! There were no salaries involved; people gave of themselves freely, just because they wanted to be there. Everyone worked hard and created a wonderful community life in an atmosphere of deep and often ridiculously playful sharing. Many remarkable people from the extended community helped out at the Madrona, cooking, baking, or doing the books. I served food, washed dishes, and talked to people. For me, as well as for many others, the Madrona was the gateway to the golden city of the larger community of Whidbey Island. To this day, people approach me on the street—often people I don't remember—to tell me that their first encounter with life on Whidbey Island was at the Madrona Restaurant and that it was such an important connection for them.

My guardian angel, Jo Shelver, arranged a room for me in the home of Chinook's secretary, Kay. Kay was a beautiful older woman with the genuine and consistent detachment of true Buddha nature. When I first met her, I thought she could not really be as detached as

she appeared to be. Many people believe that they are above the circumstances of life, but when something goes wrong, they are often enmeshed and complaining in no time. By spending many a night sitting around the kitchen table with Kay, drinking hot tea, and getting to know her better, I discovered that she had an amazingly healthy detachment. She seemed to have little patience with useless, unfruitful suffering. I was in her life in the years of her father's death and her son's death. I visited her just days before her own untimely death (a phrase she would not have used). I found her clear, strong detachment, even in the face of the worst suffering and ultimately her own physical death, to be incredible!

Kay became my dear friend. When I ran the restaurant, each morning I brought her decaf latté upstairs to the Chinook offices, where she worked at the reception desk. One day Kay came down from her office and said that Marilyn Strong, a woman on staff at Chinook, was upstairs on the floor of her office, devastated and crying. She had just received the news that her husband wanted a divorce. He had become involved with one of her best friends while she was away at school in California a month earlier. Kay seemed a little confused in her Buddha-like, detached way as to why Marilyn would lose it so completely and suffer so under the circumstances. I asked Kay if anyone was there helping Marilyn. She said, "No." I found myself a little bothered by this information. I thought, "This is supposed to be a caring, conscious community. Why isn't anyone helping her?" (I found out later that many people in the community cared a great deal about Marilyn, and they were actually very much there for her through this difficult time.) I decided right on the spot that I was going to help Marilyn. I knew about death, and I knew that what she was going through would look like death to her. Interestingly enough, "death" was about to be given a more complete expression in Marilyn's life. Within a very short period of time, she lost her job at Chinook, the covenant community disbanded, she moved out of her beautiful house into a small, one-room garage apartment, and then—the final blow—her beloved, fifteen-year-old cat, Willy, disappeared!

I did not know Marilyn very well before this; we had met only a few times. Marilyn and her husband had been involved with the Chinook Learning Center since they first visited years earlier as idealistic young college students, and Marilyn had been on staff for several years. News travels fast in a small community, especially when it's about people active in the community life, so I had heard about her husband leaving. Whenever I saw her, she looked as if she were going through a personal hell. I saw that she was very introverted; she looked like someone who needed a lot of space. She took every opportunity to remain separate from the crowd, often sitting off to the side with one or two close friends.

As I was closing up the restaurant on the day that Marilyn received her divorce summons, she came in. She had obviously been crying. She had lost so much weight during this prolonged ordeal that she was skin and bones. My days at the restaurant were so full of people that I didn't know how I could possibly be with even one more. Nevertheless, I made her lunch, and when she was finished eating, I made her a latté, put it in a to-go cup, and said, "Let's go for a walk." This began our long friendship.

The Madrona brought many loving connections into my life, and I was slowly opening back up to the possibility of an intimate relationship, a possibility that came into my life with an overwhelming vengeance. There were no half measures. I went from a very clear position of holding relationship at bay for many years, to feelings of deep and equal love for a number of attractive women! I did not know where I was going in this regard, so I held the position of unknowing with all the strength and courage I had. I had been burned before, and I did not wish to get lost in something complicated or destructive for others, the community, or myself. I grappled with a strange, unromantic question. I knew I could love many people at once, so how could a committed, monogamous relationship be possible or have any real meaning for me? I remained detached and watchful, with relentless attention to what the heavens had in mind, and stayed open to the possibilities. I once asked a close, married friend of mine how she had arrived at the clear realization that allowed her to choose marriage. I wondered how she came to believe that one person was *special* in her life, when everyone requires our love. Unfortunately, she didn't have a clear answer. Maybe there was no clear answer.

I remembered reading about Ramakrishna's unusual arranged marriage. Arranged marriage was the norm in India, however Ramakrishna was an unworldly mystic, and his marriage remained unconsummated. He said, "Life, death and marriage are up to God; everything else is negotiable in this world." If this was true and I was meant to be in a relationship, then somehow this understanding would make itself clear to me. Until this became clear, I knew I could hold on to no one, so I simply let relationship's natural process have its way.

Marilyn is the deep embodiment of all aspects of the feminine spirit; she holds the vastness of the feminine mystery as well as a wild and melancholy nature. She has the capacity to enter a variety of states, sometimes switching from one to the other, and then back to center, with the fluidity of a child. When she was sad, her feeling ran so deep; her tears were the saddest I had ever seen. I used to call her the Virgin of the Rocks, after Leonardo da Vinci's famous painting of a melancholy Madonna. Watching her cry, there were times when I envied the honesty and infinite depth of her feelings. Her suffering was as changeable, elegant, and mysterious as she was. She was in no way needy, and yet her healing process required an

Marilyn.

enormous amount of loving attention. Because she expected nothing from anyone, it was very easy for those of us close to her to give her that attention.

Marilyn had a dream around the time of her divorce, when she felt her identity and personal power were being stripped away. She told me the dream, and we worked together on interpreting it. I have done quite a bit of interpretation of my own dreams and of others'. Dream imagery is similar enough to the symbolic imagery of art that it is not much of a stretch for me to interpret the writing on the interior walls of the dreamtime. Marilyn's dream seemed to point the way to reempower herself after the devastating experience of loss from the divorce. I saw the dream as holding out something new for Marilyn, something pivotal, not yet born. I also saw this powerful new presence shyly peeking out from her soul on occasion. Her empowered being was somewhere between her dreams and her tears. Its potent innocence seemed to emerge when Marilyn surrendered to her circumstance. Remarkably, the human psyche invariably interprets the tears of surrender as a powerless defeat,

when in fact they can give us the greatest proximity to truly divine power we can attain. Marilyn accessed this power easily, and through the imagery of dreams, it became more defined and available for her to claim.

I found one dream that Marilyn told me so moving that I decided to paint it for her (see page 156). In the telling, I got such an immediate, clear image of the gift of her deeper identity that when it came down to doing the painting, it happened quite easily. I used the only paint I had—latex house paint that I had found at the thrift store. I finished the painting in three days in the stockroom of the restaurant after we closed up at night. I told Marilyn that I had a gift for her and asked her to come to the restaurant later that day when she was free. When she walked into the restaurant, the painting was sitting on the counter. When she saw it, she was visibly shaken and appeared to come slightly undone. She grabbed the painting and hid it in the back room of the restaurant under the towels. I thought that maybe she didn't like it. But she said, "You shouldn't let anyone see that!" Later, when I talked to her about it, she said, "I feel you have captured my soul and I couldn't have it out in public like that." The larger part of her, beyond the present suffering, was being encouraged, through dreams, to emerge whole and strong. However, it was still tender and not yet ready to be seen in the world. The amount of time it took Marilyn to be ready for anyone to see that painting was about the same time it took that part of herself to emerge in the world. Marilyn had her own timing and she intuited her way, doing what came next when she was ready.

The wild side of Marilyn's personality knew what she needed in her healing. To process her anger, she would go out daily with a tree branch and beat the hell out of an electric power pole! One day she came into the restaurant embarrassed. Opening her wallet, she said, "I owe you for a cup. I accidentally broke one." I laughed and said, "You smashed it, didn't you!" With a guilty smile, she confessed that she had. She said, "I hurt my hand, hitting the pole, so I smashed a cup instead." It was all healthy, unfettered, spontaneous healing ritual, which little by little worked to strengthen her. She knew intuitively how to take care of herself and not hurt anyone else in the process. On occasion, I would walk away from situations that I felt were self-indulgent, when I felt I could do nothing further to help. I was surprised that one minute Marilyn could be full of justifiable rage, and then in the next she could run into her husband on the street and be as centered, impeccable, and loving as a warrior in the face of death. I watched the cumulative effects of her acts of power build with each successful encounter in the world. Over several years, a sequence of divinely arranged opportunities and her own appropriate, rightly timed actions ultimately healed Marilyn and returned her life to her in well-deserved full measure.

I see now that Marilyn was doing the personal work that her former husband would have to do later. Isn't that the way it is for all of us, on either end, coming or going? Every choice or apparent lack of choice comes with the possibility of liberating new life. The gift of being last is that, indeed, you later become first.

For Marilyn, this devastating experience and the work that she did around it were her personal sacred wound, her death experience, and in the end, this became her greatest gift. This enormously difficult passage gave her a new strength and wholeness and helped her to become a most incredible woman.

Marilyn and I were loving friends. There were many women friends in my life as well, and I remained loving and detached to everyone equally, at times against all odds. I watched the larger process at work here with interest. I shared beautiful and intense interactions with many women, and I watched each woman fall away into the perfection of her own destiny. The detachment that allowed this organic process to unfold without interference required a great deal of strength.

I still did not see how my life could fit into the normal requirements of family life. When I first met Marilyn's parents, Ken and Joyce, I liked them immediately. They came to the island to visit, and we went out to dinner. At the time, I didn't talk very much, especially when there was a social expectation to do so. Marilyn's dad, Ken, is a gregarious, loving man, who is confident enough of his love for others that he easily instigates conversation. He has two lovely daughters, and I am sure he must have had many encounters over the years with their new boyfriends. I could see that he was accustomed to boyfriends trying a little harder to please him and win him over. I did not try at all and said very little, even when prodded. There was nothing I wanted to win. I was watching instead to see what the gods had in mind with this meeting. When all expectations fell away due to the lack of results, we all sat quietly together. Then I spoke and connected easily with both of Marilyn's parents. We still laugh when we remember this first meeting.

The defining moment, however, that clearly set our relationship in place was our first visit to her family's house at Christmastime. We had been invited to the house of one of Marilyn's relatives for dinner. Before dinner, we sat around having drinks. The conversation became more and more animated, at least partially because of the alcohol in the punch. Many of those gathered had not seen one another for years, so they had a lot of sharing and catching up to do. Everyone knew that Marilyn had gone through a painful divorce, and I think they were curious about who I was exactly, and how I was going to fit into her life. My unusual story had preceded me, and in comparison to most of those in the room, I'm sure I seemed a little mysterious and strange.

At one point, one of the relatives who probably had a little more to drink than the rest of us turned and pounced on me. The mystery of who I was needed to be revealed. Fueled by alcohol, he aggressively took on the challenge. When he confronted me loudly, the room fell silent. It was clear that he had struck a nerve and had asked *the* question that everyone else wanted to ask. I had nothing to say about myself that would be seen as impressive from a worldly perspective. When we have nothing and have consciously become nothing in relation to the world and its values, confrontation with the simple question, "Who are you?" elicits prayer. At that moment, I asked myself silently, "Who am I, God?" After a moment's silence, I turned to the man and simply told him my story. To my surprise, tears came to his eyes. He told me, sadly, about his life. Like many of us, he had been an idealistic child of the sixties, a hippie who had believed in something beautiful—an ideal that required trust and faith in life. Although this belief may have been naive at the time, he still held a small part of it in his heart. Hearing my story opened his heart. It renewed his hope to know that someone had lived out the dream, even if it wasn't him. He said, "I always knew I could live like that. I got lost some-where along the way." His poignant, emotional outpouring opened everyone's heart that day, and I felt fully accepted and loved by Marilyn's family. It appeared that my "nothing" could fit into the something of their family structure.

Many events brought me to the point where one day I looked at my life, and Marilyn was simply the one I was with. When people ask me how Marilyn and I got together and I tell this story, people often say, "How unromantic!" It was not unromantic. It was hugely charged with romantic energy all around! I did not share a greater love with Marilyn than I did with anyone else. I recognized an equality in love that could not be quantified. Our relationship and ulti-mately our marriage came about through a long, careful process. Life and relationship fell into place on their own terms, the best terms, actually. We allowed our relationship to arrange and settle into its own natural order without the interference of preference, personal desires, or insecurities. True romance's perfect delivery of a life partner is the end product of a love affair with one's own personal God. Living through the details of this organic progression and let-ting relationship settle gently onto holy ground is the making of the sacred marriage. Isn't this how the myths always end?

Now we are both quite attached. We struggle and have great battles, mostly due to that very human attachment. God is still God and will accept nothing less, so as with everything we love, we continually release our relationship and place it back on the altar for renewal. I adore Marilyn, and this is as happily-ever-after as this story gets.

Marilyn and Jerry in the squash blossoms.

Testimony to the Marilyn Strong I Know and Love

Lao Tzu says, "Better too little than too much." That best describes the wisdom of the quiet way Marilyn holds the space around her. She holds the space as though with two hands held in prayer.

The comment made most about Marilyn is, "She has such a beautiful presence." People, including me, just like to be around her. Conversations seem to go a little deeper when she is in the room. It comes with the way she holds the space for others, yet conversations are often completed when Marilyn expresses an unexpected point of view, overlooked by the rest of us. Marilyn is in touch with the spirit and pulse of our time and has been for a very long time. She is drawn to certain ideas, books, and people by an uncanny intuition.

The nature of true beauty is to know its own reflection. She recognizes her own. The beauty that she gets excited about now, I watch the world get excited about years later. Yet she has not aggressively taken a position of glory, which could easily be hers. She humbly receives what comes with grace.

She is a queen by her very nature. Everyone who knows her sees that. It is not a position that can be assumed. I have often thought of her as a shooting star. On the ground, we see only the sparks of the star as it shoots across the sky. We receive its beautiful gift, the atmosphere of wonder it creates. The star moves on to new, unexplored territory. I have watched artists, writers, and other people create entire careers with a single spark. The creative people in the fire, who create the sparks, often go unnoticed. I believe that the ultimate gift of feminine energy is undefined beauty. Definition is fed by the dross of the Muse.

Marilyn is my Muse and my teacher of all things beautiful.

Semi-Duende

Spanish poets pray for a brush with death, something to pluck them out of complacency, shake them to the core, and set them back down in close proximity to God, the very source of creativity. They poetically call this experience *duende*.

My friend Van called late one afternoon and asked if I wanted to go salmon fishing with him. He said the salmon were running, and it was a good time to go. I had just finished a very involved art piece that I had been working on for months. Going out on the water to fish would be a nice break. I had, however, one more dreaded task to do that day before I could go fishing. I had promised Marilyn that this would be the day I fed Rosie, our seven-foot boa constrictor.

Several years before, someone who attended a workshop in Tucson that we facilitated had given Rosie to us. In many Native American cultures, the snake is the symbol of death and rebirth because it sheds its skin and emerges anew. The Gulf War broke out the day of our workshop, which was titled Dying to Live. Rosie seemed an appropriately symbolic gift to take home with us. We carried her on the airplane in a padded box.

Rosie ate only once a month, and I thought that such infrequent feedings wouldn't be too difficult to do. However, I very quickly came to dread the days I had to feed her. Marilyn loved Rosie (see page 116), but didn't like feeding her either. It took six years before I could finally convince Marilyn to let me give Rosie away to a reptile-breeding program. Somehow it became my job to feed Rosie, and it was never easy for me. I had to put the biggest white rat I could find at the pet store into the cage with Rosie. Her ancient reptilian nature accomplished the rest with great skill. Rosie didn't think the rats were as cute as we did and had no trouble at all

in killing them, and then swallowing them whole! To her, I imagined, they were like tasty little bonbons. Marilyn felt that Rosie kept us in touch with death. I would agree that she certainly did! Feeding her became a silent ritual for me.

I was feeling more vulnerable than usual, so the feeding was especially difficult that day. I felt the creepy feeling I inevitably did when I fed her, so I put the rat into the cage and immediately drove to Van's. He was waiting and ready to go. With the aluminum boat in tow, we rattled our way out of the driveway and down the road to our fishing spot.

As we launched the boat, Van pointed out a white spot far up in the greenery. It was the white head of an eagle. That was as much as we could see of him from such a long distance. The bird sat in an old snag, high up on the bluff, as we approached our choice fishing spot at the southern tip of Whidbey Island.

I liked watching the eagles swoop down to grab the small bottom fish that we brought up from the depths of a hundred feet or more and then released. The fish suffer the equivalent of the bends when they are pulled up to the surface. An air bladder fills up in the fish's bellies, due to the difference in water pressure, and causes them to float when they are released back into the water. The fish floated for a minute, slapped their tails, and then disappeared back to the bottom. Often this minute was all the eagles needed to fly the quarter-mile from bluff to fish, once they spotted the floating fish. Van could whistle in a way that sounded very similar to the cry of an eagle, which would often get their attention and bring them in when we released a fish. It was beautiful to watch the precision with which the large birds came in fast from the snag, slowed, dropped suddenly to the surface, and plucked the fish out of the water. They often came quite close to the boat to grab a fish, and then took it to the nearby rocks to eat.

Having just fed Rosie, and feeling a little closer to death on this particular day, I thought about how vulnerable all living creatures are. As I watched the eagle snatch a fish away, I wondered what larger force could just swoop in from above and snatch away our lives or the lives of those we loved. Life could be extinguished in a minute that we spent lingering on the surface too long. Without the equal pressure created by the depths, remaining on the surface leaves us bloated, matter-bound, and out of touch with the sustaining environment of a deeper soul life.

Wondering who would be snatched up next by death, I asked Van if he had heard anything more about Martha, a mutual friend who lived in New York. She had been diagnosed recently with a malignant brain tumor and was not expected to survive. Van told me that he had just received a printout of something her husband had posted on the Internet. He said he would show it to me when we got back to the house.

Fishing involves killing and dying, and I would assume, reincarnating. So does eating a turnip. We have a healthy relationship with the living things that we consume when we catch them in the wild or grow them in the garden. This is a tall order for modern western culture. Instead of hiring our professional hit man, Colonel Sanders, if we were to honor and kill our Kentucky fried chickens as an eagle does, we might come to regard them as sacred. Eating could potentially become an instinctual, living prayer, the miracle we perform daily to keep us from death.

In calling the eagle in for an easy meal, I wondered if we were disturbing her prayer time. Were we overriding the natural rhythm of her next miracle, stripping her meal of its essence, deep-frying and boxing-in her mystery? I prefer to think that we were serving the god of eagles and humans alike, a god that placed us there perfectly at the right place, at the right time, to serve this beautiful hungry bird her next meal. It is so easy to become forgetful and feel outside of nature because of all the things we do that are unnatural. One just never knows what is interference and what is not.

I know an older man named Roger who lives to fish. He is a diagnosed schizophrenic. He spends his days in a rickety old boat, fishing out on the Puget Sound. For Roger, fishing is a spiritual practice. Sometimes I see him in the distance, his dangerously small boat appearing and disappearing behind the waves. Roger has crude fish painted on the inside walls of his boat, like petroglyphs. His glowing, silhouetted figure hunched over, bouncing and bobbing out on the waves, reminds me of something I read about the early Celtic monks of the Hebrides Islands. They risked their lives as a test of faith, and hoped to survive long enough to set foot on some new, holy ground. On powerful ocean currents, these monks set themselves afloat in small, round boats made of sticks and hide, called *coracles*. If the monks survived their journey and tumbled ashore like driftwood on an unknown beach, they considered it God's grace that brought them there.

Roger risked like the monks and fished like the eagles, all the while tending something sacred and unworldly. He also caught fish when no one else did, which was proof of God's assistance in any fisherman's Bible. One day Roger came to my house to give me a fish that he had caught. He came out of pity and to teach me something about fishing. While visiting, he paid close attention to every detail of my environment. Out in my yard I had an old sunken bathtub that held water lilies and a few goldfish. As Roger was leaving that day, he happened to look into the tub and see the goldfish. As if he had discovered what he was looking for, he said, "Ah-ha! That's why you don't catch fish!" He recognized a violation when he saw one. He painted his fish like prayers on the inside walls of his boat. To have real captive fish swimming

about in a bathtub apparently would not do. To Roger's way of thinking, I had inadvertently offended the fish gods.

Van and I must have done something right to please the fish gods the day we went fishing, because we were perfectly blessed with one silver salmon each. I happily cleaned the miracle fish in the boat, while Van motored us slowly back to the dock. We arrived just as the sun disappeared behind the clouds and a light rain began to fall. We returned to Van's house and cleaned up the boat, just before the rainy darkness set in fully.

Marilyn was not due back from Seattle for another hour, so before I returned home to prepare dinner, Van and I sat and had a beer. At one point, he handed a paper across the table and said, "Here is what Martha's husband wrote about the condition of her brain tumor." As I read it, I kept going deeper and deeper, as though I were slipping into a cosmic black hole. I went so deep so fast that I entered into an altered state of consciousness. I felt a profound, disquieting sadness. I thought that Martha's husband's attitude was one of denial. His letter seemed to defy the reality of death. I said to Van, "This letter lacks all reverence. If it were Marilyn's life on the line, I would be far more humble and prayerful than this." As I said that, I dove into imagining, with the deepest love, what it would be like if Marilyn were in a life-threatening situation. My imagining became so real that my eyes watered over and I began to pray silently for the protection of my beautiful wife. My prayer and my emotions seemed so incongruous with the present circumstances that I felt embarrassed and strangely exposed. When I forced myself out of the trancelike state, I felt disoriented and confused. I didn't feel very sociable, so I decided it was time to go home.

As I made my way up the stairs to the front door of my house, the phone was ringing, so I hurried in to answer it. It was Marilyn. She was calling on a borrowed cell phone from the side of the highway. Her car had been hit by a ten-wheeler semitruck as she was driving home from Seattle. The truck batted her little car down the wet highway, like a cat playing with a toy. The impact spun the car around three times, smashing it in on three sides. She spun wildly out of control as other cars screeched and swerved to avoid hitting her. She expected broken glass to come smashing in on her any second; she just closed her eyes and prayed that she wouldn't be hurt. Her car ended up sideways in the H.O.V. lane, just inches from the dividing wall between the lanes of traffic. Marilyn was badly shaken, but not hurt. The officer who arrived on the scene first said with relief, "You're lucky. This has been a bad week. I've had to deal with three fatalities this week." When I saw the eye-level scrape in the glass of the driver's side door, just inches from where Marilyn's face had been, I realized that the high bumper of the semi had made the scrape. Imagining Marilyn in that situation brought me to tears.

For the next few days, Marilyn and I were inseparable. We just held each other in soul-to-soul, grateful silence. Is this what the Spanish poets call duende? They are very courageous to pray for this experience.

Sex

I have much to say about my beautiful, powerful, and terrifying exploration in the realm of sexuality. I made this exploration over several years as I inched my way out of celibacy and back into a personal relationship, and finally into marriage for the first time at age forty-seven. In my tantric exploration, I entered some of the most powerful and mysterious territory of my entire spiritual journey. Sexual energy, according to Yogananda, is the second most powerful force, second only to the instinctual drive to survive. I believe that the life and death of the soul and the effectiveness of our creative energies are based entirely on how well we do in both of these instinctual arenas. The power and understanding we receive in our right relationship to sexuality affects, as well, the solidity and mass of our foundation in faith. Faith is nothing more than a small idea, a beggar's prayer, if it does not hold up and gather strength in the white heat and tempering flames of sexuality and survival. If we are to find the courage we need to complete our circle and find our wholeness, we must come to terms with those two powerful forces.

If I were to boil down all that I have learned through sexual exploration and make it into a short story, it would read something like the Garden of Eden story. This tale has a tantric, energetic truth. For me, it has nothing to do with morality or the notions of good and evil or religion. It has everything to do with a proper and necessary tension between the beast and the divine, and the place they meet or cannot meet.

So much of the spiritual journey through the Garden depends on which toolshed we choose once we are there and ready to do our work. With the toolshed of the Divine we can create paths through and around the Garden—glorious paths that lead right up to the forbidden tree. With the toolshed of the beast we can bump and damage the tree, eat the apple, and dig ourselves a grave just outside the Garden wall. The Garden of Eden is an all or nothing place.

We don't know what would have happened if Adam and Eve had followed the requirements posted on the gate. Some non-Judeo-Christian cultures poetically express the possibility

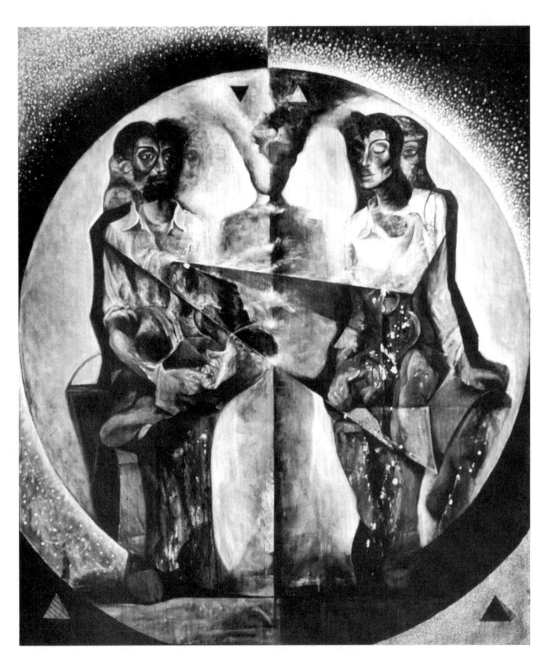

Third Body. 7' x 6'.

of remaining in the Garden until one receives the real gift and is ready to consciously move on to new learning experiences out in the world. Mostly what we have gotten out of the Garden of Eden story is a lot of guilt and a rigid condemnation of our sinful human condition. Healthy

exploration has been beaten out of us by the belief that we are born into a fallen realm and have therefore been cast out of the Garden. We are not born fallen, yet we *can* fall. Perhaps if Adam and Eve had stuck it out, they might have discovered an even more powerful communion between the natural, polarized energies of masculine and feminine. Maybe the discipline of remaining in the Garden is to inhabit a space between energetic sexual allure and the final earth-shattering event of biting into the forbidden fruit. Exactly how close can we get to the light and heat of the forbidden apple without falling out of grace? We have no way to know without carefully and reverently exploring the territory, exploring with innocent openness and trust in an attentive state of diffuse awareness. This awareness must keep one eye on the apple, one eye on the path, and an intuitive third eye on heaven. The only alternatives to this exploration are reckless, destructive behavior or adherence to religious and moral rules that promise safe, unlived lives. I will admit, however, that the dangers are so great and our listening devices so inadequate in comparison to the thunderous roar of sexual attraction that the safe alternative might be the most viable.

The dangers are very real for the spiritual seeker who leaves the safety of social, moral rules to explore the Garden. Look at the televangelists and gurus who fell from grace through their sexual adventures, and landed somewhere other than on their feet. The world is hard on the sexy spiritual teacher who wanders freely into forbidden territory, only to find himself no longer able to distinguish apples from oranges. When it comes to sex, most angels fall through their naiveté than for reasons having to do with anything evil. The ruthless guardians at the gate do not care to differentiate, however. Divine law has a way of dropping ghoulish enforcers out of the very same clouds that may have temporarily obscured our human vision. Moral judgment with its puny rules is, at best, second to divine law and its indisputable enforcement policy. The area of the Garden where the forbidden fruit grows may well be the most fiercely guarded territory in heaven and hell.

Adam and Eve thought no one else was there to see them eat the apple, but ferocious, unforgiving, and deadly guardians attend the final approach to the forbidden tree, and few of us who venture there make it back alive. If we do, we return awed and battle-weary, bearing unimaginable gifts that can serve others who attempt this passage into wholeness. This living mythology is often illustrated in the Tibetan tanka paintings. In the center of the tanka, a male and female figure are joined in sexual union. Surrounding them is a host of wrathful, dangerous deities. Many of the deities hold the body parts and hides of the last unsuspecting wanderers who, under the spell of allurement, saw no danger as they mindlessly walked to their deaths.

These guardians who wait in the wings of the tankas and at the gates of the Garden can also act on our behalf when conditions are right. But we must still meet their impossible demands impeccably. To accept this challenging and blessed position, we must begin the journey with fierce discipline and moral indifference. We must face the creative tension between the apple's overwhelming allure and the threat of sure death. The guardians at the gate, should they befriend us, will add the element of grace to the arrangement. No amount of justification, good intentions, or careful, intelligent strategy can ultimately hold without this grace.

If these conditions are met, one may courteously *visit* the territory, but only to reverently hold the forbidden, electric apple, taking not one single bite. However, the alignment of conditions necessary for this to happen borders on the impossible. In the end, it is reserved only for the most disciplined among us. What little most of us realize of the powerful and dangerous experience of tantric sexuality is the small glimpse we get when we fall in love. The one reoccurring problem with this experience is the "fall."

In my transition out of celibacy back into the world, I explored sexuality with great attention, knowing each small step offered either the blessed gift of worldly life or the complete loss of soul. There was very little in between. I listened and explored under circumstances that terrified me, because I had given my life to following a spiritual path unconditionally, and this path had led me ten years deep into the grace and gift of the celibate life. In the beginning, I experienced a lot of doubt when I perceived that life was gently nudging me back out in the direction of the world. I had finally become comfortable with my celibate life. I liked the freedom and the beautiful way I could be in the company of women friends. Women could confide in me as one of their own. I loved the easy, harmless flirting that went on. I was not sure I knew what it meant to return to the world as a sexual male. I certainly didn't like the sexual dynamics I saw going on between the men and women around me. In the ten years I learned the ways and gifts of celibacy, I had to listen to the most miniscule promptings from the sexy angels who guided my path beyond the dangers of mindless, destructive human impulse. Ten years of hard-earned territory now seemed at risk in the exploration of new sexual energies. I sensed that through this exploration I could attain the gift of a solid life in the world, but I also sensed that the established, hard-earned, unworldly ground now underfoot could be lost in an instant. I needed to be sure that this exploration was not misguided and that I was not lost in self-deceptive illusion. I did not want all that I had invested in my years of soul development to come crashing to the ground, worldly hopes and all! This all-or-nothing atmosphere, with its inherent dangers, demanded that all my best skills be placed in the service of a very deep, often terrifying listening.

The gifts I received were amazing! While I remained within the energetic limits of the Garden, my tantric exploration took me higher than I could ever have gone in my precelibate days. There are legends of Christian monks and nuns lighting up the night sky with their communing energies, sexuality turned into light and heat—apples aflame, yet mysteriously not burned.

Somewhere along the way, any true spiritual path that is fully traversed will eventually draw the sincere seeker into the challenge of the Garden of Eden. The Garden, however, is no refuge. It, too, is only a temporary area of learning. Eventually the spiritual seeker must consciously allow herself to be guided back out into the world, carrying with her the sustaining fruit of the Garden's wisdom. The sacrificial nature of this wisdom nourishes life in the world and holds all that we love in place.

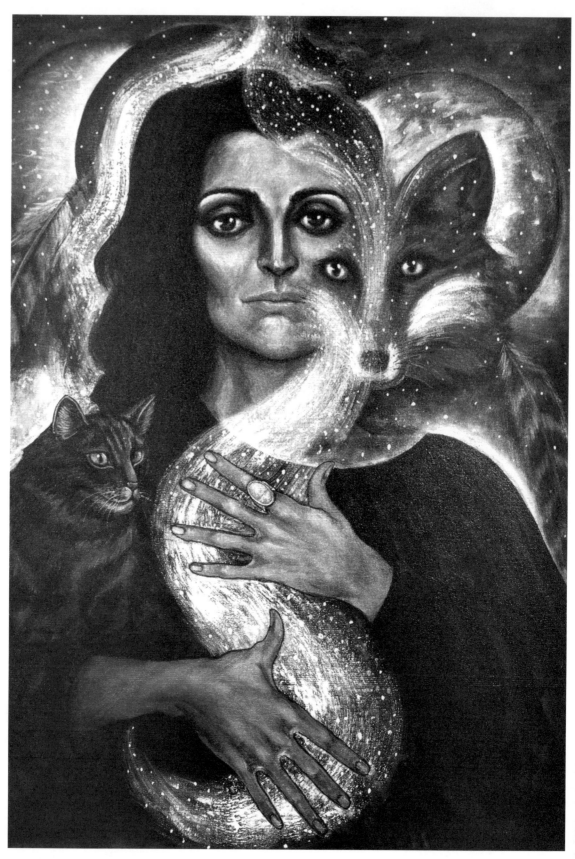

Marilyn's Dream. 32" x 24" (1990).

Art, Magic, and Discovery

Lightning

Feeling bored and out of creative touch with no project to engage me, I went to the dump to pray. Wandering the dump, waiting for a shimmering object to quietly present itself, can be a form of ritual for me. Sometimes one small object found at the dump or the thrift store, or something I have been given, can inspire an entire new art piece. On this particular day, I spotted a seven-foot-long piece of brass, roughly in the shape of a three-dimensional lightning bolt. It appeared to be the irregular edge of an old sign. It was beautifully made. I knew because of where it had been placed that it had been singled out and was probably going to be expensive. As I examined the lightning bolt, one of the women who work at the dump walked past and said, "I had a feeling you would like that."

Finding and acquiring things at the dump is an alchemical process. One must go about it with great care. The particular gods one needs to call up, once the object of choice has been spotted at the dump, are probably in the category of hungry-ghost gods. One must be indifferent to the outcome of any attempted purchase when calling on their help. Too strong a desire renders these gods insatiable; they can easily sabotage the haggling process. Excessive desire creates a reverse alchemy that can work against you. In the flash of a lightning bolt, desire can turn your particular piece of junk into solid gold, which will then be priced as such! Bored indifference and a reverent appreciation of the dump gods are helpful in securing interesting objects. My dump-wise finesse informed me that I would need to seriously consider my level of desire for the lightening bolt before attempting a purchase. It's also important to select the right person for negotiating the purchase price. Generally speaking, the women who work at the dump are far more sympathetic to the plight of the starving artist than are the men. You would never ask

the owner and spiritual leader of this dump to price a thing. A simple smile of acknowledgment when he cruises by in his noisy, fenderless, old truck is enough. Your smile is a bow to his disheveled eminence. He is omniscient; he knows everything there is to know about junk. He is personally attached to all of his junk, so he sees value in everything. Indeed, a man after my own heart, but not one, I learned early on, to ask to price anything. A friend of mine who occasionally cruises the island in his small plane happened to fly over the man's house one day. He told me that the yard around the dump master's house looks just like the dump!

To prevent this from occurring in my own yard, I try to take only what shimmers and what I would use for a particular art piece. This is a spiritual discipline and a basic rule for me. Even with this rule in place, I've had to return many items that never found their way into a piece of art. One of the other divine laws of dump spirituality is to spend only the money I have in my pocket when I arrive. I don't carry a checkbook, so this is pretty much a given, although I have occasionally defied the angels of the dump and asked to use the layaway plan.

I like the people at the dump and I think they like me. I fulfilled a long apprenticeship to learn the subtleties of dump etiquette. To earn the staff's trust, I had to make sacrifices. Often, when I was negotiating a purchase, both the dump worker and I knew that I was being over-charged, yet I would quietly pay and thank them. Somehow this helped to develop a relation-ship of trust and generosity.

An event that helped the process and became my claim to fame in the eyes of the crew was the discovery of a large old painting of mine that had been thrown into one of their Dumpsters. The attendant who found the painting pulled it out of the trash and nailed it, Christlike, to a wall. Loosely inspired by the theme of the Last Supper, the painting did have Christ as the central figure, so this crucifixion seemed appropriate.

I had made the painting years earlier. I was working with a group of bright, creative teen-agers at a liberal religious camp in Massachusetts. Having absorbed some of their youthful energy, I produced this painting in two days. Many of the personalities reflected in the paint-ing belonged to the teenagers. The painting had a history of being crucified. The day I was to complete my short residency at the camp, the teenagers hung the painting in the large meet-ing hall. Apparently after I left, the painting caused quite an organizational dilemma. The imag-ery of the painting was upsetting or frightening to some of the camp administrators, while others liked it. Some wanted it to stay where it hung, and others wanted it out immediately. Shortly after I left, the administration informed me with profuse apologies that they were returning the painting to me. I had few possessions in my life at that time so I gave the painting to a friend in New York. Years later, this same friend moved to Whidbey Island. He became

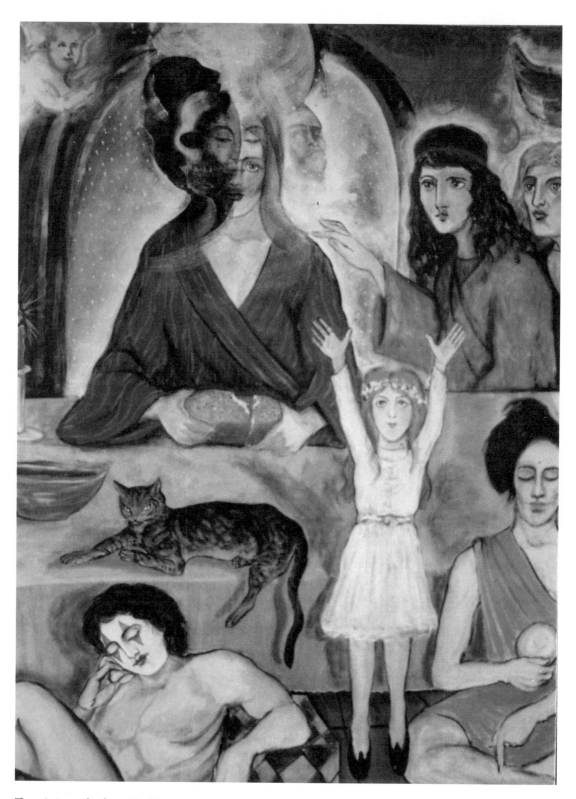

The painting at the dump. 7' x 5'.

unhappy with his move here, decided to go back to New York, and in the process, delivered the painting to its final, unrestful place at the dump. The painting now resides (and has for years) as an installed icon at the dump. It hangs on the most honorable wall of the dump's main chapel, which houses the most sacred of salvaged objects for sale.

People have told me, over the years, that when they approached the owner of the dump and offered to buy the painting from him, he would not sell it. The painting does officially belong to him. When he discovered that I had painted it, he gave me a fifty-gallon metal drum for free that would otherwise have cost me three dollars. When I attempted to pay for the drum, the owner said, "Take it, for the painting." We shook hands to clinch the deal. He deserved the painting; he did resurrect it from the dead. The painting now hangs high, at eye level with the dump's enormous alchemist, the crunching and groaning squashing machine! The alchemy required of this entity is the transformation of thousands of tin cans into green-gold, compressed bundles of metal cans, which are sold for cash to the larger recycling centers in the city.

What finally sealed my advancement into the elite ranks of artist-as-scrounger, at least in the eyes of a few members of the dump's staff, was the arrival of a film crew to shoot the painting. The people who were making a documentary film about my art and life (*In the Hands of Alchemy*) decided to film the painting at this unusual location. Our director, Phil Lucas, impressed the staff with cameras, lights, and the squawky walkie-talkies he used to stage my drive into the dump. After that, I was fully accepted as an honorary friend of the dump by those who worked there. They came to know the particular kinds of things I looked for and would often set them aside for me. I was happy to be considered a friend.

You could easily end up on their wrong side if you were not considerate of their working environment. The hardworking staff at the dump had to deal with an enormous amount of junk on a daily basis. They could sell only a small percentage of what arrived there, so they needed to be paid fairly for these items to keep the place running. I once witnessed a heated transaction when a rather brash young man attempted to override dump protocol and con one of the wise women on staff. Junkyard dogs are notorious for their ability to pounce ferociously on those who threaten their territory. Their ferocity, however, pales in comparison to the warrior spirit of an irate junkyard woman whose economic sense of fair play has just been violated. Kali, the Hindu Goddess of destruction, is alive and well in the hearts of these powerful women. However, unlike Kali, the women at the dump don't wear their victims' skulls around their necks. This makes it more difficult for unsuspecting petty wanderers, seeking to take advantage, to identify them as dangerous.

When I saw the shimmering lightning-bolt-to-be, I was sure they would want more than the seven dollars I had in my pocket. This belief proved to work to my advantage. It created

the proper demeanor of indifference as I entered the final stage of price negotiations. I was resigned to not getting the piece as I went to find Jo Ann, who was indisputably the most fair of the dump divas. Pointing to the incipient lightning bolt, I said "How much for the piece of metal?" What you name the coveted item counts for something too. Calling it a lightning bolt may have rendered it more valuable than just so many pounds of deadweight brass. Jo Ann said, "Eah—gi'me seven bucks." A miracle! The dump gods happened to be on my side that day! I sensed that I had found something magical to begin my new art piece with.

While returning home from the dump, I saw my artist friend Ro on the side of the road. He was trying to lift a heavy metal cabinet into the back of his truck. I stopped and helped him. Apparently someone had illegally dumped the cabinet by the roadside the previous night. Ro was a fellow creative scrounger who very much appreciated the brass lightning bolt in the back of my pickup.

Like hunters returning from the wild, we appropriately honored the mysterious junk lords of the day. We told stories of the hunt and gloated in the amazing workmanship of the day's catch. I had to concede, however, that Ro had proved to be the more skilled hunter, having circumvented economic exchange altogether.

Once I had the piece of brass home in the studio, I was ready to begin a new art piece (see page 107). First I needed to cut and rebraze each squared-off end of the brass, turning them into points to achieve more of the shape of a lightning bolt. I decided to incorporate the seven-foot lightning bolt into the doors of the eight-foot-high art piece. The jagged contour of the lightning was arranged so that the seam ran down the middle where the double doors met. The hinged doors, now mounted on a large coffinlike box, opened outward, as if struck and broken open by the lightning bolt. When the doors were open, each door edge was in the shape of the lightning bolt, and when closed, the jagged edges fit together like a puzzle.

At the time I began this project, a very dear friend of mine, Erica, had just been broken open by her impending divorce and she came to me for help. Before long, her intense process, our work together, and the art project began to merge, dreamlike, into a mysterious whole.

Erica visited me regularly in the hope that I might help her understand the transpersonal and mythic implications of her difficult passage. The particulars of someone else's spiritual path are always wholly their own. Each person's path is an expression of his or her personal hopes, dreams, longings, and terrifying limits. These limits are particular to an individual's history. I could bring what I had learned from my own walk into "death" to the process of working with another person who was going through the same transition. Like anyone who has walked the full length of this mythic journey, I could offer a lighted map for navigating the

transpersonal landscape. A deep understanding of our essential, holy, human story is the best that we can hold out to others. We can do this only *after* we have survived the journey and fully received its miraculous transformation. We can then hold, as witness and guide, knowledge of the ruthless requirements of the work at hand, and compassion for the one who undertakes it. Participation in the holy experience of a personal death experience as it joyfully and painfully unfolds for another human being is the ultimate gift to be shared.

As guides, we can only accompany another as far as the edge of the mystery. When we reach this edge, we must find a new stance that involves a detached holding of the other's suffering. At this point, we rely on faith in something unknown. At some point in each person's spiritual journey, determined effort can do no more. Only grace can accomplish the final leap over that small, yet humanly insurmountable gap, somewhere between heaven and earth. I don't know what brings this grace about for one, yet not for another. Timing, longing, intent, and reverent invocation seem to have something to do with its arrival. There are, however, no deals to be made and no guarantees. We must let the gods know we mean business and we cannot do so halfheartedly.

Once a man came to a great Hindu saint asking, "How do I find God?" The saint held the man's head under the water until he was gasping for air! Then the saint said, "When you want God as much as you wanted air, you will find God."

As I worked with Erica, elements of her transition crossed over into my work on the art piece. I was not sure if this was a good thing, but I wondered if something was attempting to merge into a more complete expression than I could at the time perceive. In fully trusting the spontaneous nature of my own creative process, I have come to see that when aspects of reality come through unbidden, I should pay attention. The magic of a meaningful creation often arrives in the half-light of noninterference. Trusting in circumstance can bring forth a tiny gift, larger in depth and meaning than anything a rigid plan might achieve.

I finally allowed the powerful lightning that was splitting apart Erica's twenty-year marriage to merge with my unfolding art piece. I began to see a connection as the mythic fallout from Erica's divorce locked into place in the half-conscious development of my art piece. We continued our work together, and meaningful new levels were revealed. Her personal breakthroughs corresponded beautifully with each new layer I created in the art piece. The timing and significance of both processes were parallel realities.

The entrance to the cabinet I was making appeared to split open with the force of the lightning on the front doors. Beyond that were several hinged layers, each a carved, life-sized human form. They were set one behind the other, each figure opening out to the next.

The figure just behind the lightning appeared to be in shocked reaction to its naked exposure as the doors were broken open. The next figure was an arrangement of teeth and bones that created a skeletal figure, giving the viewer a face-to-face encounter with something that looks and feels like death! Following that was an inwardly focused female figure with eyes closed, leaning on a sword. Perhaps it was the ego—defeated, surrendered, and unaware that she still holds the sword, which is available for cutting through obstacles and limitations. Finally, the journey complete, the veiled golden figure arrives, open, reverent, wise, and glowing, weightlessly holy.

However inevitably painful the process, once we set out on this journey, it does not matter. As in the birth process, once the beautiful creation arrives and the infinite life before us mirrors the investment of our hard-earned love, the pain and difficulty of coming to term is soon forgotten. All that remains is appreciation for the gift of new life. However terrifying the experience, meeting the mythic requirements of full surrender doled out through one's particular circumstances brings with it real freedom. When we learn how to die and to let go, we can dip into the wisdom of our metaphorical death like we dip into sleep, and emerge fully renewed. Without this knowledge, life can only return cyclically to defeat. Without the wisdom of this journey, we can only create meaningless buffers against the insistence of death.

This deeply gratifying involvement with another human being was the next step to follow the process of doing my own work. I felt twice gifted because I had received firsthand a deep understanding of the death experience, and then I was able to pass along what I held most sacred in my own heart. Taking this journey with another human being, against difficult odds, is a sharing that can only happen through grace. I felt privileged to support Erica as she traversed the full distance of this wonderful journey for herself.

Finally, the journey complete, the veiled golden figure arrives, open, reverent, wise, and glowing, weightlessly holy.

Lucy

I was helping Jeanine, a friend from Seattle, move from a large apartment into a small, older house she had finally managed to purchase with her hard-earned savings. I came into town with my old pickup to help transport her belongings. With my small truck and a midsize rental

truck, we managed the move in one trip. As we unloaded the contents of the rental truck into her much smaller abode, the house began to fill up with too many items. At one point, in spite of several attempts to rearrange things, it became apparent that the furniture was too much for the house, and some of it would have to go. At one point, Jeanine said, "Jerry, what's left in your truck?" I listed the few things that remained, including an oak cabinet that was six feet high, very narrow (ten inches or so), and about ten inches deep. It was an unusual old piece with small shelves, three inches apart, running its entire length. Well used and ink stained, it appeared to be something out of an old post office. When I mentioned this piece to Jeanine she said, "Oh, that thing! Do you want it?"

Actually, when I had first loaded it into the truck, I had liked it very much. The fact that it was irregular and poorly made appealed to me, and I fantasized about the art piece I could create out of it. When Jeanine asked if I wanted it, I thought her offer was pure magic! I said, "Sure, I know just what I will do with it." I began work on the piece the very next day.

The overall plan was to remove the shelves and then make a tall, narrow, primitive figure out of a slab of old cedar to fit inside the cabinet. The figure would have two images, front and back, that could be changed by turning a brass ball on top of the box. I thought I would create two very different images, opposite in nature. I wanted the figure on one side to be masculine, dark, and mysterious. I wanted the other one to be feminine, inwardly focused, and expressing something vast, innocent, and light (see page 100). I began creating the dark side of the figure first.

In the cedar grove on our land, I looked for an interesting, rotted piece of wood that I had taken note of previously. I vaguely remembered seeing it lying, covered with moss, near the sweat lodge that I had built a few years earlier. I noticed it because it was roughly the shape of a human figure. Cedar sitting on the damp forest floor can remain relatively well preserved for fifty years or more under the right conditions. Just under the rotted surface of a slab of fallen cedar, beautiful, well-seasoned wood can remain intact.

When I found what I was looking for, I carved the cedar to enhance the already rough human shape of the slab. I was careful to include the rotted section of the slab. The wood soon became a simple, stylized human form. The rotted wood gave the figure the feel of an ancient artifact. As the face appeared, it became predatory and birdlike. Just that week a friend had given me a newly killed hawk that he had found dead on the side of the road. For the nose, I used a combination of the hawk's beak and pieces of tarnished old copper from an antique toilet tank I had found at the dump. I made the hands for the figure from a pair of owl's talons that I found at our local thrift store. They had been placed neatly in a cotton-lined plastic box

and labeled "Owl." Owl medicine, I have been told, represents death medicine in certain Native American traditions.

Next I gathered bones. Two years earlier, I had buried a coyote that I found dead on the side of the road. I dug up the bones that remained to use in the piece. With the bones and some discolored, old hemp twine, I created a skeletal-like body. In the heart area, I mounted the coyote pelvis. The pelvis of a coyote looks very similar to a small skull or a human face. Just above the pelvis, and running through the "face," I hung the braid that a friend had given me after cutting her long hair a few months before. Finally, on the little face, I hung a beautiful petrified shark's tooth. My ten-year-old friend, Mercia, had found the tooth on a beach in Florida and had given it to me as a birthday gift that year. With the dark and mysterious side of the figure complete, I was ready to work in the light of its counterpart.

Our beloved friend Lucy (see page 74) is one of the most extraordinary children I know. At the time, Lucy was eight years old and could easily light up a room with her presence. As I was deciding on a face for the light-filled side of the piece, Lucy immediately came to mind. At the time, Lucy had been sick with pneumonia for quite a while, so I went to visit her. I brought her some gifts and spent the afternoon with her. When I arrived that day, she was working on a school project. The assignment was to dissect several owl pellets, or droppings, and label what she discovered in each pellet. She showed me that she had glued the recognizable elements on a sheet of paper with the appropriate labels. The remains of the owl's last meal consisted of hair, teeth, and bone. I was interested in how similar the components were to those I had just incorporated into the new art piece.

I asked Lucy about making a mold of her face to include in my piece. She was excited by the idea, and we decided to make masks together. I completed the molded mask of her face and then plated it with copper and installed it onto the figure. Lucy's face with its mysterious inner light, now glowing in copper, was further adorned with carved wood and fabricated metal. In the heart and lung area of the figure, I added a carved lotus flower, which completed the light body.

Lucy's pneumonia was staying with her longer than it should have. About the time the art piece was done, her parents decided to bring Lucy to a Seattle children's hospital for a more thorough examination. We were all concerned when the doctors found something unusual in the area of her lungs, which they called a teratoma. A teratoma is a tumor that might have begun early on in the womb as a potential twin. Within its mass, hair, teeth, and bone could develop. Removal of the teratoma required surgery, which is finally what was decided on.

Lucy was fearless as she approached the surgery, and just prior to it, she had some questions about the nature of the teratoma. She knew that it might have been nature's attempt to

create a twin and that it might contain hair, teeth, and bone, just as a real person would. In her young mind, she imagined a tiny person locked inside her body, one that might look just like her! Just before her surgery, she asked sweetly, "Does it have a face?" When I heard this, I thought of the coyote pelvis that looked like a little face. It was in the same area of the art piece as the tumor was in Lucy's body.

Lucy's operation was a complete success. She was out of the hospital and home in just a few days. She was out bouncing on her trampoline and playing soccer within the month!

In thinking about the deeply mystical nature of my loving connection with Lucy, and having felt a link between her illness and the art piece as it unfolded, I wonder about the relationship of the creative process to the love we invest in our human connections. How does this relationship form a link between human spirit and matter to empower them both with something more complete? How do we access and serve this creative, mystic component, inherent in all relationship, as we relate to both sentient creation and matter? What there is of beauty is clearly held in place by the love surrounding us.

A friend told me a story not long ago about the death of her grandmother. Her ninety-year-old grandmother lay dying, surrounded by a few close friends and relatives who held her quickly diminishing life in the container of their love. But she seemed not quite able to leave this world. At one point, her daughter said aloud, "You can leave now, Mom, we have let you go." At that moment, she came out of her semicomatose state and reached into the air, as if to brush aside cobwebs, and said, "I can't, there are strings." Her husband of sixty years began to cry and said, "I can't let you go." With the release of his grief, he was then able to release his beloved wife. Minutes later, she died peacefully. Heartstrings? I don't know. But whatever these glowing, fibrous threads are, they are the elements that link physical creation to the divine.

The goal of any creative life has to be to link these components, even if we experience only the glow and resonance of right creation. That creation that looms larger than its physical limits we call *inspired*. A mature creative life, which has discovered its source, finds it is linked to *everything*. When we are able to tap this source and link the illumined threads, we no longer want to live our creative lives separate from it. A creation that does not have the residual glow of its source can, at best, only sound a deathly rattle—however impressive that rattle may be!

In my own exploration, I found that my very identity as an artist became too limiting for the expanding, creative universe I was discovering. By limiting my focus only to the creation of art, I inadvertently held at bay art's potential conscious link to everything! Hovering expectantly, while doing the most mundane of activities, might just as effectively illumine creation. If we

hold all aspects of our lives in unknowing, with equal attention, something may surprise us and become the unexpected entrance into a magical new encounter.

By taking responsibility for what is manageable in our lives and tending the small things with reverence, we can relinquish the impossible attempt to play god to our larger creation. There is great freedom in knowing that nothing is ours to hold or identify with. Any victory or accomplishment gets offered back, brightening the overall light of a vaster whole. In the brightening, creativity becomes more detached. We place it in the service of a mystery that we can then join forces with. In this scenario, attentively refraining from interfering with the mystery becomes far more useful an activity than any strategic involvement. Properly invited, the mystery becomes the well-prepared, *empty* channel through which inspiration can enter.

Creation actually requires very little, too little for most of us to handle. There is not much in our postmodern, western culture that teaches us to pay attention to the things that require less. These things give birth to the unpredictable surprises that inspire a larger and deeper soul connection with creative life. With the soul well tended, even when all is lost (which it inevitably is in death), our creation lives larger than its physical limits.

The best that any of us can do with the heaven and hell that surrounds us is to become willing participants in the unfolding of our soul's life. Any creative act emerging from this tending becomes One with the elements of the Mystery.

The Key to Heaven

The power pole fell dangerously close to Christina and Ann's house. A fierce windstorm set the pole down perfectly in the one narrow area of their yard where it would do no damage. I received a phone call from them the morning after the storm, asking if I could bring my pickup and help remove the large pole. I sharpened my chain saw and set off up the island to help my good friends.

The old cedar pole had been in the ground for many years and was eaten through by termites. I had never seen a power pole made of cedar before. It was probably quite common to use cedar in the Northwest when it was more available. The surface wood of the pole was nicely weathered and the inside wood, at least the part above the ground, was beautifully seasoned. This clear cedar was perfect for carving. The termites had done their work just below ground where the damp soil held the pole in the earth for so many years. The pole had broken off just

below ground level, revealing the complexity of the termites' subterranean village. Some of the structures they created as they worked their way deep into the wood were as thin as paper. There were little peaks and valleys, canyons, and catacombs. It was a living sacred site in miniature, like an aerial view of an Anasazi Indian village, as it might have appeared hundreds of years ago when their villages were fully inhabited and active with daily life. I decided to try to preserve the half of the termites' creation that was lying on the ground, still connected to the bottom end of the pole. I thought I might be able to incorporate the termites' astonishing creation into the art piece I had just begun. I carefully cut the pole just above the area of decay and placed it in the back of my truck, along with the other sections of the pole.

I was still formulating my ideas for the new piece, which could change along the way, as often happened with my creations. But the basic idea was to create a prayer machine, called *The Key to Heaven.* (See page 108.)

After clearing the termites out of the decayed section of the pole (no small task), I fitted the piece into the top of the seven-foot box I was working on. The delicately sculpted wood of the termite nest spiraled upward another foot above the box, giving it the appearance of an eroded mountain, replete with detailed natural formations. I make my boxes in human scale, so the termite nest served as a topknot for the being this creation was becoming. With the overall shape of the box complete, I began installing various religious paraphernalia that I had been collecting for this particular piece. To be sure the machine would work, I thought I had better include symbols for every religion, just in case the religious fundamentalists were right after all, and one particular religion did have more of an in with God than the others! I wanted to cover all of my holy bases.

I carved and gold-leafed a peaceful Buddha face for the box-being. The golden face looked out from behind a crucifix. This combination gave the Buddha the appearance of looking out from behind bars or the crossed members of a small, four-panel window. The golden Buddha wore the termite wood, which I had adorned with many decorative and symbolic objects, as if it were an elaborate headdress. Among these objects was a small black ceramic skeleton that moved up and down, projecting out of the mountainous landscape of the Buddha's headdress. This was mechanically linked to several other moving parts within the larger creation.

Just before I left Christina and Ann's house the day I helped with the fallen power pole, Christina handed me a bag and said, "I thought you could use this for one of your creations." In the bag were the broken remains of an old doll. Christina told me she had had the doll when she was a child and she had held on to it all this time, but now she felt it was time to release it. The doll was from the fifties and was made of an old-fashioned plastic. The plastic was now as brittle

as an eggshell. When I got the doll home, I noticed that it had the most beautifully made glass eyes. I carefully removed the eyes and decided to incorporate them into the prayer machine. This particular piece was one of the most mechanically complex that I had made thus far. It took several more weeks to finish it and get all of the moving parts functioning properly. I went through two motors and saw the mechanical assemblies self-destruct more than once in the process of figuring out the complex, interconnected workings of the piece.

I was at the final stages of completion when I received word that Ann was quite ill. We were all concerned about her. Christina and Ann had both clearly been involved in the creation of this art piece, so I thought now that it was done, I would put the machine to the test. The first real prayer to activate the machine was its most important one—a prayer for Ann. I cannot say that my prayer machine is anything short of ridiculous, but I loved all of the connections that came into play in its creation. I loved how the piece found completion in a prayer for Ann and Christina, the two people most involved with it.

Here is how the prayer machine works. The first and most important step is to not take it too seriously. The next step (and the real magic) is to feel the love you hold in your heart for those you are praying for. With my friends Ann and Christina, that was the easy part. Once these preliminaries have been observed, you then insert a dime and turn the large brass crank on the front of the machine. This mechanism dispenses a little slip of colorful paper with an angel on one side. The other side is blank. On it, you write the name of the person for whom you wish to invoke a prayer. Then you put the slip of paper into the designated slot of the prayer wheel, which is mounted on the side of the art piece. You give the prayer wheel a spin, which rings a little bell and sets your prayers in motion. At this point, you might want to meditate reverently on your prayer while you search out the many secret compartments of the art piece, where you will find beings who support your prayers. Images and figurines representing different religions are hidden throughout the body of the piece. Having done all of this, you are now ready for the big moment. You take the Key to Heaven that hangs from a large brass padlock and you insert it into the keyhole and give it a turn. This awakens the guardian angel of the piece and brings it fully alive! The wings mounted on the sides of the being begin to flap, the Buddha face pops open, and "Amazing Grace" plays. Behind the face, which is also a door, are two other masks, one inside the other. The outer mask separates in the middle and slowly opens and closes. As it does, the glass doll eyes roll back into the head of the inner mask. At the same time, the little skeleton above comes up out of the termite-eaten headdress and then returns inside.

I cannot say for sure whether my prayer machine works or not, but most people feel that it's worth a dime to get a chance of contacting heaven. Ann did get better, so one just never knows about these things!

The Tower

The twelve-foot-high cistern out in our yard already had the necessary bolts set into the cement, should one choose to build a tower on top of it. They were a constant reminder of Marilyn's dream to have a tower there someday. She had wanted one for a very long time. Years earlier, before I met her, she read *Memories, Dreams and Reflections* by Carl Jung and loved the personal, sacred tower that he built for himself. Marilyn wanted a quiet *temenos* (sacred space), separate from the activity of daily life, a place of prayer and meditation, a place to do her spiritual practice.

When considering a creative project, especially one as large as this, I will often hold the creation as a possibility in my heart, sometimes for years, until I feel the time is right. I knew one day I wanted to build the tower for Marilyn. I had not done much building, so I knew very little about the basics of construction. I did, however, slowly begin to collect things that I ran across or things that were offered by friends in the construction trade. One of the events that initiated the tower's beginning was the gift of a good quantity of unusual, two-inch-thick cedar siding. A contractor friend called one day to ask if I had a use for this siding. He said he had removed it from a large beach house he was remodeling. There was no place to put the boards on the small lot, and they were about to burn it all. I needed to come right away and take it if I wanted it. The beautiful old cedar siding was in quite good shape, but full of nails. I told my friend I wanted it, went immediately to the site, and brought back several truckloads of it. Looking at it all, I thought that just taking the hundreds of nails out of the wood would be an enormous job.

Around this time, a friend who was involved with a Sufi religious order called to find out if our large room and bunk room were available for the following weekend. He said his group of twelve people was interested in doing a special day of spiritual training that would include physical work. The particular requirements of this training were that the attendees had to work all day and night without sleep. He asked if I had any large jobs for them to do to keep them busy. I had several, and pulling the nails was one of them. I felt that this was a very good sign that the creation of the tower was soon to begin. Here was a group of spiritual seekers willing to do sacred work. This right intent would have to add something special to the building of a meditation tower. Isn't that how churches used to be built? People worked as a form of dialogue, creating something sacred through selfless concerted effort, something physical to fill the gap between heaven and earth.

Marilyn and I had just been married the previous winter, and all of our friends had pooled their resources to give us a trip to the island of Iona, off the western coast of Scotland. It was

springtime, and our trip was planned for the end of summer. My goal was to build Marilyn a simple meditation tower as a late wedding gift before we went away to Scotland.

I had an idea of what I wanted the tower to look like, but I didn't know how to begin. I wanted something very high, like a church steeple. The cistern I was going to build the tower on was only eight feet square, so the tower was going to be tall and narrow. I thought I would go up about forty feet. When I spoke with my carpenter friends about how to proceed, they said it would be impossible for me to build a tower that high without scaffolding. So I considered building the tower in two pieces, because not even knowing how to build a building, I did not want to use my time figuring out how to build scaffolding! I knew the lumber company had a truck with a boom on it for lifting heavy things, so I called them and found out just how much height and weight their truck could accommodate. They said that for a low fee they could easily lift into place what I wanted to build. I am indebted to my friend Mike, who came over and gave me a quick lesson in carpentry and got me started on the four-foot-high room that we built on top of the cistern. This humble beginning already set the structure sixteen feet in the air! I planned to have the lumber truck lift the other twenty-five-foot section of steeple onto this room.

We have a very high deck attached to our house, so I framed and aligned the point of the steeplelike structure from up on the deck. Once the bare bones of the structure were in place, I had some friends help me carry it around to the front part of my studio where I planned to complete the construction. I thank the gods many times for an amazing tool called a hand grinder. A good carpenter would never need such a tool, but it was my most valuable possession. It could easily shape joints and pieces of wood to fit anywhere—a labor-intensive but effective means of accomplishing the task at hand when all else failed.

Throughout the building of this tower, the absolute magic of unseen forces guided me. Several times, just when I was about to make a serious error that would have been impossible to fix later, someone with building skills would show up, see what I was doing, and say something like, "Well, did you think about doing this before you do that?" On two occasions, I had to say, "No." I truly believe that when we do something with our whole heart, grace guides our actions and helps us along the way. Building this tower was a miracle for me, and the miracle continues in the life of the tower. Occasionally, one friend or another would come and help me for a few hours and then leave, but I was there every day, working with the grace of joyful enthusiasm from daylight until dark, all summer long. I spent days just doing the detail work, such as carving the spiraled columns for the four corners of the building, making decorative wood cutouts, and fabricating metal details.

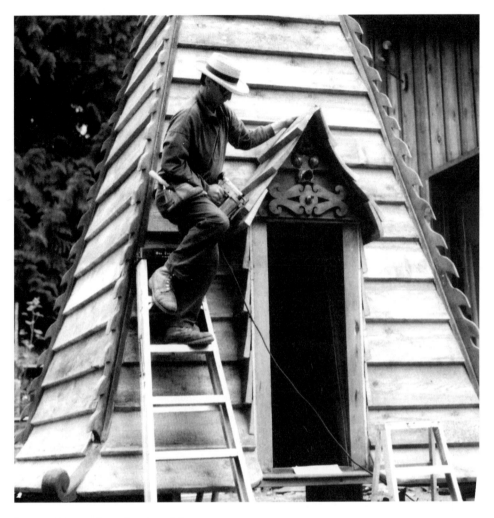

Jerry working on the roof section of the tower.

When the upper structure was finally finished, I had some ideas, but I was not sure how I was going to get the heavy structure up the driveway and into the right spot to be lifted by the truck. When I began the construction of this section of the tower, I thought I might gather people together to carry or drag the structure on logs to its liftoff location. It grew quite large and heavy, however, so this idea began to lose its practical appeal. Around this time, I was visiting a friend's house and spotted some large wheels in his barn. The wheels were once used to move airplanes around the hangars at the Boeing factory. I thought they might serve to move the heavy roof section of the tower up the driveway and nearer to its final destination. I borrowed them and mounted a wheel at each corner of the structure. I then fastened a line to the back of my pickup. With the other end tied to the heavy structure, I

towed it about fifty feet up the driveway and situated it where the boom truck could easily place it high up on the tower.

When the day arrived for lifting the section of tower into place, many people wanted to come and watch the process, so we made something of a party of it. We had champagne and chocolate-covered strawberries to celebrate the moment of lift-on. I had built several plates into the tower, through which I ran a large threaded bolt for the boom truck driver to attach his cable. I also built in a steel plate to hook a ladder on, so I could climb to the top of the tower and thread the final decorative topknot into place. The topknot was also threaded onto the large bolt that the boom truck used to lift the structure. The operation went smoothly, and everything worked and fit as planned. This was a magical creation, dedicated to God and to my beautiful wife, Marilyn. It was finished just in time for our honeymoon in Scotland.

When we returned, I took on the enormous task of creating a stairway up to the entry of the tower (see page 178). The entry was twelve feet up, and I wanted to create a massive, yet aesthetically appealing stairway to reach that height. I had just read about earth ships, a type of house being built in the Southwest with discarded tires. You pounded dirt into the tires until they were full, hard, and immovable. Then you covered them with chicken wire, then a layer of stucco cement. The process was cheap and ecologically sound but labor intensive. This is what I decided to do. I used fifty tires to create the ascent and made the railings for the stairs out of recycled, one-inch copper pipe. At the entrance to the stairs, I welded up a decorative arch out of rebar and old horseshoes, and I planted wisteria to climb up the arch. It was very free form and looked quite natural when the ivy that I planted along the sides of the massive stairway grew over the cement. I made an S-shaped pathway leading to the arch and lined it with bricks, filling the spaces between the bricks with over three hundred pounds of small, reflective ingots of broken safety glass.

At the end of my last day of work on the stairs, I added some final touches of color. Stopping to rest, I joyfully said aloud, "It's done!" As soon as I said that, the phone rang. The person at the other end said her name was Laura Chester and she lived on the East Coast. She was doing a new book in collaboration with a photographer named Donna Demari. The book was called *Holy Personal,* and it chronicled the creation of small, private chapels across America. The book would also include the stories of how the sacred spaces came to be. She said that she had heard about my tower! I was dumbstruck by her timing—baffled as to how a woman from the other side of the country had heard about a tower that, at the very moment she called, I had just decided was finished being built. Laura said she had heard about the tower through word of mouth. Laura and Donna came west to Whidbey Island several weeks later.

Donna took pictures, Laura interviewed Marilyn and me, and the tower and our stories were included in their beautiful book.

The irony is that there are so many better-equipped carpenters in this country who know so much more than I do about how to build things. I thought it astonishing that my humble tower should be singled out for this attention. When I mentioned this to a carpenter friend, he said, "Well, if you knew what you were doing, you never would have taken on the creation of a building that unusual."

One more synchronistic event fully established the tower as a holy place. I wanted to have a ritual blessing of the tower. Marilyn had been involved with a Tibetan Buddhist group for some time, so I thought a Buddhist ritual would be most appropriate. As I fantasized about who might empower the tower with Buddhist blessings, I first thought of the Dalai Lama or perhaps a Buddhist monk. Then I let go of the thought, feeling I was expecting too much here. A few days later, I went for a walk on the trails behind our house. Our trails link up with trails on the hundred-plus acres of the Chinook lands. As I approached the trailhead near an open field, I heard a group of people playing soccer. Just as I came up the hill near the field, a soccer ball came flying into the stinging nettles near me. Then I saw a robed, bare-armed, Tibetan monk setting out into the nettles after the ball. I said, "Wait, let me get it for you. I have long sleeves and those are nettles!" When I made my way to the ball and then to the field where they were playing, I saw nine Tibetan monks playing soccer. Only one of them, by the name of Tenzing, spoke English well. He told me they were on a peace tour and were staying at Chinook's retreat house. They were in town for the next few days, creating a sand mandala up the island at the Loganberry Winery's public space. They were touring the country, doing ritual performances, speaking about the plight of Tibet under Chinese rule, and making the peace mandalas. I later found out that these were the Gyuto monks who were in the film *Seven Years in Tibet*. Their peace tour was sponsored by the actor Richard Gere. The Gyuto monks are the Dalai Lama's personal choir!

I talked with Tenzing for a while and explained to him that my wife practiced Tibetan Buddhism. I asked if he and the other monks could possibly come a short distance through the woods to perform a blessing on our tower. He didn't quite understand what a tower was, so I explained that it looks a little like a Tibetan stupa. By this time, the soccer game had ended, and the other eight monks came over. I later found out that Tenzing was the only monk in the group who was not a lama. When they heard that the tower looked like a stupa, they wanted to know which variety it was. I said I didn't know, so we all went inside to look at pictures from a book on stupas that they had. We looked at silhouettes of various stupas, and I said, "Well, it doesn't really look like any of those." So I drew a picture of the tower, which

had flamelike wooden cutouts running up the ridges of the long roofline. The head monk looked at the picture and said, "Ohhh! Flaming Stupa!" and they all chimed in, "Flaming Stupa." (See page 112.) They began chatting in Tibetan and agreed to come over the next day about dinnertime to bless the tower. I told them that I would prepare a nice meal for them, and they seemed quite happy with this arrangement.

The monks arrived on schedule and asked for incense, rice, and a bowl of water to use in the blessing of the tower. All nine monks piled into the eight-foot-square space. The head lama saw the picture of Simhamukha that Marilyn had sitting on the altar and asked which deity it was. Simhamukha was the deity associated with the practice Marilyn was doing. The monks tailored their blessing for this Tibetan deity and for the particulars of a Flaming Stupa (see page 112). They launched into a long and reverent blessing. As they did their incredibly resonant overtone chanting, they rang a bell loudly and threw rice and water. The tower seemed to glow in the dark after that! You could feel the effects their blessing had.

When the monks finished, we all went to the large open space that is downstairs from our small apartment. They chanted some more to bless the food, and we had a wonderful gourmet meal that my friend Sydney helped make. The monks' American driver had told me on the sly what the monks liked best to eat, so that was what we had prepared.

The space where we ate is full of my large, interactive creations, and the monks wanted to play with all of them. They also picked up some musical instruments that I've made and played them quite well. I found the Tibetan monks to be joyous, wise, innocent, and childlike people. It was interesting to me that three of them approached me separately and asked the same question about my artwork: "What tradition is this from?" Their culture is steeped in tradition, and they simply could not conceive of creating anything without it. It didn't quite translate that I did not work from an established system. At one point, a friend said on my behalf, "His artwork is his own tradition." This brought a kind and puzzled look to the monk's face, as if nothing could exist meaningfully without tradition. Tibetan creations were familiar deities, known for thousands of years, expressed freshly with new meaning and power each time. Americans don't think that way; we tend to think in terms of cultural influences, or at best, radical new breakthroughs. Or, on the safer side of western culture, we work within stiff, dead conventions in hopes that a small sentiment might come alive to help us feel something. A real and long-lasting tradition, with deep spiritual roots and practices, that continues to awaken the spirit in its people for thousands of years is an alien concept for most of us in the western world. Our commercialism consumes the slow evolution of integrity by trivializing it and teaching us to value what we don't have in our possession. Ours is a tradition of insatiable economic growth rather than spiritual growth.

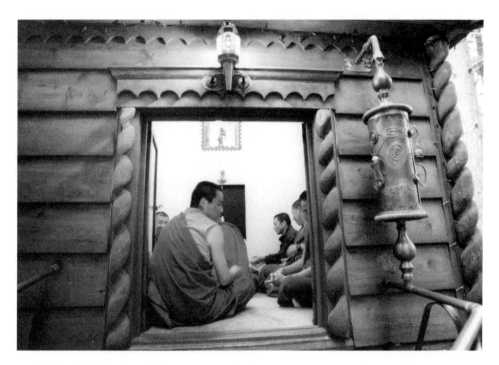

Monks blessing the tower.

The monks looked for meaning in much of what they did. I had an old condom machine that I had found at the dump and painted with mysterious images and symbols, and then filled with Nordic runes. Instead of getting a prophylactic when you put your fifty cents in the machine, you received a prophetic message. One of the monks decided to try the rune machine, so I gave him the two quarters the machine required. As he put the money in, several other monks gathered around to watch. It seemed important to them to find out what his rune had to say. The machine delivered a most appropriate rune, "Inguz—Fertility and New Beginnings," into his waiting hands. It was the rune of the joyous deliverance of new life and a new path, the completion of a circle, and an emergence from a closed, chrysalis state. It also spoke of freeing oneself from unwanted influences and choosing not to live permanently amid obstructions. After centuries of self-contained cultural and spiritual isolation, wherein very little came into or went out of their country, the Tibetans are now opening out to the world, as a gift to us all. The rune that the monk received seemed to relate to this as well as to the difficulties that the Tibetans have endured in the Chinese occupation of their homeland.

The nine Tibetan monks' generous blessing of our tower was an extraordinary gift. It was the event that set the Flaming Stupa invisibly spinning, like a prayer wheel, blessing with each continuous turn.

The Flaming Stupa stairway.

Art as a Spiritual Path

The Inspired Heart

The most complete expression of the zeitgeist by art in my generation is best described as one of *wholeness*. Art, full circle, is the human story. In this story, metaphoric death is inevitable, and the consciously lived life offers the possibility of something new. A Hindu mystic said, "To set out with any holy purpose and to 'die' along the way is to succeed." High Art is the gift of resurrection as we continually die along the way. It is the Master's piece, a surrender into the hands of a success larger than our own. We may need to pass through darkness as a prerequisite to completion, but as in birth, darkness is forgotten when the new life presents itself. Our completed circle becomes a container that represents a dimension larger than we originally anticipated. It can hold life—our own and others. We cannot know this by maintaining a safe intellectual distance from the full experience of the journey. We must give ourselves to the experience creatively, completely, and with consistent attention.

As small human beings, we must believe in something with all our heart and soul, even if what we believe in turns out to be a false god. The god that "fails" may, in fact, hold the seed of our success if we trust our original good and innocent intention. What is faith if it does not hold up, however hesitantly, in the face of apparent death? The very place the world seems to fail is the same place where intelligence, will, and good intentions no longer work for us. They may actually become destructive forces should we push beyond their limited capacity to be useful tools in our lives.

Most artists believe (however unconsciously) that they can create their way to heaven. This is a good and noble ambition but impossible to achieve. Paradoxically, to do anything less than to try to create a heaven on earth is to waste a perfectly good life. The belief that we can

do what has never been done moves hope into action. Forces larger than our efforts *can* accomplish our dream, but we cannot avoid the moment of failure, in which we must rely on those forces. Our innocent, passionate belief in the possibilities inherent in this world, in spite of our apparent human limitations, lets God know we mean business! Great art comes out of this quest. Yet, it is not enough to simply know this truth. Many scholars can speak eloquently on this subject, and in a sense, they know *about* this truth. But only in the moment of real surrender—a moment when that which is known no longer holds—are we given the pure, simple experience of the arrival of something holy, which is ancient and yet truly new, in the best and most inspired sense of the word. To go beyond the limits of human effort through surrender is to go beyond death.

I spoke in an earlier chapter about artists who came up against this moment in the fifties and sixties and about many of their untimely deaths, some deliberate, some perhaps not. I believe that those who destroyed themselves arrived at their metaphorical death and could go no further. They could not assimilate the full blast of their encounters with the energetic conditions of the formless abstract. The ego's identity with form and control had to be relinquished. This relinquishing is often more difficult than physical death itself. We need only look at the fear-based choices many of us make and see the lives created out of those choices to know that this is true. Many of these self-destructive artists may have come to believe, consciously or unconsciously, that suicide was the inevitable alternative to surviving the death of the ego. I don't know. For whatever reason, many of us struggle enormously with this personal dilemma when confronted with the conditions and full blast of a radically inspired moment. We all have to face it at some point in our lives. The bottom line is that metaphorical death leads to either physical death or renewal. How we face this dilemma seems to have everything to do with the courage and freedom we are able to envision for ourselves. When we can allow the ego to die, we give ourselves to a mysterious quantum leap that takes us over the limits of death and into the territory of renewal.

Artists and mystics are often the first to discover beautiful new directions in consciousness. That these new directions inevitably take us through our worst fears is the reason most of us avoid the landscape completely. This is also why so many of the men and women who are the first to point the way for us—the bushwhackers of consciousness—have been misunderstood, condemned, or worse, killed! Death will always look like death even if it is only the death of a way of life that is no longer working for us, personally or collectively. It seems to me that our collective consciousness is up against that moment in which new expression and healthy change demand our attention.

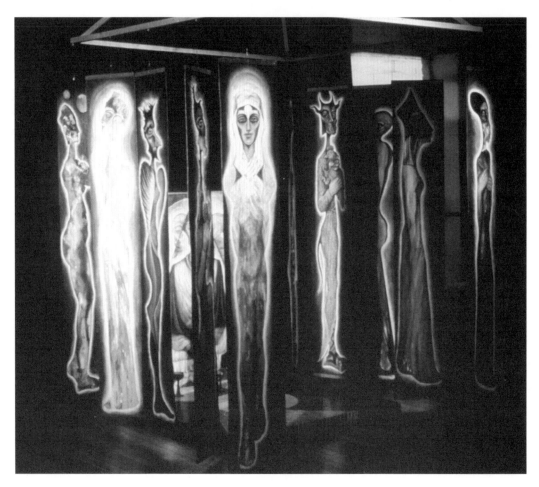

Angels and Demons. Hung and turning.

What are we going to do? What are the artists seeing now? What are the choices that will allow us to die along the way and to succeed in our quest? The alternative to metaphoric death can only be fear or continued self-destructive behavior. There are no limits to the ego's manipulations and strategies as it attempts to dominate and control, even if it means destroying ourselves or our world. Like the artists of the fifties and sixties, we find that allowing our bodies to die is often much easier than allowing the well-established, rooted ideas about ourselves to die. How do we allow for the organic unfolding of the deeply spiritual, creative life that is our birthright?

We may find temporary rest in beauty itself, but with art, as with all other disciplines, the only territories consistently worth exploring are the badlands of limitation and fear. Creative life can only gain power and offer freedom as it moves forward in these areas. To

journey onward across the holy ground of personally perceived limitation, and then to live out in determined beauty the mystery and the creation that awaits us at the end of that journey, *is* art, and life, at its very best. The particular form of expression an individual artist adopts while moving through this landscape is their unique gift, a natural by-product of a life well lived.

When the gift of the inspired heart is given, there is no longer a separation between art and any other aspect of our lives. We come full circle when we are fully and equally attentive to everything in our lives. There can be no identified, fixed priority, only the requirements of each given moment. We can no longer say, "I am an artist" or "I am a theologian" or "I am an anything" separate from the alluring Whole of the heart's inspiration, with all its possibilities intact.

Everything counts and fits into place. The way we get out of bed in the morning becomes as important as the moment of creating an inspired new work of art. When we fix our gaze abstractly on the Whole, all action and nonaction have the potential to support what is holy and creative. High Art becomes the art of all things, of whispers from God in all directions. Creative life requires one to listen carefully to the whispers and to become fully involved in manifesting the products of a generous universe in the world. Art is as good a way as any to express the whisper, yet art is not defined as separate from any other expression of creation. What is important is not the particular form of creation, but the completed circle as the premise for right action in our world. We begin to see the patterns that connect our actions to those of others, centered in their own unique circles. The universal circle that emerges as we interconnect is the creative energy that holds our world in its new form. We become, with those we are connected to, the inspired heart of creation itself.

The Holy Fool

"He who fears to be foolish will never learn to be wise."
— 1 Cor. 3:18

"A slave you must be. Either you are a slave for the world or you are a slave for God."
— Paramahansa Yogananda

There is in all of us a Holy Fool, a friend to the soul of our world, often forgotten, or worse, feared. When we make a complete and unconditional surrender and trust the mysterious, unknown void with our lives, we enter the domain of the Holy Fool for God. We become a slave to God, which is as free as we can be as human beings. We are led by the allure of a deeper mystery, a presence that leads to unimaginable freedom.

Fearing that we may be fools in the eyes of the world, we use this world as a safe and reasonable reference point. We go about creating our lives in the image of what we see externally, thus eliminating all mystery. We risk nothing at all that may lead to a unique and holy freedom. Reason has an important place in our lives, but its range is limited, and it becomes a foolish activity when we rely on it too heavily. There is a saying, "Reason will take us to the door of heaven, but love will get us in."

We can reason ourselves into being, fool ourselves into believing that our lives are our own unique, logical, fixed creation. Then we must use endless amounts of will and strategy to uphold this illusion. We receive no support from the larger creative forces in this effort. When approached by the trusting and emptied Fool for God, these same forces are available, hovering in manifestation mode, ready to dispense of their gifts. The personal link to the sacred is all we have when we are fully engaged in our own true life. The mystery is all the support and structure we need to bring through the magic that charms our lives.

Most of us do our best to live for something that feels like life and beauty. However misguided, we pour our energies and our life force out with great determination into whatever world we believe in. It is disheartening when the final expression of that investment looks more like dust than dance. This brings to the surface a deep grief, for which the only remedy is a final and lasting victory that is uniquely our own.

In stories, "happily ever after" resonates with our souls. It is a truth that we know in our bones. "Happily ever after" is our birthright! When grace delivers at the end of the well-lived

story, the final gift is compassion, which allows us to forgive ourselves and our world. In this we find our freedom. We allow ourselves to be happy, knowing that creation is not all our responsibility. We work hard and joyfully and allow space for the universe to meet our gifts halfway. The Mystery of the universe leads us gladly, given the chance. It can free us from an unconscious creation, with a final expression we did not intend or hope for, and bring into play the life we had imagined for ourselves.

There is an image in the *Bhagavad Gita* of a bodhi tree that is seen as upside down from the worldly perspective. When seen from heaven, it is clear that the tree is right-side up and that the upside down tree is its reflection. The Holy Fool is right-side up in this upside down world. She sees the real tree and does not create the illusion of a reflection. With an eye on the way things truly are, the Holy Fool can use her alchemical touch to hand over what is difficult and out of order to the divine, to be returned sanctified. Like a child, she can laugh when God laughs and cry when God cries.

If we go deeply into the difficult places in our life, we find an edge where we have faltered before, which remains unresolved and therefore unchanged. We have backed away or run away from this edge more than once. If we have not done the necessary introspective work, backing away is an unconscious, instinctual response. The ego informs us that we are confronting our death, so we believe that we need to retreat from the edge to survive.

The ropes course is a wonderful training ground for practice of the metaphoric death experience. It is a way to activate the internal Holy Fool. You have to be a little foolish to do it in the first place. One of the exercises in the program is to climb way up high, forty feet, to the top of a pole. There are iron stakes in the pole to climb on. When you reach the top, you let go with your hands and stand fully erect on the top of the pole. You are told to leap out and catch the large bar hanging six feet away and slightly above you. Of course, while all this is going on, you are in a harness fastened to a rope that will hold you should you fall.

The ego does not interpret this experience as a metaphorical death. The irrational need of the unconscious to survive is more powerful than we imagine. In spite of the metaphor and the safety rope, what you feel is terror! The Holy Fool is empowered by the mythic reality of the metaphor and has faith in the unseen safety rope above. When we are immersed in our own journey, alone and full of doubts, and hearing the message, "This is death," then we should remember this: There is a rope.

The metaphorical death experience is a given in our lives. As time will always reveal, we have no choice but to fully traverse this dark landscape and emerge into light on the other side. The form the journey takes is a uniquely individual experience. In telling the collective

stories of this journey, we create and share a newly emerging myth. Conscious participation in the shared story is probably the most important gift we can experience, physically and spiritually, in the world today. We need a healthy and irrational foolishness to receive this gift. We must trust our intuitive feeling for the simple love, adventure, and joy of life! There is no reference point for this experience. We have only the inherent support that comes with being in right relationship with the Mystery. The support and communication we get from the universe along the way—the feedback that informs us that all is well in our creation—is a miracle!

There is a story told about the Buddha calling the earth to witness. The Buddha was asked a reasonable question, something like, "Exactly who do you think is going to understand these lofty ideas of yours, and who do you think you are anyway, to become such a large and beautiful truth?" His answer was a most unreasonable one. He reached down and touched the ground, and there was a rumble from the core of the earth. The earth itself spoke on the Buddha's behalf. I am not sure he caused the earth to quake. I believe, however, that he was at the perfect place at the perfect moment, being asked the perfect question by the perfect person, who may in fact have been the archetypal devil himself. This right relationship to a larger harmony is the unreasonable reality of the Holy Fool for God.

The ego responds to life by trying to survive, avoiding difficult situations, rather than expecting a miracle. Remember the TV comedy show from years ago, *Sanford and Son*? Sanford would feign a heart attack when confronted with something that he didn't want to look at. He would place his hand dramatically on his heart and say, "This is the big one!" And he'd solicit the help of his dead wife in heaven to coerce those responsible to have pity and back off. I think that we are all often a bit like Sanford when we attempt to avoid the uncharted territory that awakens our fears.

If we can keep our immediate reactions in check when we are confronting difficulty and discomfort, we discover a place in our hearts where we know that all is well. Held in innocence, this place protects us. The people or events that present the challenges are seen ultimately as our best helpmates. They come bearing gifts, even those who choose to be our enemies. "An insult, to a sage, is a boon!" (Lao Tzu)

The immediate response of backing away to survive a difficult situation is often the product of an old habit. When we remember what previous choices we made at this juncture, we begin to see the recurring pattern of this habit. We realize that we have turned away at this decisive moment before. We can make a different choice this time. We can break old patterns and set in place the good habits that serve us.

We do, however, have our own timing for full entry into the mysterious Fool's journey. Although we need to work diligently and be as conscious and self-aware as possible, there is, in the end, that all-important element of grace. Grace is on good speaking terms with the Holy Fool. We must call on her constantly with passion, invoking her power as we go. How we do that seems not to matter as much as that we do it consistently. This invocation is a living prayer. There is a way of *being* prayer that is fully grounded in a personal relationship with the divine. It is the way of trust, in which we do not feel separate from the source. The entrance to this way has everything to do with the sincerity and intention of the practice and little to do with the particular form of practice. Being prayer includes time and space for lighthearted foolishness and beauty.

There is a wonderful story from the Hindus, I believe. Once a very determined spiritual seeker went to see a very great guru who was also a king. The guru was a Holy Fool. Upon seeing the determination of this young seeker, he instructed the woman to walk through his entire castle. She was told not to miss a single room. The castle was a dark and beautiful place, and she would need a light to see. She was given an oil lamp that was filled to the very brim with oil, and she was told that it was most important not to spill a single drop. This young seeker, intuiting the spiritual significance of the task, was extremely careful with the very full lamp. After several hours of walking with great seriousness of purpose through the entire castle, she finally returned to the king, feeling that she had accomplished the difficult assignment he had given her. She said, "I managed to go through every single room without spilling a single drop of oil." The king said, "Very good! But tell me, did you enjoy the beauty of my castle?" The young woman said, "No! How could I? I was focused on the oil and was being very careful not to spill it. I didn't notice a thing!" The king said, "Then you have failed the test!"

We must find the beauty in our own journey, but many spiritual traditions hold that it may not be accomplished in one lifetime. This is a timeless involvement; therefore, it can also happen *now,* and why not? What more important work is there to do?

The importance we give to this Fool's journey will fade if we do not maintain the relentless attention that it requires. Most of us begin our soul's journey with at least one foot limping along. And many of us begin it as young people, with the foolhardy belief that we can do the things that have never been done! Eventually, if the entirety of our being does not engage the process and ground it in consistency, we lose our dream that a deeper spirituality even exists. We need to focus on the spiritual reality of our lives with a fierce hold on our original innocence. We apply enormous amounts of time, energy, and discipline to the things that do not last in this life. These activities have little to do with anything that results in real happiness for others or for us.

We are at a rare time in the history of our world. Consciousness is attempting to come through the spirit of our lives. It brings with it all that we need to live out its gift. At the same time, our old ways of being on the planet are beginning to fail. Our social forms and structures are radically changing and breaking down. Our mother, the Earth, is ailing! We are truly in uncharted territory.

Perhaps the Holy Fool in us trusts that this, too, is God. The light could not exist except in relation to the dark. When we hold this Fool's vision, we can begin to see that where we stand *now* is holy ground, perfectly in place under our feet, ready for our next step in a meaningful new direction. This unknown, mysterious universe will show us the way that *it* needs to go! We must realize that we do not know how to save ourselves or our world. This not-knowing is a healthy, worthy position that can lead us in a true direction. The wisdom of the Holy Fool is off-limits to human manipulation. It is out of the reach of intellectual understanding and control. It is a holy wisdom inside experience, where mind leaves off and spirit takes over. Even our best intentions are rendered useless here.

"Goodness is the final obstacle to God," says the *Bhagavad Gita*.
We need to wait and trust that all will be served in some joyful, mysterious way, in which we can be willing participants in our own good stories. Reality knows the way; it is not lost, and neither are we.

A time may come when you are asked to let go of everything you think you are and all that you think you possess. If you can give yourself to this process, what will emerge will be a truer self in a truer world. All will be well. All that you had hoped for, all that is most important to you, all that seemed to be impossible or gone forever will be sanctified and returned to you. This is the innermost wisdom of the Holy Fool!

Dann bete du, wie es dich dieser lehrt
(To that younger brother)

Now pray,
as I who came back from the same confusion
learn to pray.

I returned to paint upon the altars
those old holy forms,
but they shone differently,
fierce in their beauty.

So now my prayer is this:

You, my own deep soul,
trust me. I will not betray you.
My blood is alive with many voices
telling me I am made of longing.

What mystery breaks over me now?
In its shadow I come to life.
For the first time I am alone with you—
you, my power to feel.

—RAINER MARIA RILKE

From *Rilke's Book of Hours: Love Poems to God*,
translated by Anita Barrows and Joanna Macy.

About the Author

Jerry Wennstrom was born in New York on January 13, 1950. "I don't have much of an impressive bio," he admits. "All I could do was paint, and because I had nothing else, I laid all of my identity on that. It didn't hold though did it? I became nothing and found everything."

Jerry *was* trained in art, however. "I went to school for 3 years at Rockland Community College and the State University of New Paltz, both in New York. The one teacher who believed in me at New Paltz saw how driven I was and how much work I had produced. He said, 'What are you doing here? Why don't you just go out and do it?' He said what I knew I needed to do, but was afraid to do. Even though I had almost completed my degree program, when he said that, I walked straight out the door and didn't return. I do have an A.A. degree, for those interested in my scholarly credentials."

At age 29, he set out to discover the rock-bottom truth of his life. For years he questioned his motives as an artist and got by on next to nothing. Finally, Jerry moved to the state of Washington and got married. He has filled his charming Whidbey Island house with his unique sculptures and paintings, and built a 40-foot meditation tower, the Flaming Stupa, on his property.

A video of Jerry's life and work, *In the Hands of Alchemy,* is available from Parabola. Jerry is available for film showings, speaking engagements, and workshops with his wife—singer and adult education teacher, Marilyn Strong. His website is *www.JerryWennstrom.com.* You can write to Jerry at *alchemy@whidbey.com.*

Sentient Publications, LLC publishes books on cultural creativity, experimental education, transformative spirituality, holistic health, new science, and ecology, approached from an integral viewpoint. Our authors are intensely interested in exploring the nature of life from fresh perspectives, addressing life's great questions, and fostering the full expression of the human potential. Sentient Publications' books arise from the spirit of inquiry and the richness of the inherent dialogue between writer and reader.

We are very interested in hearing from our readers. To direct suggestions or comments to us, or to be added to our mailing list, please contact:

SENTIENT PUBLICATIONS, LLC

1113 Spruce Street
Boulder, CO 80302
303-443-2188
contact@sentientpublications.com
www.sentientpublications.com